MW00824499

Collectible Glass Bells
of the World

A. A. Trinidad, Jr.

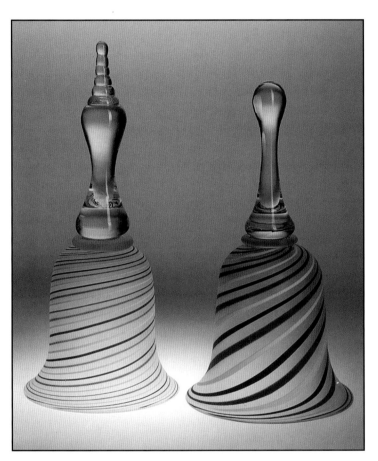

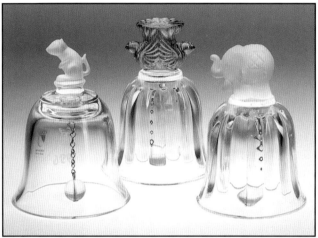

Schiffer Publishing Ltd

4880 Lower Valley Road, Atglen, PA 19310 USA

Dedication

To my wife, Jo; together we continued to explore the world of glass bells.

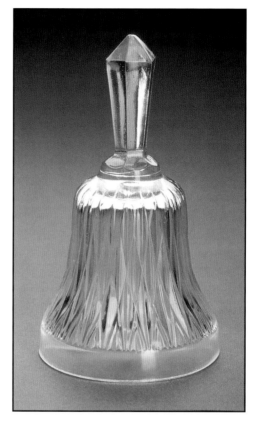

Our second bell.

Library of Congress Cataloging-in-Publication Data

Trinidad, A. A.
 Collectible glass bells of the world / by A. A. Trinidad, Jr.
 p. cm.
 ISBN 0-7643-1918-3
1. Glass Bells--Collectors and collecting. I. Title.
NK5440.B37 T74 2003
748.8--dc21

2003012472

Designed by Mark David Bowyer
Type set in Bernhard Mod BT/Souvenir Lt BT

ISBN: 0-7643-1918-3
Printed in China
1 2 3 4

Published by Schiffer Publishing Ltd.
4880 Lower Valley Road
Atglen, PA 19310
Phone: (610) 593-1777; Fax: (610) 593-2002
E-mail: Info@schifferbooks.com
Please visit our web site catalog at
www.schifferbooks.com
We are always looking for people to write books on new and related subjects. If you have an idea for a book, please contact us at the above address.

This book may be purchased from the publisher.
Include $3.95 for shipping.
Please try your bookstore first.
You may write for a free catalog.

In Europe, Schiffer books are distributed by
Bushwood Books
6 Marksbury Avenue
Kew Gardens
Surrey TW9 4JF England
Phone: 44 (0) 20 8392 8585
Fax: 44 (0) 20 8392 9876
E-mail: Bushwd@aol.com
Free postage in the UK. Europe: air mail at cost.

Contents

Acknowledgments

The contribution of information from many bell collectors, museums, and bell producers over many years has made this book possible. I am especially indebted to the many friends in the American Bell Association and the American Cut Glass Association who have been a source of information and encouragement to write another book.

Thanks to Bruce Waters for the painstaking effort in photographing bells from the author's collection. My thanks also to the many bell collectors and others who made photographs of their bells available to be included, and in particular Alan Anthony, Arlene and Alvin Bargerstock, Dowlton and Ruth Berry, Warren Biden and Teddie Steele, Gary L. Childress, Bruce Clayton, Jim Cook, Warren and Elizabeth Dean, Curtis and Lenore Hammond, Ed Hendzlik, MaryAnn and Don Livingston, Donald and Carrol Lyle, Bruce Millstead, Kelsey Murphy, George and Lora Pecor, Max J. Redden, Carol and Bob Rotgers, Sally and Rob Roy, John and Charmel Trinidad, Julie Marie Trinidad, and Barbara Wright.

Finally, my thanks to my editor, Donna Baker, for giving me the benefit of her experience with the writing and production of her books on bells.

Introduction

Bells have been used as a means of communication and ornamentation in many cultures for over three thousand years.

Generally, bells have been made of metal, porcelain, wood, clay, and glass. In bell collections you will find animal bells, transportation related bells, commemorative bells, church bells, fire bells, and school bells. Figural and figurine bells in brass, bronze, silver, porcelain, and glass are very popular.

This book focuses attention on glass bells, presenting them by country of origin, type of glass, and manufacturer when known. When the manufacturer is not known the bells are presented as unknown or under a special grouping.

Prices for bells vary based on condition, age, number made, availability, and attractiveness to the collector. Therefore, for bells shown herein, a range of values has been shown.

In recent years, many bell producing companies have merged with other companies. The attributions presented in this book are the latest the author has been able to determine. Bells previously shown in the author's book *Glass Bells* are not repeated in this book unless additional information has become available.

The author has gathered photographs of glass bells from various museums throughout the world. They are shown primarily under the respective countries or producers to which they are attributed.

Chapter One
The History of Glass Bells

There is very little reference to glass bells before the sixteenth century. However, in *The Life of Christopher Columbus from his own Letters and Journals*, written by Edward Everett Hale in the 1890s, Hale writes the following:

CHAPTER IV. THE LANDING ON THE TWELFTH OF OCTOBER

It was on Friday, the twelfth of October, that they saw this island, which was an island of the Lucayos group, called, says Las Casas, "in the tongue of the Indians, Guanahani." Soon they saw people naked, and the Admiral went ashore in the armed boat, with Martin Alonzo Pinzon and, Vicente Yanez, his brother, who was captain of the Nina. The Admiral unfurled the Royal Standard, and the captain's two standards of the Greek Cross, which the Admiral raised on all the ships as a sign, with an F. and a Y.; over each letter a crown; one on one side of the iron cross symbol and the other on the other. When they were ashore they saw very green trees and much water, and fruits of different kinds.

October 11-12.

"So that they may feel great friendship for us, and because I knew that they were a people who would be better delivered and converted to our Holy Faith by love than by force, I gave to some of them red caps and glass bells which they put round their necks, and many other things of little value, in which they took much pleasure, and they remained so friendly to us that it was wonderful."

A Venetian blown glass bell with a small network of threads of glass embedded in clear glass with tiny air bubbles. The brass handle has a standing lion holding an unmarked coat of arms shield. It has an elaborate gilded silver clapper. The bell was possibly made from a sixteenth century glass goblet. 4-3/4"d. x 8"h. *Courtesy of Kunstsammlungen der Veste Coburg, Germany.*

This is the earliest reference to glass bells found by the author.

Some commemorative Belgian, Dutch, and German glass bells are known from the sixteenth century and there are Bohemian and Venetian glass bells from the sixteenth and seventeenth centuries.

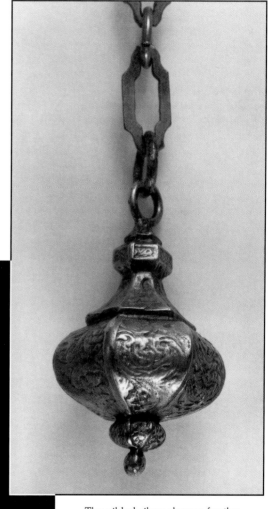

The gilded silver clapper for the Venetian glass bell. *Courtesy of Kunstsammlungen der Veste Coburg, Germany.*

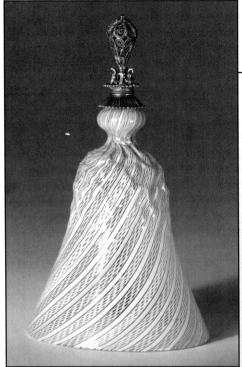

A Venetian blown clear glass bell with spiral solid white stripes alternating with a network of threads, possibly made from a seventeenth century glass goblet.. The bell has an elaborate silver filigree handle and clapper. 3-3/4"d. x 6-1/2"h. *Courtesy of Kunstsammlungen der Veste Coburg, Germany.*

The silver filigree clapper for the bell. *Courtesy of Kunstsammlungen der Veste Coburg, Germany.*

A thick glass bell, with a gray hue and four parallel, uniformly applied, glass double rings. It has a heavy glass handle of two balls separated by two disks and a short stem. An interior glass eyelet supports a coarse brass chain without a clapper. Possibly Belgian, Dutch, or German from the sixteenth century. 4"d. x 4-1/2"h. *Courtesy of Kunstsammlungen der Veste Coburg, Germany.*

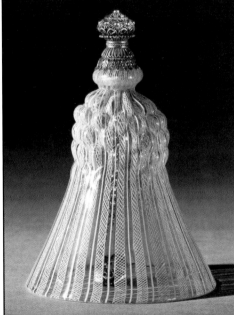

Another Venetian glass bell, with thin white stripes imbedded in clear glass and alternating with stripes of a network of threaded glass. The handle and clapper are of silver filigree. This bell also may have been made from a seventeenth century glass goblet. 4"d. x 5-3/4"h. *Courtesy of Kunstsammlungen der Veste Coburg, Germany.*

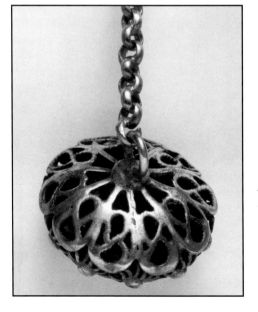

The elaborate silver filigree clapper for the Venetian bell at left. *Courtesy of Kunstsammlungen der Veste Coburg, Germany.*

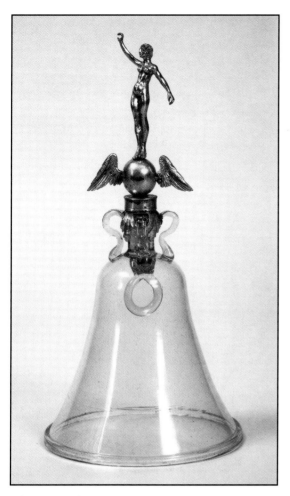

A late sixteenth century Venetian glass bell with a gilt bronze figural handle. 5-1/8"d. x 10-3/8"h. *Courtesy of The Metropolitan Museum of Art, Gift of J. Pierpont Morgan, 1917.*

For some of the Venetian glass bells it is not clear whether they were planned as bells or if they were goblets originally and then converted to bells.

Some early European marriage cups resembling bells are collected by bell collectors. They have a bell shaped base cup and a smaller suspended cup. Most have been made in Germany.

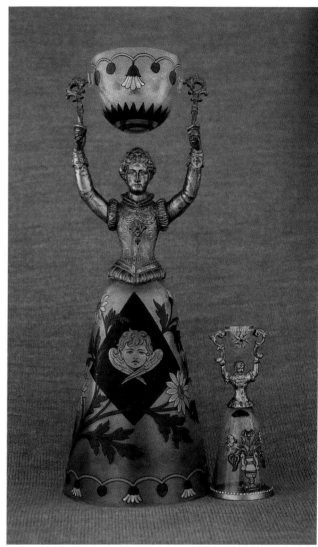

Two marriage cups. The larger one on the left is 11"h. with the bottom cup having a diameter of 4" and is attributed to a Norwegian origin. $1,000-1,500. The smaller one on the right is 4-1/2"h. with a 2"d. base. It has an inscription in German which translates to "All happiness to him who drinks." $150-300. *Courtesy of The Pecor Collection.*

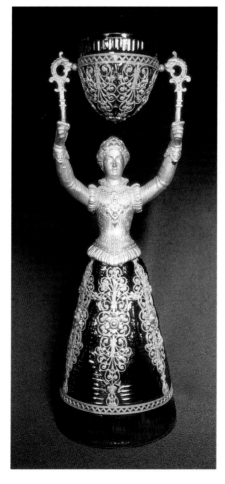

A marriage cup of dark green glass with bronze body and cup overlay. The base is 3-3/8"d. and the overall height is 10-1/4". German origin. $400-500.

9

Most glass bells available to collectors, primarily from Europe and the United States, are known from the mid-eighteenth century to the present time. While some glass bells were used to call servants at the end of the nineteenth century, most recent glass bells have been made primarily for decorative purposes, souvenirs, advertising, and for commemorating events.

References

Springer, L. Elsinore. *The Collector's Book of Bells.* New York, Crown Publishers, Inc., 1972.

———. *That Vanishing Sound.* New York, Crown Publishers, Inc., 1976.

Theuerkauff-Liederwald, Anna-Elisabeth. *Venezianisches Glas der Kunstsammlungen der Veste Coburg.* Herausgegeben von Joachim Kruse, 1994. 194-197.

Trinidad, A. A. Jr. "Glass Bells." *Antique Trader's Collector Magazine & Price Guide.* Vol. 6, no. 3 (March 1999): 7-12.

———. *Glass Bells.* Atglen, PA: Schiffer Publishing Ltd., 2001.

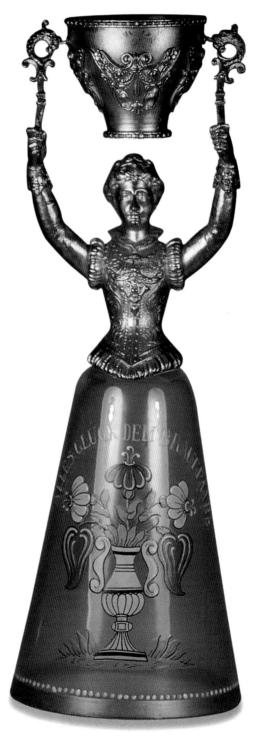

A clear glass marriage cup with floral decoration and gilded bronze handle and smaller cup. 5-1/4"d. x 12"h. $600-700. *Courtesy of Bruce Millstead.*

General Information

Glass

Glass is a homogeneous material produced by heating together a silica, from sand, and a flux, usually soda or potash. Soda glass is the earliest form of glass. It was first used for making items wholly of glass over four thousand years ago. It is lighter, less resonant, and less lustrous than lead glass, and likely to be flawed by bubbles and color tints. Glass that contains at least twenty percent lead oxide is known as lead glass. It is relatively softer, heavier, and stronger than soda glass, and has a refractive index that provides brilliance when the surface is covered with cut polished facets. George Ravenscroft in England first used this type of glass about 1676.

Colored glass generally achieves its color by the use of various metallic oxides in the mixture fused in the process of making glass. Sometimes glass is colored by impurities in the basic ingredients. Color can also be achieved by imbedding particles of colored material.

Flint glass is another name for a type of lead glass. It came into use during the seventeenth century in England when flint was used temporarily to replace sand as a source of silica. It has persisted since that time as an alternate name for lead glass.

Some bells are found in cased or plated glass, a glass that has been created by combining two or more layers of colored and clear glass. Cased glass is used primarily to emphasize a pattern that has been cut or engraved on the surface layer to reveal the clear or colored glass below. Flashed or stained glass has a very thin outer coating of colored glass made by staining the clear glass or dipping a clear glass object into a bath of colored glass. The staining technique has been used extensively on Bohemian glass bells.

Glass bells will be found in lime and lead glass, the lead glass being used primarily for bells that have a cut or engraved design.

Forming the Bell

Glass bells are formed in several ways: free-blown, mold-blown, and mold-pressed. A free-blown bell is one in which the body has been shaped solely by inflating it with a blowpipe and shaping it with tools. Flame working, sometimes called lampworking, is a form of free blowing in which tubes of glass are heated in a flame or gas-fueled torches and manipulated to the desired shape. Mold-blown bells are made by blowing partly inflated hot glass into a mold; the glass assumes the shape of the mold and any decoration that is on the mold. In mold-pressed bells, hot molten glass is forced into a multiple parts mold by means of a plunger to press the glass against the mold. In many bells the handle is formed separately and combined with the body of the bell while hot or joined by an adhesive. Some bells have the handle fitted into a sleeve at the upper end of the body of the bell and held there by plaster or an adhesive material.

Clappers and Attachments

Clappers produce a sound when striking a bell on the inside or outside. On glass bells, clappers are usually made of solid or hollow metal, glass, plastic, or wood. Metal clappers are known in silver, brass, bronze, iron, and lead. Most clappers are supported by a heavy or light metal chain or wire.

The method of attaching to the glass the chain or wire that holds a clapper varies and can sometimes be used to determine the approximate period of time during which the bell was produced. During the second half of the nineteenth century and early twentieth century, most American cut glass bells supported a chain and a two-part hollow clapper by attaching the chain to a loop on a twisted iron wire imbedded in the glass. The Blackmer, Pairpoint, and Unger cut glass companies used a solid silver ball clapper and silver chain on almost all their cut glass bells. The Mount Washington Glass Company used the solid silver clapper and silver chain on a few of their bells.

From about the mid-1920s to around 1970, many bells had a hole formed or drilled at the base of the handle, the chain was inserted, and the hole filled with plaster. This method is common on better quality bells today. Since around 1970, many glass bells, worldwide, have the chain attached to a glass, metal, or plastic disk glued to the glass.

Large glass bells, made in two parts and joined by plaster, have a wire loop imbedded in the plaster to hold the clapper, usually made of glass. This is typical of wedding bells described in Chapter Nine.

Some bells have hollow handles with the chain passing through the handle and attached to the top of the handle. Some American bells from the 1950s and earlier have a hollow handle with a cork inserted to hold the chain or wire. A few American bells from the twentieth century have two glass prongs holding the chain. Some

companies had special clappers and attachments produced for their bells and these are described for specific bells in the following chapters.

Decorating Methods

Glass bells have been decorated using four primary techniques, individually or in combination: cutting, engraving, etching, and painting. The base glass can be clear colorless, clear colored, colored opaque, or cased, also known as plated glass. When a bell is to be cut or engraved with a pattern, clear or cased lead glass is generally used.

During the late nineteenth century and early twentieth century, when a cut pattern was desired on bells, the cutter started with a bell shaped glass blank on which a design was marked. Looking through the glass, the cutter applied the glass to rotating stone or metal wheels — of various sizes and shaped perimeter — while an abrasive suspended in water dripped on the wheel. The resulting completed pattern had a whitish gray color that had to be polished to produce a clear sparkling finish. Before the turn of the twentieth century, wooden wheels with rouge or putty powder were used for this polishing; afterwards, a paste of pumice was used with cork or felt wheels to produce the required finish. To reduce labor costs, acid polishing using a combination of sulfuric and hydrofluoric acid was introduced at the end of the nineteenth century. Today, much of the cutting is done with diamond-coated wheels.

Engraving of glass bells is sometimes combined with cutting, but most engraved glass bells are made of thin glass. Engraving is done by applying a rotating copper wheel of various sizes to the glass. The wheels are fed with a mixture of oil or water and an abrasive. Sometimes the engraved pattern is left unpolished, leaving a gray or matte finish for contrast with the clear uncut areas.

Acid etching produces gray or frosted finishes with a stencil used as a guide to produce the required design. In the early part of the twentieth century, needle etching was sometimes used to produce a uniform design. The design was programmed into a machine that applied a needle to a revolving piece of glass covered with wax. The uncovered portion was coated with vaporized acid to produce the pattern; then the wax was removed.

Plate etching was also used. In this method, the pattern was printed on stone or metal and then transferred to thin paper and the inked design received the acid. The paper was then pressed against the item to be etched. Any uncovered part of the glass was coated with wax.

Painting on bells is a common decoration by itself or in combination with other decorating techniques. On some early twentieth century bells, the painted surface was not fired in the kiln to fix the paint, resulting in the bell losing some of the painted design.

Carnival glass is a glass that has been made iridescent by spraying a metallic salt on the surface of hot glass, prior to being reheated, to produce a characteristic metallic finish. It imitates the iridescent finish developed by Tiffany as Favrile Art Glass.

Identification

Very few glass bells can be identified by inscribed or etched signatures or trademarks. Many bells have been produced with paper labels that have since been removed. Generally, few American glass bells are signed; bells of some smaller art glass studios do show a signature. Some larger American glass houses that are producing or have produced bells used symbols.

The French glass houses producing higher quality bells, such as Lalique, Baccarat, Val St. Lambert, Daum Freres, and St. Louis, usually sign or etch a symbol on their glass bells.

The best way to identify the maker of glass bells is by studying the characteristics of the bells themselves, as most producers incorporated their own design features. Of course, a paper label helps, if still on the bell. Labels can be found on many new American glass bells; most European glass companies use a paper label as well.

Chapter Three
American Cut Glass Bells

Very few cut glass bells are illustrated in books and catalogs on American cut glass. When looking for bells made of cased glass, colored on the outside surface and a pattern cut to expose the clear glass below, there are fewer still. Colored glass represented less than ten percent of all cut glass produced. Companies that cut bells also cut goblets in similar patterns; illustrations of cut glass goblets are more prevalent and these can help to identify the company and the pattern of a bell. It is only after seeing many American cut glass bells that you find that most of the major cutting firms had their own distinctive patented patterns and some had one or more distinctive designs for cutting the handles of bells.

There were very few cut glass bells produced prior to the 1880s. In the homes of the more affluent in the late 1800s and early twentieth century, cut glass bells to summon servants would be seen as part of table settings of rich cut glass. After the introduction of electricity in the 1890s, the availability of electric call bells gradually reduced the use of cut glass bells. After World War I, cut glass bells became primarily decorative.

The Brilliant Period of cut glass in the United States, from the time of the Centennial in 1876 to about 1915, was a period during which many fine cut glass bells were produced in geometric patterns using lead glass. Overlapping this period was the Flower Period, from about 1906 to the 1920s, during which cut and engraved flowers and other natural subjects appeared on bells. At about the same time, less expensive pressed pattern glass bells were being made in imitation of the more expensive cut glass patterns.

As described in Chapter Two, a study of clappers used on bells helps to identify generally the period in which bells were produced. On most American cut glass bells from the Brilliant Period and the Flower Period, a chain supporting a clapper was attached to a loop in a twisted wire imbedded in the glass. T. G. Hawkes is the only American cut glass company known by the author that rarely used the twisted wire attachment; that company, throughout its long history of producing bells, attached the chain to the glass primarily by inserting the chain in a hole in the glass and filling the hole with plaster.

Lead glass blanks used for cut glass were produced by many American companies, but primarily by the Corning Glass Works, C. Dorflinger & Sons, and the Union Glass Co. Some blanks, particularly in colored glass and cased glass, came from European companies. Blanks specifically for bells can be attributed to the Dorflinger, Steuben, and Union companies. The twisted wire, holding a chain for the clapper, must have been inserted into the handle when the blank was made. A tapered hole can usually be seen at the inside top of bell to provide access to the handle when joined.

Below is an alphabetical listing of American companies that produced cut glass bells with examples of some of the bells they made.

T. B. Clark & Co.

Honesdale, Pennsylvania, 1884-1927

The T. B. Clark company produced bells with a very distinctive pattern cut at the top of handle. The top has radial miters forming a star with a crosscut diamonds pattern encircling the side just below the top. Some Clark bells are known also to have used a blank similar to that used by their subsidiary company, the Maple City Glass Co.

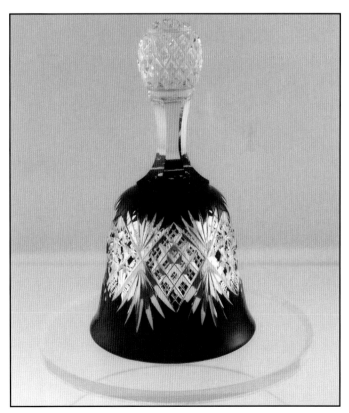

A Clark bell in dark blue cut to clear in the "Jewel" pattern with typical Clark handle of radial miters forming a star on top and crosscut diamonds encircling the side just below the top. 3"d. x 5"h. $1,800-2,200.

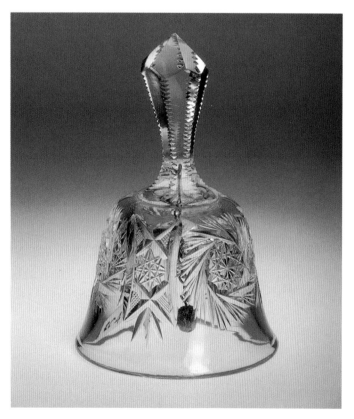

A Clark bell in the "Winola" pattern. 2-3/4"d. x 5-3/4"h. $350-400.

C. Dorflinger & Sons

White Mills, Pennsylvania, 1865-1964

The Dorflinger company produced some of the finest cut glass bells in the United States at the end of the nineteenth century and early twentieth century. Their bells have three very distinctive designs cut on the tops of handles. Two of these designs are prevalent. One has strawberry diamonds cut on the top and along the perimeter immediately below the top of the handle; the other shows radial miters cut on a relatively flat top of the handle. The less prevalent design has raised buttons on a curved top of handle and the buttons are decorated with parts of the design cut on the body of the bell. Most of the bells have handles with six sides, but an occasional bell will have an eight-sided handle.

Dorflinger glass bells generally were produced from four different size molds with known finished heights of about 5-1/2", 6-1/2", 7-1/2", and 8-1/2".

A November 10, 1897 advertisement in *The Jewelers Circular* shows that Dorflinger cut glass bells in crystal and three colors: ruby, blue, and green.

In the records on Dorflinger glass at the Corning Museum Rakow Library there is a Lambert Dorflinger salesman's book from about 1895. This book lists thirteen bell patterns available: American, Belmont, Colonial, Dresden, Hob Diamond, Lorraine, Marlboro, Oriental, Parisian, Royal, Star & Diamond, Strawberry Diamond & Fan, and Sultana. Their prices vary with the size of the bell in crystal or colored. Based on this listing and other known Dorflinger patterns on bells that are not listed in that book, there are over one hundred different Dorflinger bells that may exist.

A Dorflinger bell in ruby cut to clear "Parisian" pattern. 3"d. x 5-1/2"h., c.1886. $1,900-2,300. *Courtesy of Dowlton and Ruth Berry.*

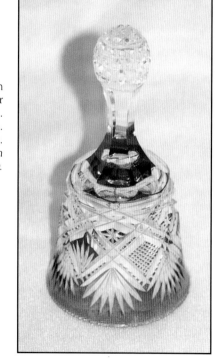

A Clark bell in a "Harvard" pattern with hexagonal handle with serrated edges. 3"d. x 4-3/4"h. $300-375.

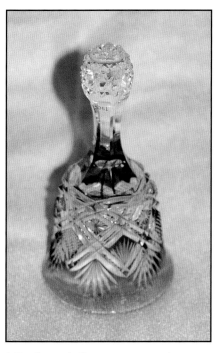

A Dorflinger bell in green cut to clear "Parisian" pattern. 3"d. x 5-1/2"h., c.1886. $1,900-2,300. *Courtesy of Dowlton and Ruth Berry.*

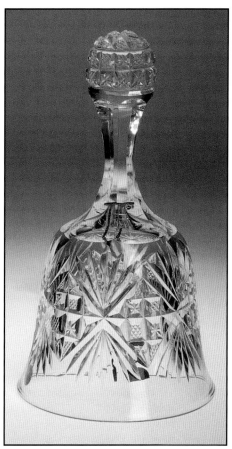

A Dorflinger bell in a clear "Royal" pattern with part of the pattern reflected in the top of the handle. 3"d. x 5-1/2"h. $700-800.

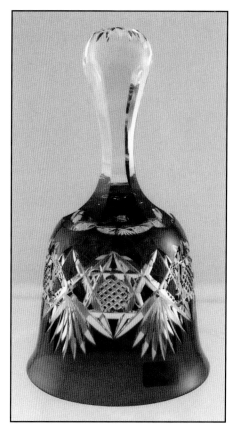

A Dorflinger bell in ruby cut to clear "No. 40" pattern with a clear colorless handle with a cut star on top. 3"d. x 5"h. $1,800-2,200.

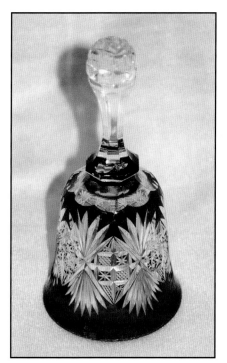

A Dorflinger bell in blue cut to clear "Royal" pattern. 3"d. x 5-3/4"h. c.1891. $2,100-2,400. *Courtesy of Dowlton and Ruth Berry.*

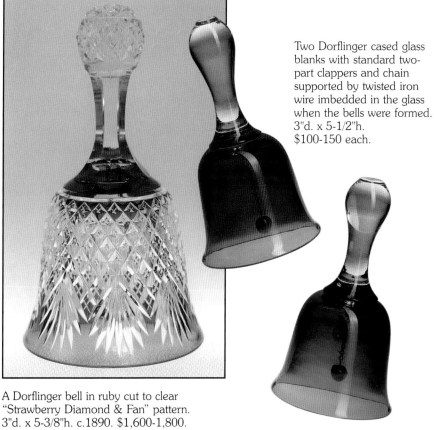

A Dorflinger bell in ruby cut to clear "Strawberry Diamond & Fan" pattern. 3"d. x 5-3/8"h. c.1890. $1,600-1,800. *Courtesy of Sally and Rob Roy.*

Two Dorflinger cased glass blanks with standard two-part clappers and chain supported by twisted iron wire imbedded in the glass when the bells were formed. 3"d. x 5-1/2"h. $100-150 each.

T. G. Hawkes & Co.

Corning, New York, 1880-1962

The T. G. Hawkes company produced many fine glass bells during its eighty-two year history of production of cut glass articles. Like many other glass houses, Hawkes produced many fine goblets in known patterns similar to those on bells, and illustrations of these help to identify the patterns on their many bells.

On Hawkes bells, the chain holding the clapper was attached to the glass by inserting the chain in a pre-formed or drilled hole and filling the hole with plaster. This is contrary to the clapper attachment method of imbedding a twisted wire into the glass, used by other cut glass companies during the Brilliant Period and Flower Period of American cut glass. However, it is known that Hawkes salvaged broken stemware by converting some of them to bells. This was accomplished by drilling a hole and inserting the chain and plaster.

Earlier than 1915, Hawkes used a special solid, heavy, silver clapper produced by the Gorham Manufacturing Co. The company must have learned from its experience with broken bells using the heavy clapper, as some bells produced around the year 1900 are known with a wooden clapper. For a short period around 1915, Hawkes bells appear with metal clappers in a shape similar to the earlier clappers, but weighing about half the weight of the original metal clappers.

From about 1915 to the 1950s, the clapper used by Hawkes has a two-part hollow metal ball attached to a chain. This is typical of clappers used by American firms during that period and before.

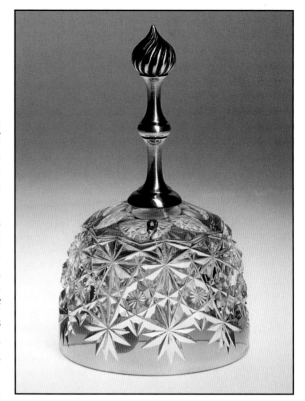

A Hawkes bell in rose cut to clear glass in a "Russian" pattern. Made by Hawkes with a sterling silver handle by Gorham. Wood clapper. 2-3/4"d. x 4-3/4"h. $500-600.

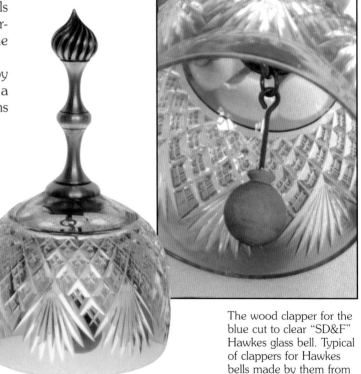

The wood clapper for the blue cut to clear "SD&F" Hawkes glass bell. Typical of clappers for Hawkes bells made by them from broken cut glass goblets around 1900. *Courtesy of Sally and Rob Roy.*

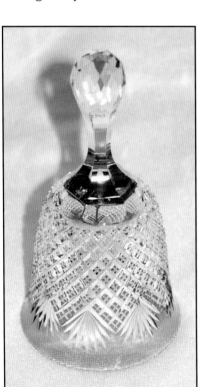

A Hawkes light blue cut to clear "Strawberry Diamond & Fan" pattern bell. 3"d. x 5-1/2"h. c.1915. $1,000-1,200. *Courtesy of Dowlton and Ruth Berry.*

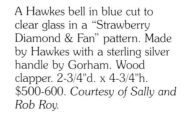

A Hawkes bell in blue cut to clear glass in a "Strawberry Diamond & Fan" pattern. Made by Hawkes with a sterling silver handle by Gorham. Wood clapper. 2-3/4"d. x 4-3/4"h. $500-600. *Courtesy of Sally and Rob Roy.*

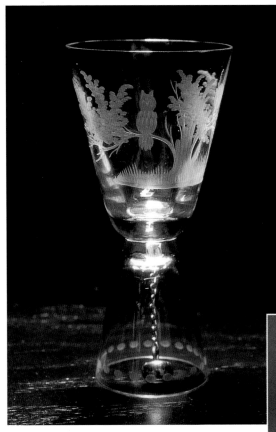

A Hawkes bell in ruby cut to clear made by Hawkes from stemware. It has a sterling handle. 2-3/4"d. x 4"h. $600-800.

A signed Hawkes combined jigger and bell engraved with an owl and foliage. 2-1/4"d. at the top and 1-5/8"d. at the bottom. $125-175.

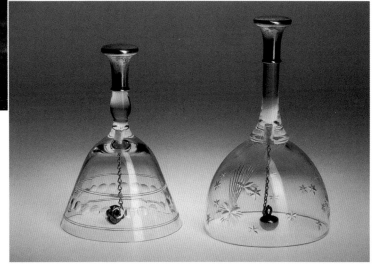

Hawkes bells with sterling silver handles in a "Pearl Border" pattern on the left, 2-3/4"d. x 4-1/4"h., and in an "Acquila" pattern on the right, 3"d. x 5"h. $75-175 each.

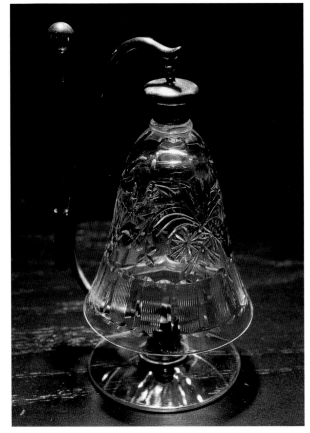

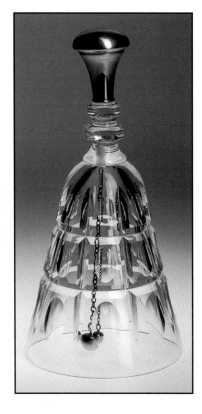

A Hawkes bell with sterling silver handle in a "Wexford Waterford" pattern. 3-1/2"d. x 6-3/4"h. $100-150.

A Hawkes bell in the "Coronet" pattern supported on a sterling silver stand. 5-1/2"h. on a 2-3/4"d. base. $250-300.

Higgins & Seiter

New York, New York

Higgins & Seiter were wholesale distributors of china and glass in New York City. Several of their catalogs illustrated cut glass, but the manufacturer of the glass was not named. The bell shown was illustrated in their 1905-06 catalog.

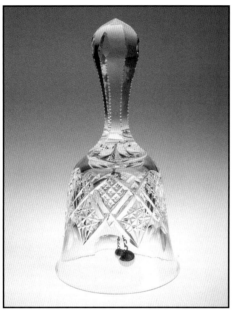

A Higgins & Seiter bell in their "No. 3" pattern of eight point stars alternating with crosscut diamonds and punties. 3"d. x 5-3/4"h. $300-400.

J. Hoare & Co.

Corning, New York, 1853-1920

Hoare produced many fine bells. The handles typical of Hoare bells have six sides with serrated corners and two or three horizontal miters.

A Hoare bell in the "Monarch" pattern. c.1896. 3"d. x 5 3/4"h. $600-700.

Krantz, Smith & Co.

Honesdale, Pennsylvania, 1898-1908

Krantz & Sell Company, Inc., 1908-1932

Krantz & Sell Company, Inc. was the successor company to Krantz, Smith & Company, Inc. formed in 1898. The company produced few bells. The former company produced a Belmont pattern bell around 1904.

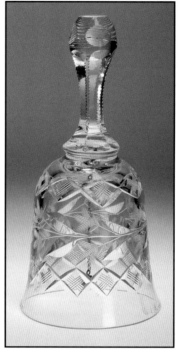

A Krantz & Sell bell in a "Wreath" pattern. c.1912. 3-1/2"d. x 7-1/2"h. $350-450.

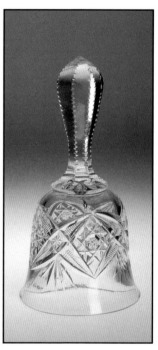

A Krantz, Smith & Company bell in a "Belmont" pattern. 3"d. x 6"h. $300-400.

Libbey Glass Co.

Toledo, Ohio, 1880-1935

Libbey produced a few fine cut glass bells with various pattern handles.

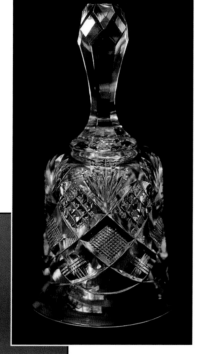

A Libbey Glass Company bell cut in an unknown pattern. 3-3/8"d. x 6-1/8"h. $400-500.

A Libbey Glass Company bell in a "Harvard" pattern. 3"d. x 5-1/4"h. $650-750.

Maple City Glass Co.

Honesdale, Pennsylvania, 1898-1927

The Maple City Glass Co. produced many fine bells with plain hexagonal handles. Maple City was a subsidiary of T. B. Clark & Co., who sometimes used the same glass blank for bells as Maple City.

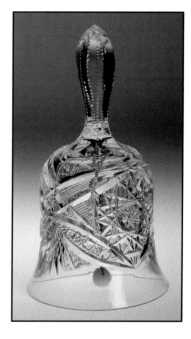

A Maple City bell in the "Verona" pattern. c.1909. 3-1/4"d. x 6"h. $300-400.

C. F. Monroe Company

Meriden, Connecticut, 1901-1916

The C. F. Monroe Company produced very few cut glass bells with handles. The company is well known for producing some cut glass tap bells with silver plated trimmings.

A C. F. Monroe twist bell in an unnamed cut glass pattern set in a silver plated metal base with bird-like feet. 4-1/4"d. x 4-1/2"h. $1,100-1,800. *Courtesy of Donald and Carrol Lyle.*

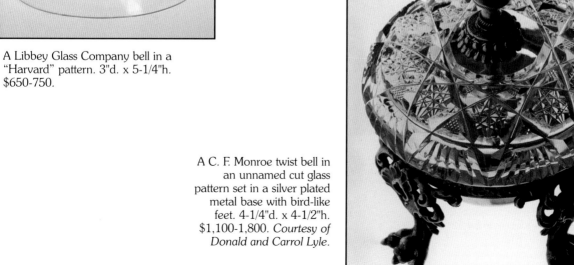

19

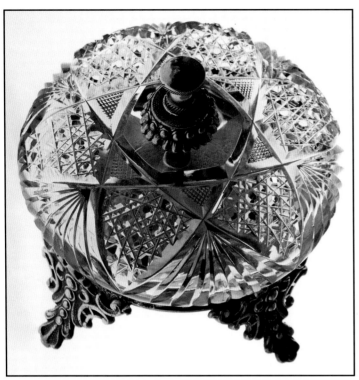

A C. F. Monroe twist bell in an Allita pattern set in a silver plated metal base. 4-1/2"d. x 3-3/4"h., c.1906. $1,100-1,800. *Courtesy of Donald and Carrol Lyle.*

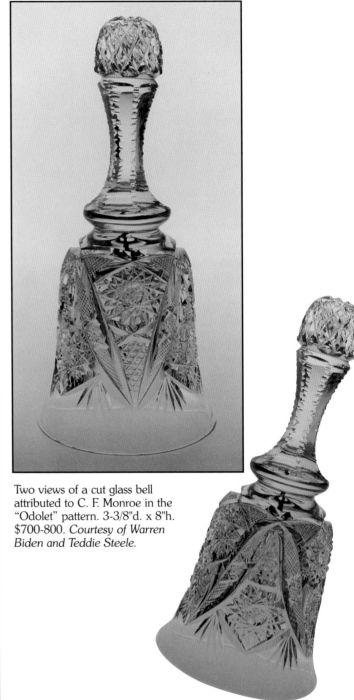

Two views of a cut glass bell attributed to C. F. Monroe in the "Odolet" pattern. 3-3/8"d. x 8"h. $700-800. *Courtesy of Warren Biden and Teddie Steele.*

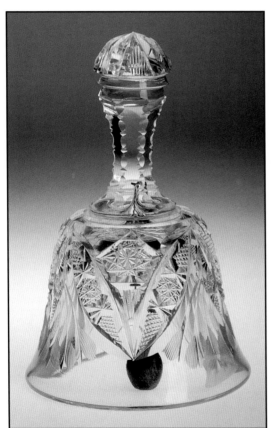

A bell attributed to C. F. Monroe in the "Odolet" pattern with a complex cut handle. 3"d. x 4-3/4"h. $400-500.

Pairpoint Corporation

New Bedford, Massachusetts, 1900-1938

The Pairpoint Corporation produced some cut glass bells, but is better known for its blown bells produced after 1970 by a successor company. The company's cut glass bells usually have a solid silver ball clapper and silver chain.

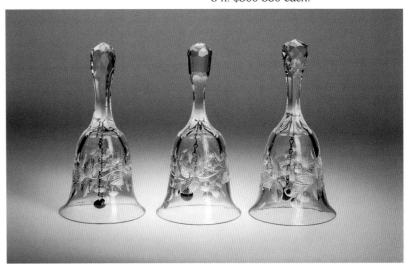

Three Pairpoint Glass bells in a crabapple and leaves design showing a variation in cut glass handles. 3"d. x 6"h. $300-350 each.

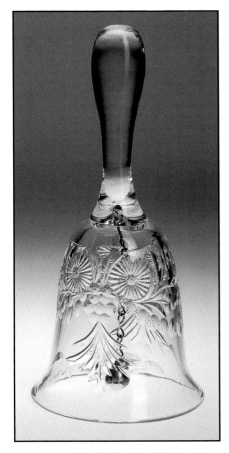

A Pairpoint glass bell with a "Chelsea" pattern. 3"d. x 6-1/4"h. $300-350.

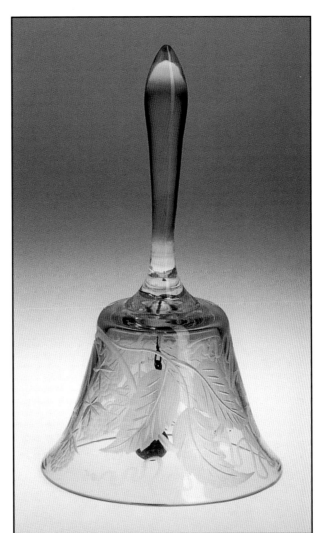

A Pairpoint bell in clear amber Canaria glass with engraving #41, berries and leaves. 2-3/4"d. x 5"h. $175-250.

21

Pepi Herrmann Crystal

Gilford, New Hampshire, 1974-

Pepi Herrmann Crystal has produced some of the finest cut glass bells since the Brilliant Period of American cut glass. Some bells have been produced in unique one-of-a-kind patterns.

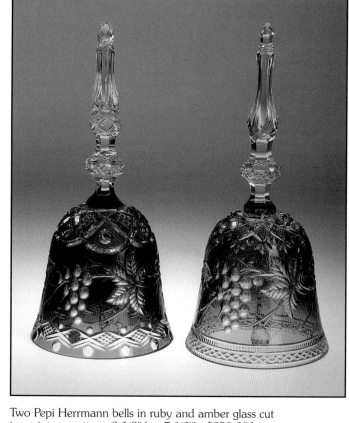

Two Pepi Herrmann bells in ruby and amber glass cut in a vintage pattern. 3-1/2"d. x 7-1/2"h. $250-300.

A Pepi Herrmann bell in dark green glass cut to clear with a vintage pattern. 3-1/2"d. x 7-1/2"h. $250-300. *Courtesy of Warren and Elizabeth Dean.*

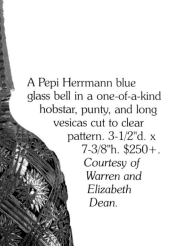

A Pepi Herrmann blue glass bell in a one-of-a-kind hobstar, punty, and long vesicas cut to clear pattern. 3-1/2"d. x 7-3/8"h. $250+. *Courtesy of Warren and Elizabeth Dean.*

A Pepi Herrmann green glass bell in a one-of-a-kind hobstar and punty cut to clear pattern. 3-1/2"d. x 7-3/8"h. $250+. *Courtesy of Warren and Elizabeth Dean.*

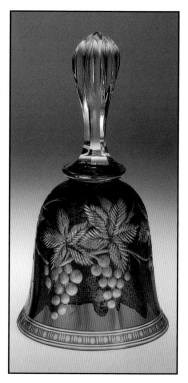

A Pepi Herrmann one-of-a-kind bell in a rose cut to clear vintage pattern on an old American twelve-sided glass blank. 3"d. x 5-3/4"h. $600-700.

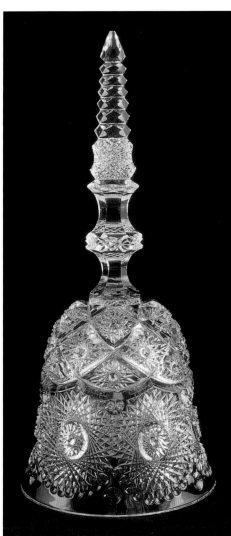

A Pepi Herrmann pale green glass bell in a one-of-a-kind cut to clear hobstar design. 3-1/8"d. x 7-3/8"h. $300+. *Courtesy of Warren and Elizabeth Dean.*

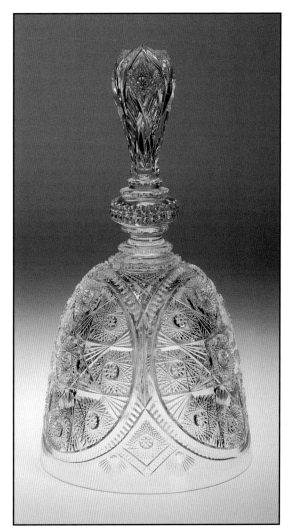

A Pepi Herrmann one-of-a-kind bell cut in a "Cathedral" pattern with 1994 cuts, including thirty-three 32-point hobstars, on a blank from the Hawkes archives. 3-1/2"d. x 7"h. $1,000+.

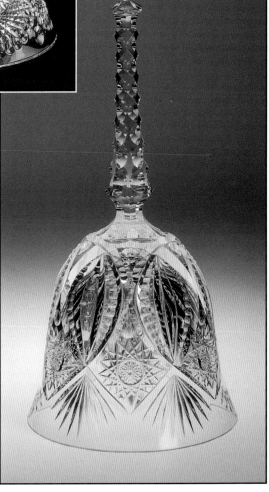

A Pepi Herrmann bell cut in the "Millennium 2000" pattern. #24/150. 3-1/2"d. x 7-1/4"h. $225-250.

Pitkin & Brooks Company
Chicago, Illinois, 1872-1920

Pitkin & Brooks produced bells typically with hexagonal handles with serrated corners and three horizontal miters. Less frequently, the company produced bells with hexagonal handles with a flat top.

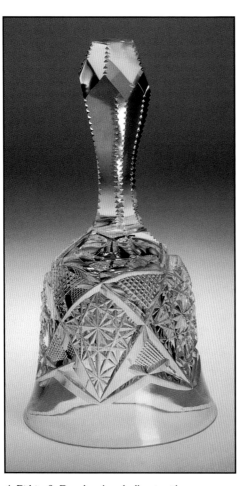

A Pitkin & Brooks glass bell cut with hobstars alternating with cross-cut diamonds. Flat top handle with hexagonal facets and serrated corners. Signed P&B on the handle. 3"d. x 5-3/4"h. $400-450.

Rochester Cut Glass Company
Rochester, Pennsylvania, 1896-?

Only a bell in one pattern from this company is known to the author.

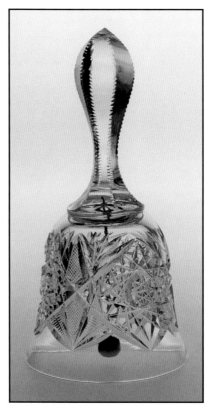

A Rochester Cut Glass Company bell in a double lozenge and hobstar pattern. 3"d. x 5-3/4"h. c.1910. $550-650. *Courtesy of Warren Biden and Teddie Steele.*

L. Straus & Sons
New York, New York, 1888-1925

Straus produced many fine bells in various patterns. Most of their bells have a distinctive multifaceted top of handle.

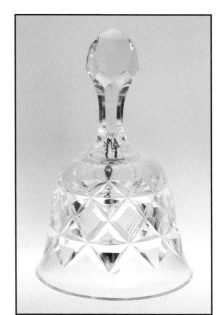

A Straus bell cut in a diamond pattern. 3"d. x 4-1/2"h. $300-350. *Courtesy of Sally and Rob Roy.*

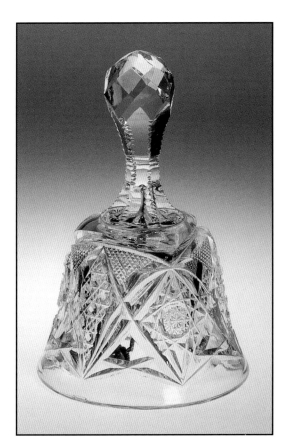

A Straus bell cut in the "Corinthian" pattern with a twelve point star in the hobstar. 3"d. x 4-3/4"h. $400-450.

Unger Brothers

Newark, New Jersey, 1901-1918

Bells in very few patterns are known from this firm. All bells have a solid silver ball clapper and chain.

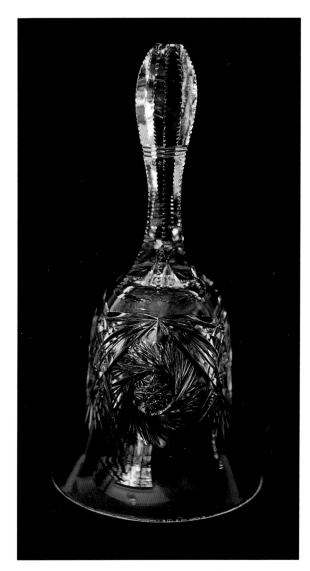

An Unger bell cut in an unknown pattern. It has a solid silver clapper and chain. 3-1/8"d. x 6"h. $250-300. *Courtesy of Sally and Rob Roy.*

A Straus bell cut in the "American Beauty" pattern. 3-1/4"d. x 6"h. $600-675.

American Cut Glass Bells of

Unknown Origin

There are many cut glass bells the author has seen that presently have not been identified. Several are included here to illustrate the great variety of cut glass bells that are available to the collector and to challenge collectors to continue researching their origin from among the many firms known to have produced rich cut glass.

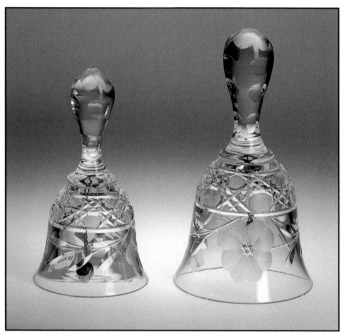

Two bells of similar unknown Harvard type pattern with eight petal flower and four sided handle. 2-3/4"d. x 5-1/4"h. on left and 3-1/4"d. x 6"h. on right. $375-450 each.

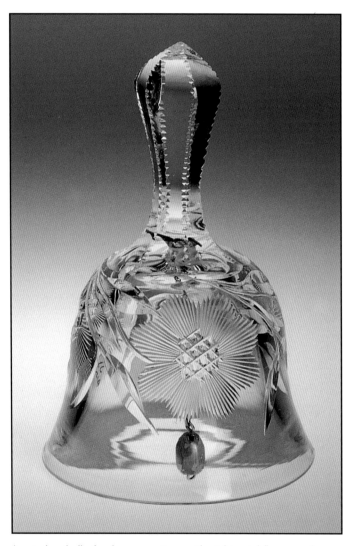

A cut glass bell of unknown pattern with eight petal flower and hexagonal serrated handle. 3"d. x 4-1/2"h. $175-225.

References

Feller, John Quentin. *Dorflinger - America's Finest Glass, 1852-1921*. Marietta, Ohio: Antique Publications, 1988.

Miller, Jim. "Patriotic Motifs in Cut Glass." *Glass Collector's Digest* XIII, no. 1 (June/July 1999): 18-22.

Trinidad, A. A. Jr. "American Cut Glass Bells." *The Bell Tower* 54, no. 5 (September-October 1996): 25-36.

Trinidad, Al. "Ring for Service — Gently, Please." *The Hobstar* 19, no. 6 (January, 1997): 1 and 6.

Trinidad, A. A. Jr. "Hawkes Cut Glass Bells." *Glass Collector's Digest* XII, no. 4 (December-January 1999): 70-77.

———. *Glass Bells*. Atglen, Pennsylvania: Schiffer Publishing Ltd., 2001

Waher, Bettye W. *The Hawkes Hunter*. Bettye W. Waher, 1984.

American Engraved Glass Bells

There are many fine American glass bells that are engraved on thin glass blanks. This chapter presents representative bells produced by some of the firms who produced these bells during the end of the nineteenth century and the twentieth century.

Bacalles Glass Engravers

Corning, New York, 1967-

Starting in the 1970s, Bacalles produced many engraved ruby glass bells amongst its line of engraved glass products. Engraved designs on ruby glass bells known to the author include Wild Rose, Goldfinch, Hummingbird, Cardinal, Owl, Clipper, Vintage Grape, Eagle, Horse, Capistrano Swallow, and Fortieth Anniversary. Some of the bell blanks were produced in West Virginia. More recent bells have been engraved on colorless blanks.

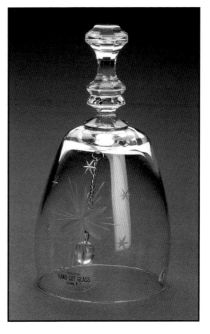

A Bacalles clear glass bell with engraved stars. 2-3/4"d. x 5-1/2"h. $20-25.

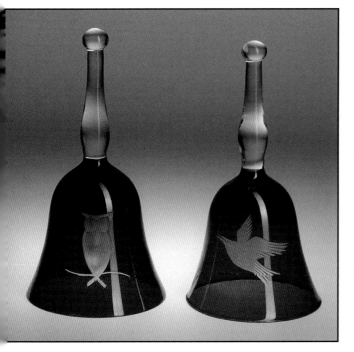

Two Bacalles bells in flashed ruby glass with #214 engraved owl and #208 engraved hummingbird. 3-1/4"d. 6"h. $25-30 each.

Boston and Sandwich Glass Company

Sandwich, Massachusetts, 1870-1887

The Boston and Sandwich Glass Company produced a few blown glass bells that were needle etched and more that were engraved. The bells from this period are mostly engraved with initials surrounded by a wreath that is unique to Sandwich glass.

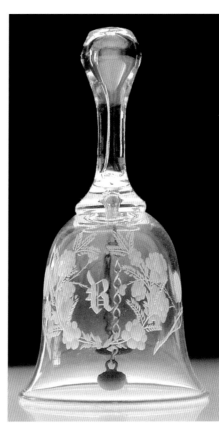

A Boston & Sandwich blown lead glass bell engraved with an "R" inside a floral wreath, with sprays of roses on either side. Applied hollow handle. 5"h. *Courtesy of the Sandwich Glass Museum.*

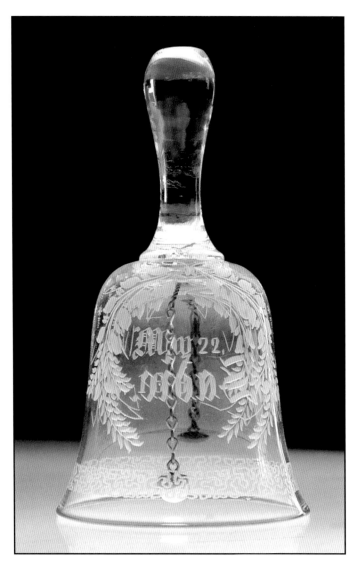

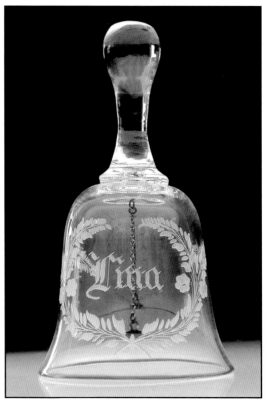

A Boston & Sandwich blown lead glass bell engraved "Lina" in script and in an open floral wreath with a branch of leaves on each side. It has an applied solid glass handle. 5-1/2"h. *Courtesy of the Sandwich Glass Museum.*

A Boston & Sandwich blown lead glass bell engraved "Sadie" inside an open wreath of leaves. On the opposite side, "May 22, 1887" is engraved inside an open wreath. Dividing the main wreaths are engraved inverted pyramids of stars and lines forming flower pots. The lower edge is engraved in a vermiculated design. The applied solid handle is cut and ground at the top. 5-1/4"h. *Courtesy of the Sandwich Glass Museum.*

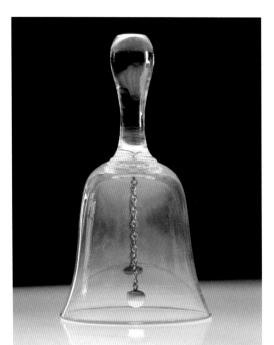

A blown lead glass bell attributed to Boston & Sandwich, with an applied solid glass handle. 5-3/8"h. *Courtesy of the Sandwich Glass Museum.*

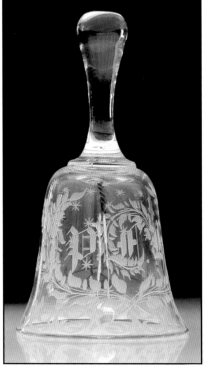

A Boston & Sandwich blown lead glass bell engraved "P.F.H." in an open floral wreath with stars in the background. It has an applied solid glass handle. 5"h. *Courtesy of the Sandwich Glass Museum.*

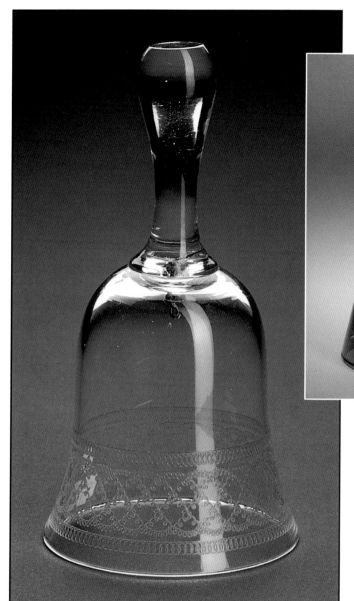

A clear glass bell with a needle etched scroll design attributed to Boston & Sandwich, 1880-1887. 2-3/4"d. x 5-1/2"h. $150-200.

Two Damron's cranberry flashed bells with engraved "I love you Mom" on the left and "Knoxville World's Fair 1982" on the right. 2-3/4"d. x 5-1/2"h. $15-25 each.

Damron's Glass Engraving

Sisterville, West Virginia, 1922-

Damron's has engraved glass, including bells, for many years. The company engraves colored glass bells with many decorations. It has also produced bells with decals fired for permanence. Most bells are 5" high, but some 8-1/2" high are known.

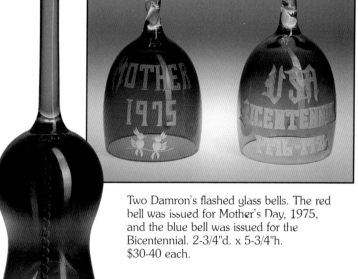

Two Damron's flashed glass bells. The red bell was issued for Mother's Day, 1975, and the blue bell was issued for the Bicentennial. 2-3/4"d. x 5-3/4"h. $30-40 each.

A Damron's cranberry flashed bell with engraved flowers. 3-1/2"d. x 8-3/4"h. $30-40.

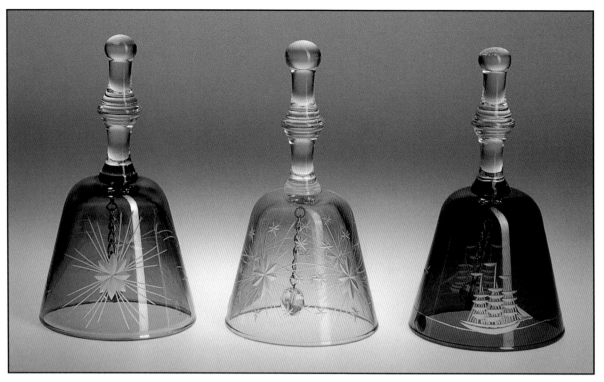

Three Damron's flashed glass bells with engraved stars and a ship. 2-3/4"d. x 5-1/4"h. $15-25 each.

Seneca Glass Company

Morgantown, West Virginia, 1891-1983

Seneca made many fine bells on very thin blown lead glass in the 1960s and 1970s. The bells, with a few exceptions, have a unique feature of a hollow handle through which the chain, holding a crystal clapper, passes to the top of the handle and is held there by a metal pinhead, flat spiral, or star. The bells were made in several heights, but primarily 3-3/4", 4-1/2", and 5-1/2". A small 2-1/4" hanging Christmas Bell with a gold rim, but without a handle, was produced in 1977 through 1980. Seneca decorated its glass by acid etching, needle etching, plate etching, and engraving. In the 1970s, Seneca produced some bells in colored glass but generally these were not decorated.

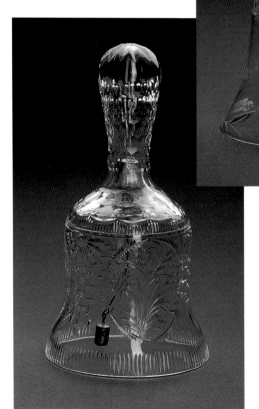

A Seneca glass bell engraved with cut No.373. The hollow handle has a cork to hold the chain for the clapper. 3-1/4"d. x 6-1/4"h. $175-200.

Two Seneca Glass bells in a "Majestic" pattern on the left and an "Eleanor" pattern on the right. 3-1/4"d. x 5-1/2"h. $40-50 each.

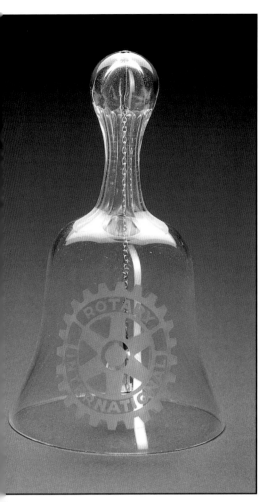

A Seneca bell made for Rotary International. 2-1/2"d. x 4-1/2"h. $35-40.

H. P. Sinclaire & Company
Corning, New York, 1903-1920
Bath, New York, 1921-1929

The Sinclaire Company made bells from blanks 6" high and 5" high with molds numbered 2475 and 2476 respectively. An 8" high bell in mold 2476-1/2 is known also. In the archives of the Corning Museum of Glass Rakow Library are sketches of many patterns cut and engraved on the three blanks.

Patterns of H. P. Sinclaire Bells

6" Mold 2475 / Patent Date	5" Mold 2476 / Patent Date
Cut No.1 & Ivy	Eng. Chrysanthemum
Cut No. 1	Eng. Ivy
Eng. Antique No. 2	Eng. Stars & Roses
Eng. Flutes & Panel Border (1910)	Eng. Miters & Eng.
Eng. Snow Flakes & Holly (1911)	Eng. Adam (1915)
Strawberry diamond & Eng.	Eng. Roses
Versailles & Eng.	Rock Crystal 1003
Rock Crystal "a"	Eng. No. 1
Eng. No. 18	Eng. No. 3
	Eng. No. 8 (1909)
8" Mold 2476-1/2	Eng. S9
	Eng. 1000
Eng. No. 18	Eng. 1009
	Eng. 1023

A Seneca silvered glass bell made for Christmas 1978. 2-1/2"d. x 4-1/2"h. $35-45.

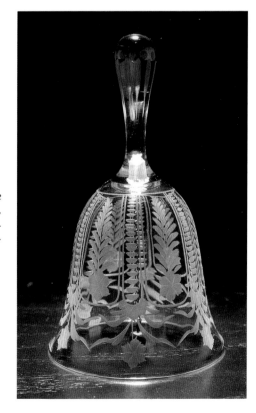

An H. P. Sinclaire bell in the "#18" engraved pattern. 3-1/4"d. x 5-1/2"h. $300-350.

31

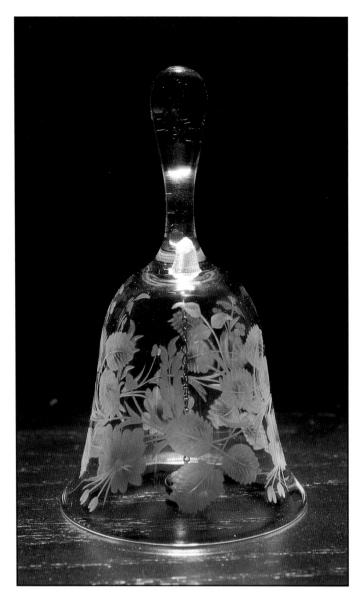

An H. P. Sinclaire bell in the "#1000" engraved pattern. 3-1/4"d. x 5-1/2"h. $300-350.

Two Sinclaire bells in "Engraving No.8," patented 1909, on the left and engraved "Ivy" pattern on the right. 3-1/4"d. x 5-1/2"h. $300-350.

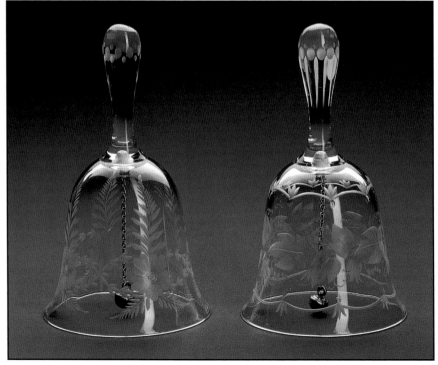

American Blown and Pressed Glass Bells

American blown and pressed glass bells are known from the middle of the nineteenth century. Many of the earlier bells in pressed glass patterns were produced in imitation of the more expensive cut glass patterns made before and after the beginning of the twentieth century.

Companies that have produced blown and pressed glass bells are presented in alphabetical order. Few of the companies from the nineteenth and early twentieth centuries have survived to the present time.

Some of the current companies that started in the last half of the twentieth century selling many types of articles, and with their main office in the United States, have made arrangements to have glass bells made in Europe with labels showing the name of the country where the bells have been made without identifying the location of the fabricating plant. These companies include Arte Italica, Mikasa Inc., and Ofnah Crystal.

Akro Agate Company

Clarksburg, West Virginia, 1911-1951

Akro Agate bells can be found in many colors in a smocking pattern. A ribbed pattern is found in clear colorless glass and rarely in clear green. All Akro bells have the Akro Agate logo of a flying crow holding two marbles (agates) together with a "Made in USA" on the inside top of bell adjacent to two prongs holding a wire with an iron clapper.

See Chapter Twelve for further discussion on Akro Agate molds.

An Akro Agate red slag glass bell with wooden handle likely made by Akro Agate from a graduated dart pot. The metal clapper matches the clappers on their glass bells. 3-1/2"d. x 5-1/2"h. $40-50.

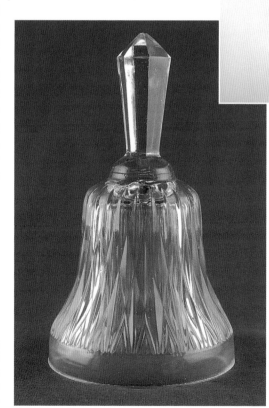

An Akro Agate clear glass "Smocking" pattern bell typical of similar bells available in several colors. 3-1/2"d. x 5-1/2"h. $20-25.

Arte Italica

New York, NY, 1997-

Arte Italica is an importer of luxury Italian decorative accessories, working with Italian glass companies to produce exclusive designs. Some glassware, including a bell, has been made with silver overlay.

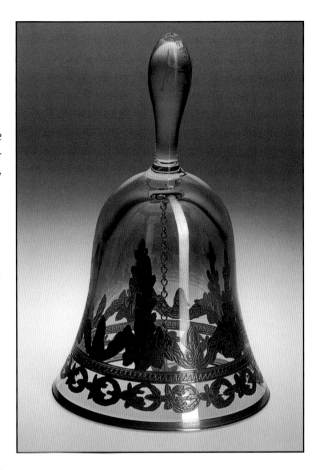

An Arte Italica clear glass bell with silver overlay pattern. 3-1/2"d. x 6"h. $30-40.

Boston and Sandwich Glass Company

Sandwich, Massachusetts, 1870-1887

The Boston and Sandwich Glass Company produced a few decorated molded glass bells.

Bryce Brothers Company

Mt. Pleasant, Pennsylvania, 1895-1965

Based on a Bryce Brothers catalog of 1942-1950, the author attributes bells to Bryce Brothers that have handles matching stems shown on Bryce stemware. Some similar bells with engraved designs are attributed to the Lotus Glass Company that bought blanks from Bryce Brothers.

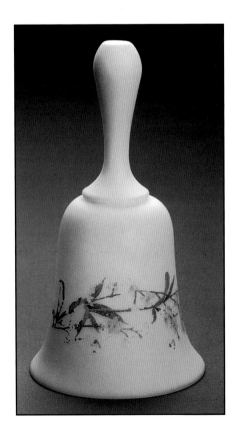

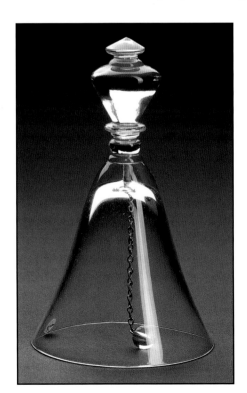

A clear glass bell attributed to Bryce Brothers based on the shape of the handle. 3"d. x 5-1/4"h. $20-30.

A frosted glass bell with painted flowers attributed to the Boston & Sandwich Glass Company. 3"d. x 5-1/2"h. $175-200.

Carl Kraft Glass

Sylvania, Ohio, 1970s

Carl Kraft operated a private studio, Glass Apple Studio, producing blown glass articles, including bells similar in style to English wedding bells.

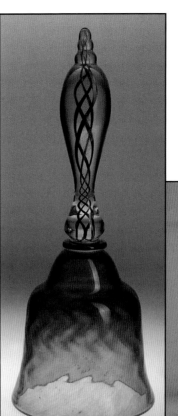

A Carl Kraft cranberry glass bell with colorless three knop handle with twisted red ribbon. 4-1/4"d. x 11"h. Signed "Kraft 74". $175-225.

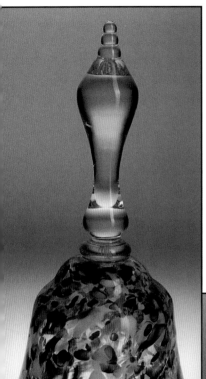

A Carl Kraft glass bell with a splatter of many colors and clear three knop handle. 4-1/2"d. x 9-1/2"h. Signed "Kraft 73". $125-175.

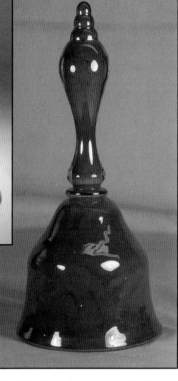

A Carl Kraft opaline glass bell with a three knop handle. 4-1/2"d. x 10"h. signed "1975 #1". $250-300.

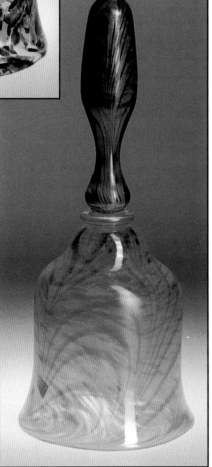

A Carl Kraft bell in iridescent mottled green glass with Nailsea type striping and two knop handle. 4-1/4"d. x 11-1/4"h. Signed "Kraft 76". $150-200.

Central Glass Company

Wheeling, West Virginia, 1867-1895

Central Glass Works

Wheeling, West Virginia, 1896-1939

The Central Glass Company started in 1867, making bar goods, tableware, and lamps. In 1891, it merged with the United States Glass Company, becoming its Factory O. A new company, Central Glass Works, independent of the USGC, was formed in 1896 after the inactivity of Factory O from 1893-1895. In the early part of the twentieth century, Central produced clear thin crystal stemware in many colors. During this period, the company has been

attributed as being the maker of some clear, colored, crystal bells. These bells typically have a swirled tapered handle with a hexagonal base.

See Chapter Eleven, "Who Really Made These Glass Bells," for presentation of a possibly different attribution.

In 1919, Central acquired molds for thicker glass bells with a raised rim from the Jefferson Glass Company. The bell is illustrated in a Central Chippendale Glass catalog, c.1919. These bells are found in clear glass with engraved or etched decoration to commemorate events and places. A clear glass bell with the original Central Glass Company Label is displayed at the Oglebay Institute Glass Museum in Wheeling, West Virginia. Some of the clear glass bells were cut with floral patterns.

See Chapter Twelve for a presentation on the movement of Jefferson glass bell molds.

Two Central Glass Company bells, the left with flashed pink handle and body, the right with clear amber body with floral engraving and a clear colorless handle. 3-1/4"d. x 5"h. $50-100 each.

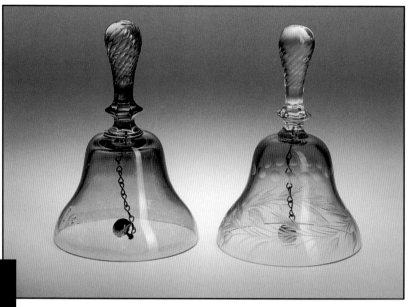

Dalzell-Viking Glass Company
New Martinsville, West Virginia,
1987-1998

The Viking Glass Company was purchased in 1987 by Kenneth Dalzell, a former president of Fostoria Glass Company, to form the Dalzell-Viking Glass Company. The company produced several glass bells.

A clear Central Glass Company bell with a floral cut pattern. 3-1/4"d. x 6-1/2"h. $50-60.

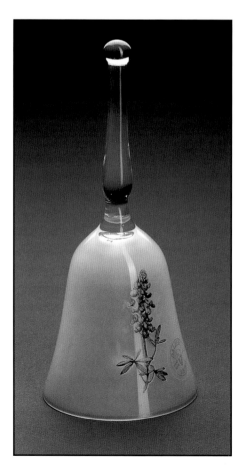

A Dalzell-Viking frosted glass bell with painted floral decoration and clear glass handle. 2-3/4"d. x 6"h. $20-30.

Durand Art Glass

Vineland, New Jersey, 1924-1931

The Durand Art Glass company, an art glass division of the Vineland Flint Glass Works, produced much art glass during its brief period of existence. In 1926, Charles Zara, a glasscutter at Durand, cut the bell shown from a goblet blown by another worker and tried unsuccessfully to convince Martin Bach, Jr., Manager of the art glass division, to make the bell part of their line. Mr. Zara subsequently left the company and took the sample bell with him. Following Mr. Zara's death, the Museum of American Glass acquired the bell from his son in 1995.

Fenton Art Glass Company

Williamstown, West Virginia, 1905 -

The Fenton Art Glass Company is the oldest American glass company still in continuous operation. The company produced its first pressed glass bell in carnival glass in 1911 as a souvenir for the Elks convention in Atlantic City, New Jersey.

Most Fenton bells have an applied paper label. However, starting in 1970 on carnival glass items, and in 1972 for other items, the company impressed "Fenton" in an oval in the glass. Starting in 1980, an "8" was added and this number changed with each decade. In 1983, the company impressed a script "f" in an oval for glass produced from molds acquired from other companies. In 1984, a script "f" overlapping a circle started to be used on sand blasted articles and on paper labels. Bells made for the television shopping channel, QVC, have a "C" prefix on the pattern number.

Since 1970, Fenton has used hundreds of different patterns and designs for pressed glass and blown glass bells, so that presently they are the most prolific producer of glass bells in the United States.

Through the cooperation of Frank M. Fenton and Dr. James Measell, Historian for Fenton Art Glass, the author was permitted to photograph bells displayed in the Fenton Museum and its archives. *Unless otherwise noted, the bells shown below are courtesy of Fenton Art Glass.*

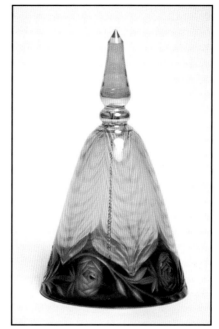

A Durand Art Glass one-of-a-kind bell of blue luster on gold with blue peacock feather and "Laurel" cutting, known as "Bridgeton Rose." 3-3/8"d. x 6"h. *Courtesy of the Museum of American Glass at Wheaton Village, Millville, New Jersey.*

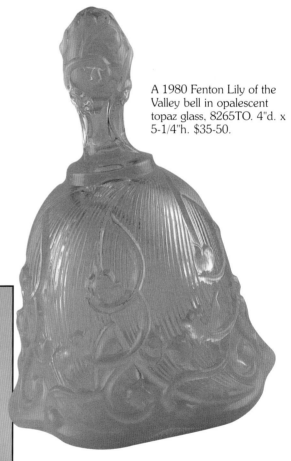

A 1980 Fenton Lily of the Valley bell in opalescent topaz glass, 8265TO. 4"d. x 5-1/4"h. $35-50.

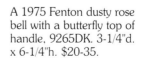

A 1975 Fenton dusty rose bell with a butterfly top of handle, 9265DK. 3-1/4"d. x 6-1/4"h. $20-35.

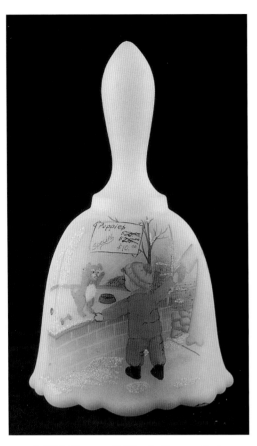

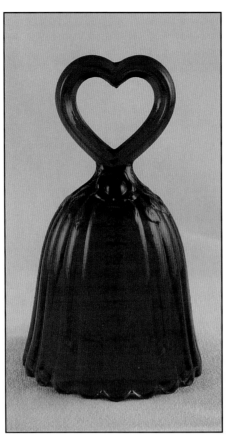

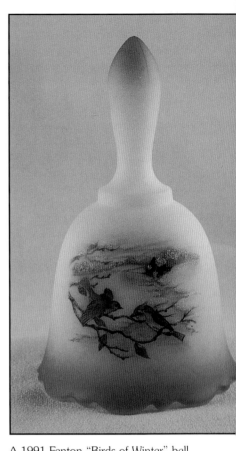

A 1985 Fenton Children's Fantasy Series bell in custard satin glass, "Heart's Desire," 7667WP. 3-1/2"d. x 6"h. $60-70.

A 1990 Fenton ruby paneled glass bell with heart shaped loop handle, 9764RU. 3-1/4"d. x 5-1/2"h. $20-30.

A 1991 Fenton "Birds of Winter" bell showing bluebirds on opal satin glass, 7667NB. 3-1/2"d. x 5-3/4"h. 4500 issued. $30-40.

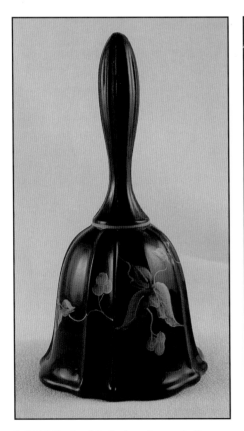

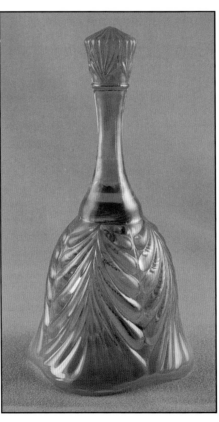

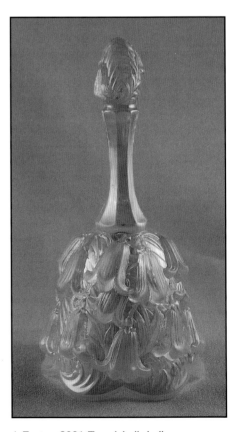

A 1994 Fenton black glass Aurora bell with hand painted Autumn leaves, 9667AW. 3-1/2"d. x 6-1/2"h. $40-50.

A year 2000 Fenton Beauty bell, 9665GI, in iridized willow green glass. 3" square base x 6-3/4"h. $30-40.

A Fenton 2001 Templebells bell, 9560TS, in topaz opalescent satin glass. 3-1/2"d. x 6-1/2"h. $60-70.

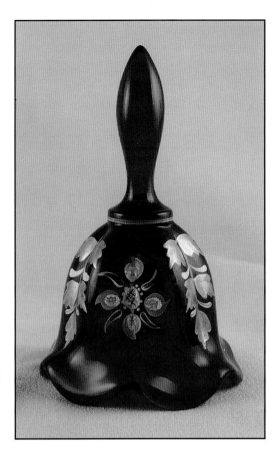

A 1998 Fenton ruby glass bell in "Ornamental Magic," 6864RY. 3-1/2"d. x 5-3/4"h. $60-70.

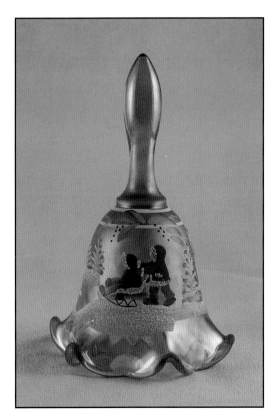

A year 2000 Fenton "Winter Memories" bell in gold iridescence with children sleigh riding, hand painted by Robin Spindler, 1127LB. Scalloped rim. 4-1/4"d. x 6-3/4"h. $60-75.

Fenton's Connoisseur Collection, consisting of glass with special treatments, began in 1983. Most were made as numbered limited editions.

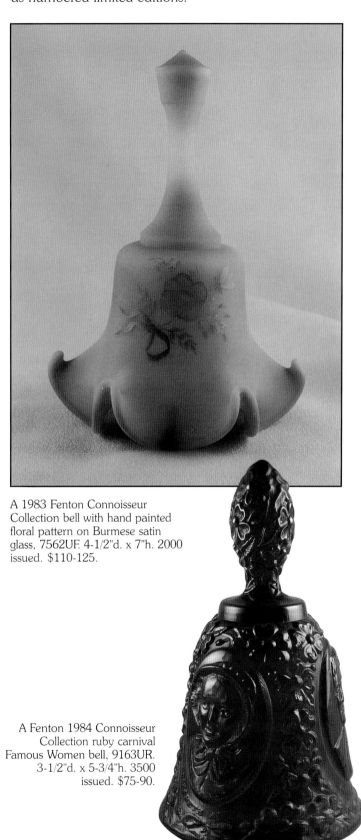

A 1983 Fenton Connoisseur Collection bell with hand painted floral pattern on Burmese satin glass, 7562UF. 4-1/2"d. x 7"h. 2000 issued. $110-125.

A Fenton 1984 Connoisseur Collection ruby carnival Famous Women bell, 9163UR. 3-1/2"d. x 5-3/4"h. 3500 issued. $75-90.

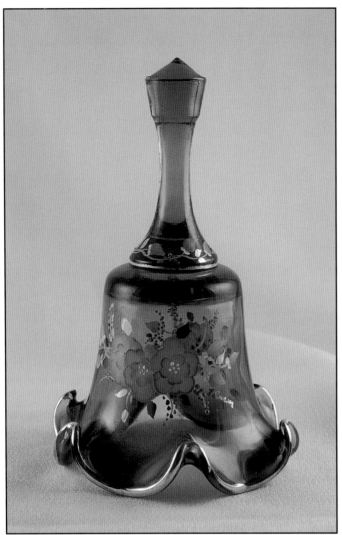

A 1988 Fenton Connoisseur Collection amethyst glass bell decorated with blue stain "Wisteria" with scalloped rim, 7666ZW. 4-1/2"d. x 6-3/4"h. 4000 issued. $95-110.

Fenton has made various glass items on special order, including bells.

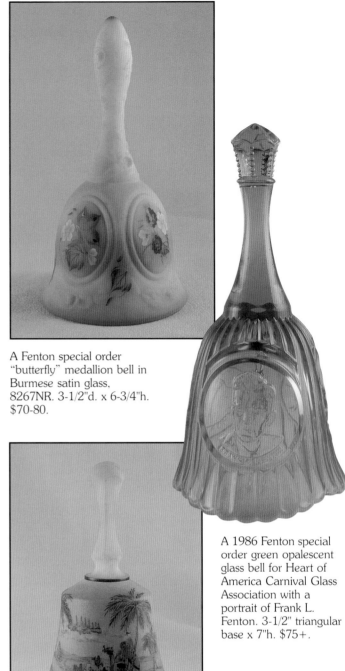

A Fenton special order "butterfly" medallion bell in Burmese satin glass, 8267NR. 3-1/2"d. x 6-3/4"h. $70-80.

A 1986 Fenton special order green opalescent glass bell for Heart of America Carnival Glass Association with a portrait of Frank L. Fenton. 3-1/2" triangular base x 7"h. $75+.

A 1996 Fenton special order bell for the Tadmore Shrine Temple in opal satin with a hand painted decoration by Susan Bryan, shape 7662. 3-3/4"d. x 6-1/4"h. $50-60.

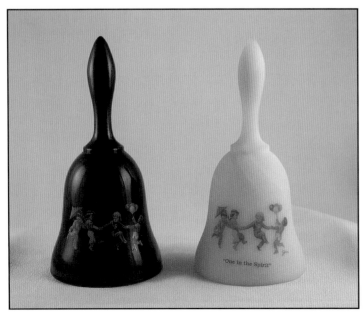

Two 1980s Fenton special order bells with "One in the Spirit" transfer prints in diamond optic cobalt and blue satin glass, 7669. 3-1/4"d. x 6-3/4"h. $60-75 each.

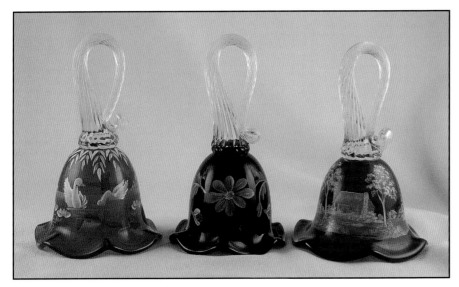

Three Fenton bells in the 3271 mold with crystal handles. The left hand Mary Gregory type bell in cranberry glass with Swan Lake design was made in the year 2000 in a limited edition of 2350. Don Fenton signed the center 1998 royal purple bell with Colonial Scroll floral design. The right hand bell in cranberry glass is decorated with a log cabin scene in white enamel. It was made as a special order for the Tamarack gift shop in Beckley, West Virginia. Don Fenton also signed it. 4"d. x 6-1/2"h. $90-125 each.

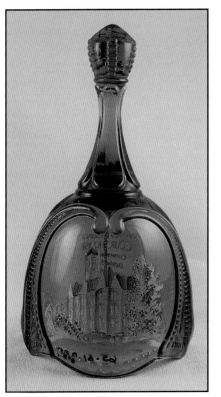

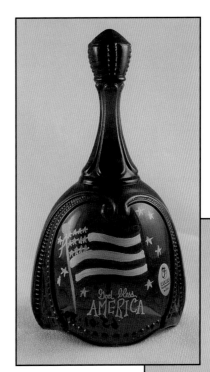

A Fenton special order "God Bless America" bell for Ohio Valley College President's Club, 2002, 7566KB in cobalt glass. 4" x 3" oval x 7"h. $70+.

A Fenton special order year 2000 bell, "Wood County Court House," Parkersburg, West Virginia, in spruce green, 7566SO. Second in a series. 4" x 3" oval x 7"h. $50-60.

This photo shows a Fenton two part mold for an oval bell in an open position.

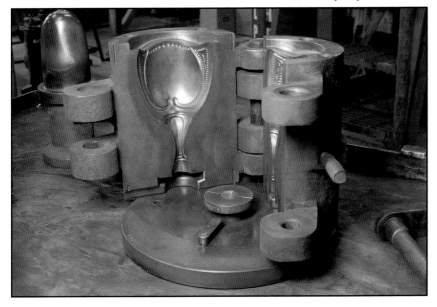

A 2001 Fenton Stars & Stripes Collection bell "Let Freedom Ring," 7566F8, in cobalt glass. Profits from sales were donated to United Way's September 11 Fund. 4" x 3" oval x 7"h. $35-45.

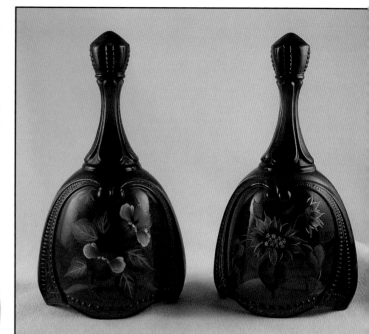

A Fenton milk glass bell with a Clydesdale horse drawn carriage, limited edition made for Budweiser. 3-1/4"d. x 6-1/4"h. $125-175.

A Fenton milk glass bell showing an old train. 3-1/4"d. x 6"h. #66 of 1250. $125-175. *Courtesy of a bell collector.*

Occasionally, some sample and one-of-a-kind bells have been made.

A 1970s Fenton one-of-a-kind sample "Kittens" bell, 1765CU, in diamond optic custard glass. 3-1/4"d. x 6-3/4"h. $75+.

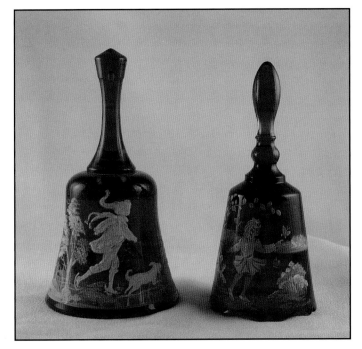

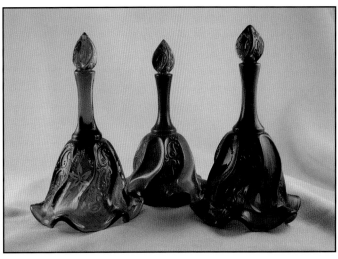

Fenton produced some bells on an experimental basis.

Two Fenton Mary Gregory style bells in ruby glass. The left bell, 7362RU, is a one-of-a-kind Louise Piper design of an ice skater and dog created in 1978. 3-3/4"d. x 7"h. $100+. The bell on the right, 7463RG, is a 1995 "Butterfly Delight" by Martha Reynolds. 3"d. x 6-1/2"h. $60-75.

Three Fenton Paisley bells. The left bell in 1995 holiday green glass, 6761GB, has a "Star of Bethlehem" motif, $40-50; the center bell, 6761, is a 1970s experimental bell in blue, $60-70; the bell on the right, 6761PL, is a 1994 bell in plum glass, $25-35. All are 4-1/4"d. x 6-1/2"h.

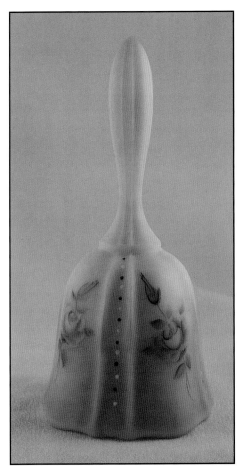

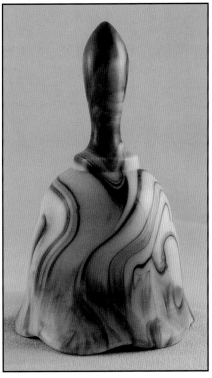

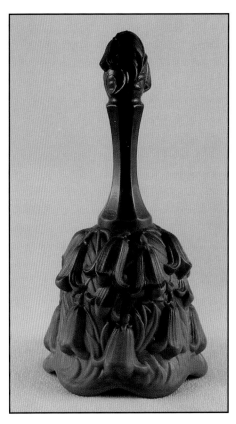

A Fenton experimental amethyst slag bell, 7466, from the 1970s. 3-3/4"d. x 5-3/4"h. $100+.

A 1970s Fenton Templebells bell in experimental malachite, 9560. 3-1/4"d. x 6-1/2"h. $100+.

A Fenton Aurora bell in Rosalene satin glass decorated with blue roses. Made as a sample in the 1990s. 3-1/4"d. x 6-3/4"h. $50-70.

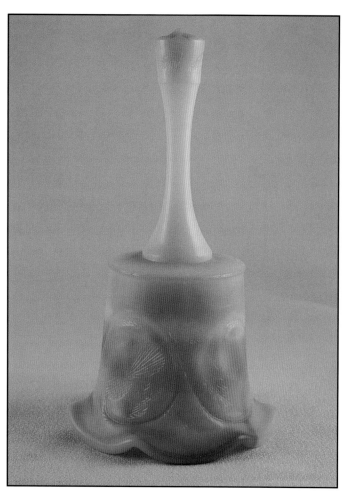

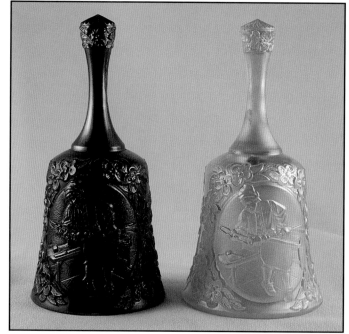

Two Fenton Craftsman bells. The 1981 left hand bell is in amethyst carnival, 9660CN; and the 1981 right hand bell is in experimental green carnival glass, 9660. 3-1/4"d. x 7"h. $35-50 each.

A Fenton experimental 1980s thistle pattern bell in Rosalene glass. 3-1/2"d. x 6-3/4"h. $100+.

Some special bells were made during the Christmas season and other holiday occasions. Some of these special bells are also shown below under bells produced for QVC.

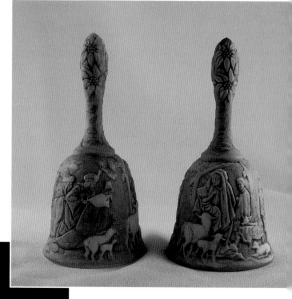

Two Fenton "Nativity" bells in milk glass satin, the left bell in Florentine stain blue, 9463FT, and the right bell in antique blue, 9463TB. 3-1/4"d. x 6-1/4"h. $45-65 each.

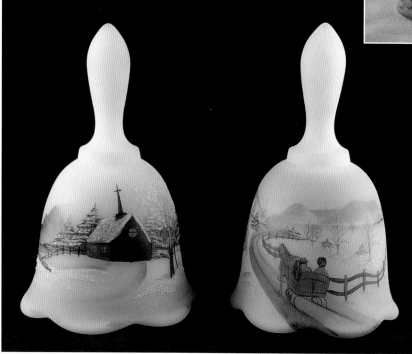

Two Fenton Christmas Classic bells in custard satin glass. The left bell, 7466CV, is "Christmas Morn," 1978; the right bell, 7466GH, is "Going Home," 1980. 3-3/4"d. x 6"h. $60-70 each.

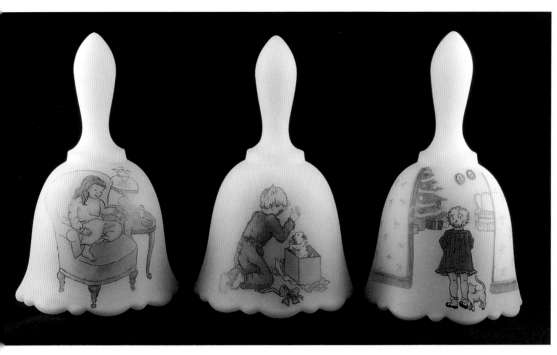

Three Fenton 1984 "Christmas Fantasy" sample bells in opal satin, 7667. 3-1/2"d. x 6"h. $75+ each.

Three opal satin Fenton bells from the 1990s. The left and right bells are from the Christmas at Home Series: 7668HD, "Sleigh Ride" and 7668HT, "Family Holiday." 3500 of each issued. The center bell is a 1996 special order Oglebay Park Flowers, Poinsettia. 250 issued. 3-1/2"d. x 6-1/2"h. $65-75 each.

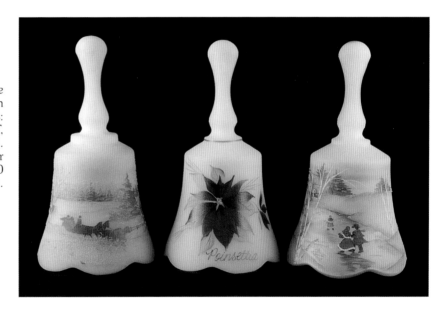

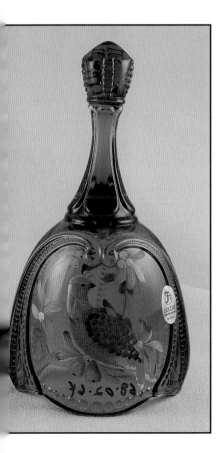

Two Fenton bells from the Birth of a Savior Series: "The Arrival," 1998, green glass 7566XS, and "The Announcement," 1999, blue glass 7566KP. 4" x 3" oval x 7"h. 2500 issued. $60-75 each.

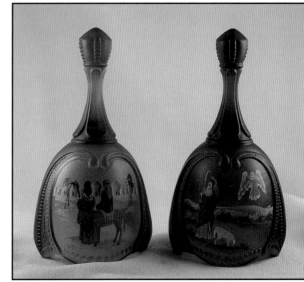

A year 2002 Fenton Christmas design by Frances Burton for "Partridge & Pears" in emerald green with 22k gold highlights, 7566EK. 4" x 3" oval x 7"h. $45-60.

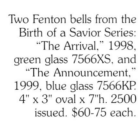

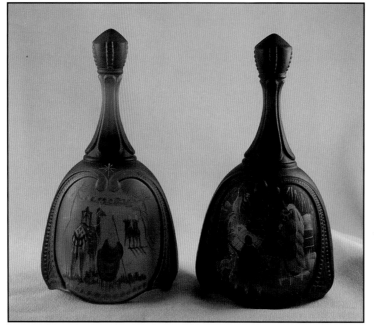

Two additional Fenton bells from the Birth of a Savior Series: "The Journey," 2000, green glass 7566QP, and "The Celebration," 2001, blue glass 7566KH. 4" x 3" oval x 7"h. 2500 issued. $60-75 each.

In 1996, Fenton started a Designer Series of glassware featuring designs decorated by Frances Burton, Kim Plauché, Martha Reynolds, and Robin Spindler.

A 1996 Fenton bell, 7667HW, Designer Bell Series "Wild Rose" design by Kim Plauché in a sea mist green opalescent satin glass with an uneven rim. 3-3/4"d. x 5-1/2"h. 2500 issued. $60-70.

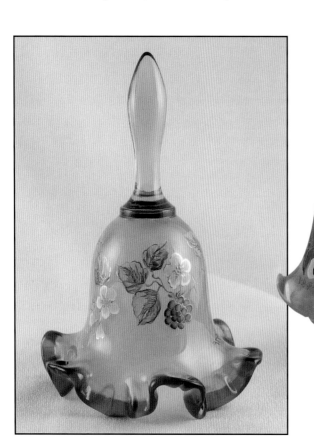

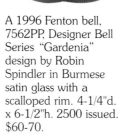

A 1996 Fenton bell, 4568EB, Designer Bell Series "Gilded Berry" design by Frances Burton in a diamond optic spruce green glass with a plum scalloped rim. 5"d. x 6-3/4"h. 2500 issued. $75-85.

A 1996 Fenton bell, 7562PP, Designer Bell Series "Gardenia" design by Robin Spindler in Burmese satin glass with a scalloped rim. 4-1/4"d. x 6-1/2"h. 2500 issued. $60-70.

A 1996 Fenton bell, 4564IN, Designer Bell Series "Floral Medallion" design by Martha Reynolds in French opalescent glass with a dusty rose scalloped rim. 4-1/2"d. x 6-1/4"h. 2500 issued. $65-75.

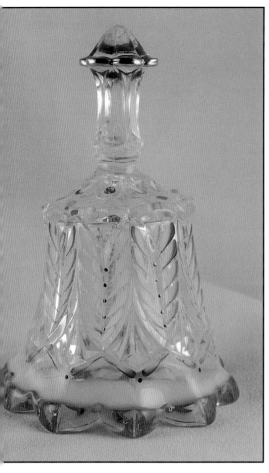

A 1997 Fenton Whitton bell, 9862BF, Designer Bell Series "Feathers" pattern in French opalescent glass with a dusty rose rim. Designed by Robin Spindler. 4-1/2"d. x 6-1/2"h. 2500 issued. $60-70.

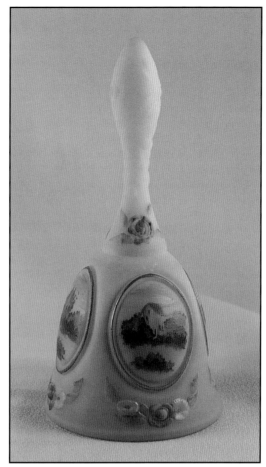

A 1997 Fenton bell, 8267CF, Designer Bell Series "Forest Cottage" medallion design by Frances Burton in Burmese satin glass. 3-1/2"d. x 6-3/4"h. 2500 issued. $80-90.

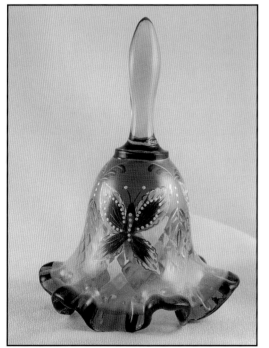

A 1997 Fenton bell, 1145GF, Designer Bell Series "Butterflies" design by Martha Reynolds in an opalescent misty blue glass with a plum scalloped rim. 5"d. x 7"h. 2500 issued. $65-75.

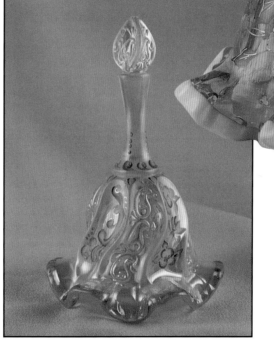

A 1998 Fenton Paisley bell, 2962YD, Designer Bell Series "Topaz Swirl" design by Martha Reynolds in topaz opalescent glass with a sea mist green scalloped rim. 4-1/2"d. x 6-3/4"h. 2500 issued. $65-75.

A 1998 Fenton ribbed bell, 3279GN, Designer Bell Series "Hibiscus" design by Frances Burton in misty blue glass with a milk glass scalloped rim. 5"d. x 5-3/4"h. 2500 issued. $65-75.

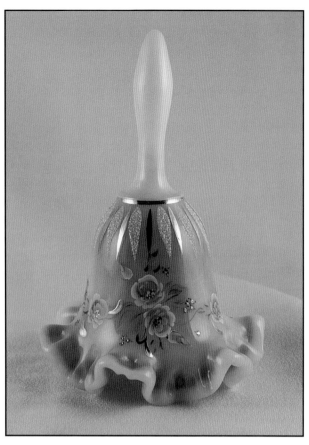

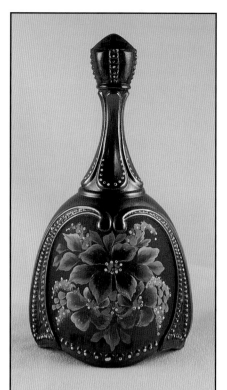

A 1999 Fenton bell, 7566HT, Designer Bell Series "Floral" design by Martha Reynolds in cobalt satin iridescent glass. 3-1/2" x 3-1/4" oval x 7"h. 2500 issued. $65-75.

A 1998 Fenton bell, 1145QW, Designer Bell Series "Fairy Roses" design by Kim Plauché on Rosalene glass with a milk glass scalloped rim. 4-3/4"d. x 6-1/2"h. 2500 issued. $65-75.

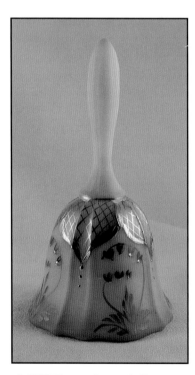

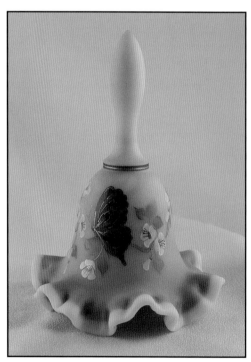

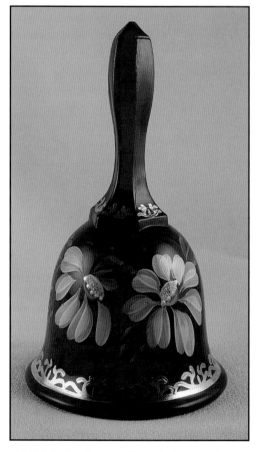

A 1998 Fenton Aurora bell, 9967UJ, Designer Bell Series "Bleeding Hearts" design by Robin Spindler on Burmese satin glass. 3-3/4"d. x 6-3/4"h. 2500 issued. $70-80.

A 1999 Fenton bell, 1145EY, Designer Bell Series "Butterfly and Floral" design by Frances Burton in blue Burmese glass with a satin milk glass scalloped rim. 5-1/4"d. x 6-1/2"h. 2500 issued. $85-95.

A 1999 Fenton bell, 6662NI, Designer Bell Series "Gilded Daisy" design by Robin Spindler on ruby glass. 3-1/2"d. x 5-3/4"h. 2500 issued. $75-85.

Collector Book
203-A Delaware
Leavenworth, KS 66048
buyers@collectorbookstore.com
Phone: (913)651-0600
Fax: (913)651-1189

INVOICE/PACKING SLIP

SHIP TO: **William Churchill**
333 school street box 702
carlisle, MA 01741

Order #581027
Date: Jul 23, 2004

Qty.	Sku	Description	Unit Price	TOTAL
1	SCH-2003-0764319183	Glass Bells of the World by A.A. Trinidad, Jr	$34.99	$34.99

Sub-Total: $34.99

Payment Details: Payment has been made by through eBay Checkout.

Marketplace ID: 3737005267

Shipping and Handling: $3.68

USPS Insurance: $1.30

Tax: $0.00

TOTAL: $39.97

Thank you for shopping with Collector Book!
If applicable, please let us know it arrived safely by leaving us positive feedback.
Visit us online at http://www.collectorbookstore.com

THANKS for your purchase with us!

We'd be pleased to post positive feedback if you'll et us know this book has arrived! Our email address: **buyers@collectorbookstore.com**

By the way, did you know we carry over 2,500 titles on nearly every topic related to antiques and collectibles? Our full catalog is available at

www.CollectorBookstore.com

Our books are discounted roughly 20-25% off retail every day – and you need not purchase multiple books in order to receive a discount! We carry all the top publishers – Collector Books, Schiffer Publications, Krause, Hobby House, Millers, Antique Collectors Club, as well as a large selection of hard find books from small publishing houses and self published authors.

Thanks, and please come again!

John Kincaid

John Kincaid, Webservant
Collector Bookstore

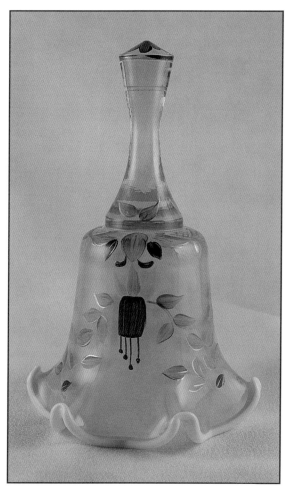

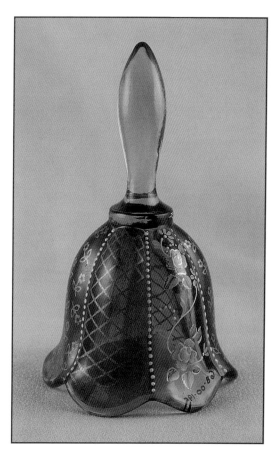

A 1999 Fenton bell, 7562AG, Designer Bell Series "Deco Fuschia" design by Kim Plauché on aquamarine glass with milk glass scalloped rim. 4-3/4"d. x 7"h. 2500 issued. $65-75.

A year 2000 Fenton bell, 6864UL, in empress rose glass with a "Victorian Stripes" wallpaper design by Martha Reynolds. Scalloped rim. 3-1/2"d. x 5-3/4"h. 2500 issued. $65-75.

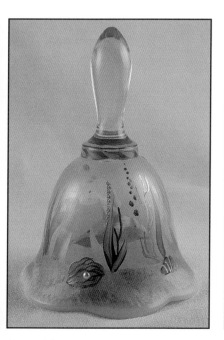

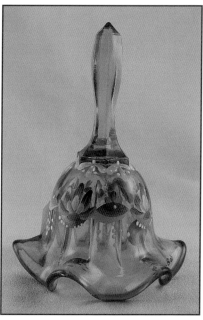

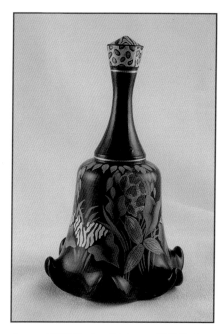

A year 2000 Fenton Designer Bell Series bell, 7667TW, in willow green opalescent glass, with a "Dolphin Frolic" sand-carved design by Kim Plauché. 4-1/4"d. x 5-1/2"h. 2500 issued. $65-75.

A year 2000 Fenton Designer Bell Series bell, 7568YB, in ice blue glass with a "Water Lilies" design by Robin Spindler and a scalloped deep cobalt rim. 4-1/2"d. x 6"h. $65-75.

A year 2001 Fenton Designer Bell Series bell, 75621L, in black glass with a "Midnight Safari" design by Martha Reynolds showing hidden leopard spots and zebra stripes. Scalloped rim. 4-1/2"d. x 6-3/4"h. 1500 issued. $80-90.

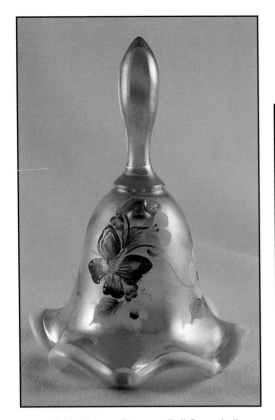

Fenton started making special glass items for the television shopping channel, QVC, in the 1980s. Included among these items were bells.

A Fenton 1988 QVC milk glass bell with a ruby rim and "Poinsettia" decoration, C7562JQ. 4-1/2"d. x 7-1/4"h. $100-125.

A year 2001 Fenton Designer Bell Series bell, 94741V, in iridized pink chiffon opalescent glass with gold highlights on the butterfly wings and leaf veins, with a "Cotton Berry" design by Kim Plauché. Scalloped milk white rim. 5"d. x 6-1/2"h. $70-80.

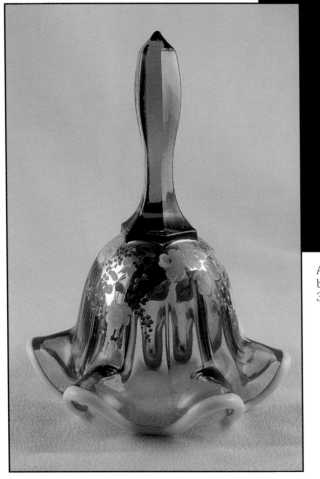

A year 2001 Fenton Designer Bell Series bell, 75681Q, in violet glass with a "Rose Court" design by Frances Burton. Scalloped milk white rim. 4-3/4"d. x 5-3/4"h. $70-80.

A Fenton 1988 QVC iridescent shell pink glass bell with blue floral decoration, C7667EQ. 3-1/2"d. x 6"h. $40-50.

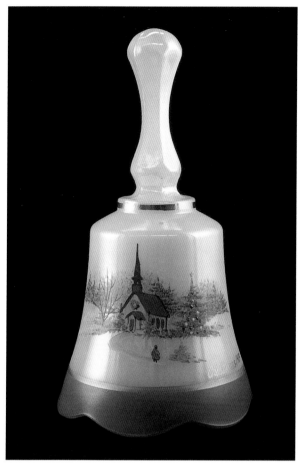

A Fenton 1989 QVC Christmas bell in opal iridescent glass and painted green base with a "Church" decoration, C7668NA. 3-1/2"d. x 6-1/2"h. $$50-60.

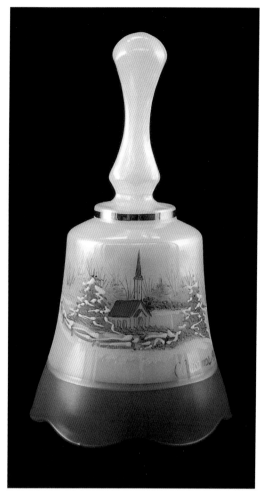

A Fenton 1990 Christmas QVC opal iridescent bell with a painted blue base and "Church," C7668XA. 3-1/2"d. x 6-1/4"h. $50-70.

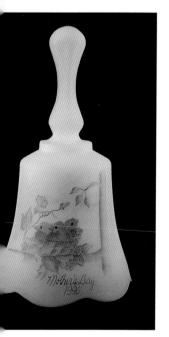

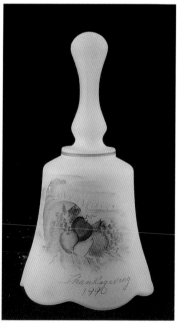

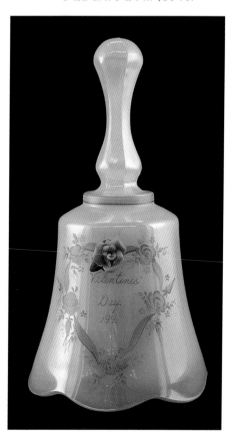

A Fenton 1990 QVC Mother's Day bell in opal satin glass with painted "Baby Birds," C7668MN. 3-1/2"d. x 6-1/2"h. $55-70.

A Fenton 1990 QVC Thanksgiving bell in shell pink satin glass with "Cornucopia" decoration, C7668UW. 3-1/2"d. x 6-1/2"h. $75-90.

A Fenton 1991 QVC Valentine's Day bell in opal iridescent glass with an applied rose, C7668VD. 3-1/2"d. x 6-1/2"h. $40-60.

51

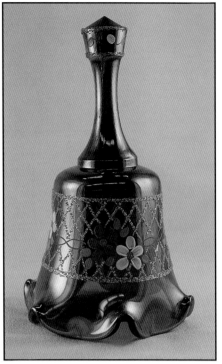

A Fenton 1994 QVC plum carnival glass bell with a hand painted decoration and gold accents, C7562 6W. 4-1/4"d. x 7"h. $50-60.

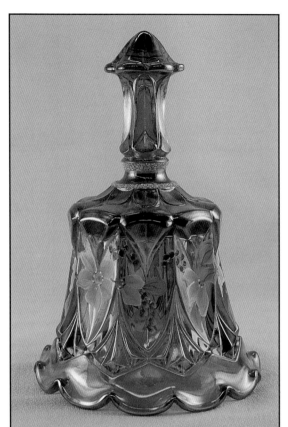

A Fenton 1997 QVC Christmas bell in spruce green iridized glass in a Whitton Red Cliff mold with floral decoration, C9066XD. 4-1/4"d. x 6-1/2"h. $50-70.

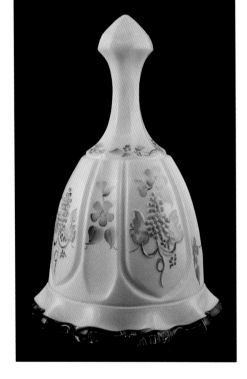

A Fenton November 1997 QVC milk glass bell with a spruce green rim and embossed grape pattern, CV196 3W, made from a Red Cliff mold. 4-1/2"d. x 6-3/4"h. $70-90.

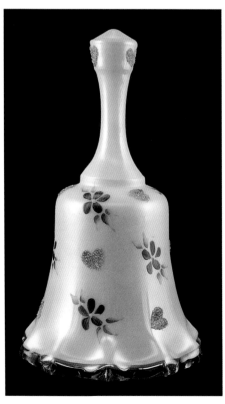

A Fenton January 1998 QVC iridescent milk glass bell with empress rose rim and painted "Fuschia & Hearts" design, CV205 D8. 4-1/4"d. x 7"h. $60-80.

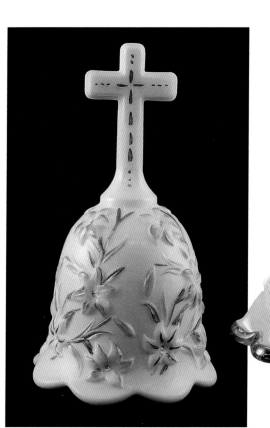

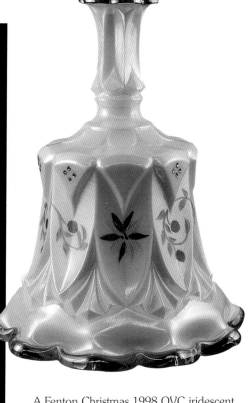

A Fenton March 1998 QVC milk glass bell with gold wash highlights on the pattern of the "Cross" bell, C9761 5H. 3-3/4"d. x 6-1/4"h. $60-80.

A Fenton Christmas 1998 QVC iridescent milk glass bell with gold rim in a Whitton Red Cliff mold and "Berry Floral" decoration, C9066 8P. 4-3/4"d. x 6-1/2"h. $70-90.

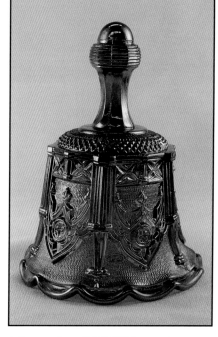

A Fenton June 1999 QVC turquoise iridescent glass bell in a "Sable Arches" pattern from a Red Cliff mold, CV272 B7. 4-1/4"d. x 5-3/4"h. $40-50.

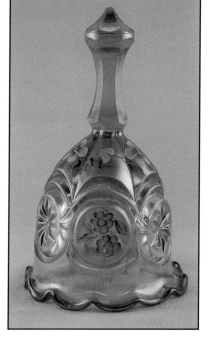

A Fenton June 1998 QVC misty blue satin glass bell in a knobby bull's eye pattern from a Red Cliff mold with "Pink & Purple Floral" decoration, C9061 7Q. 4-1/4"d. x 7"h. $60-70.

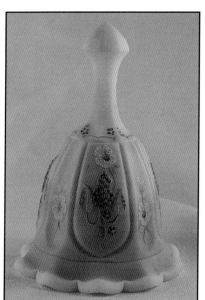

A 1999 Fenton New Century Collection Burmese satin glass bell with hand painted embossed grapes made for QVC with Bill Fenton signature, CV196HF. 4-3/4"d. x 6-1/2"h. $150-175.

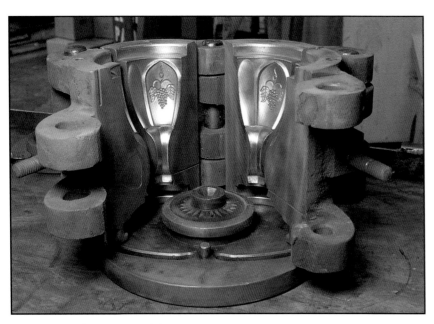

A Fenton four part mold shown in an open position.

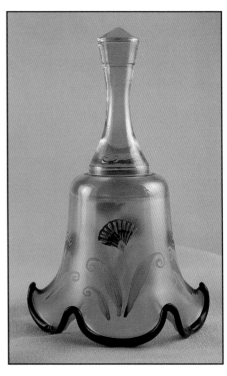

A 2002 Fenton QVC "Deco-floral" bell in pink chiffon with a black scalloped rim, C7562GM, 4-1/2"d. x 7"h. $70-80.

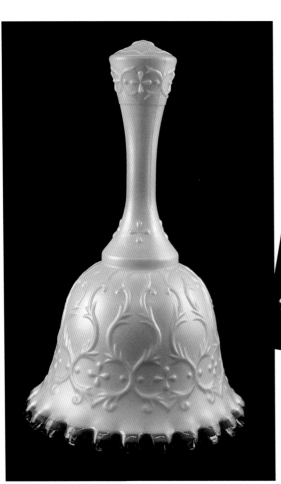

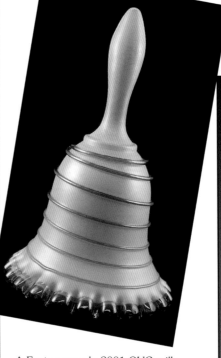

A Fenton sample 2001 QVC milk glass bell with blue trailing and iridescent blue rim, C2053. 4-1/4"d. x 6-3/4"h. $100+.

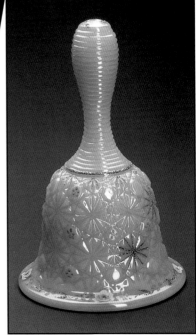

A Fenton 2001 QVC iridescent milk glass bell with a teal glass rim in "Spanish Lace" pattern, C3567TC. 3-3/4"d. x 6-1/4"h. $50-70.

A decorated ivory "Daisy and Button" pattern Fenton bell made for QVC in August 2001, #C22702. 3-1/2"d. x 5-3/4"h. $40-50. *From the author's collection.*

Fischer Crystal Bells

Overland Park, Kansas, 1972-

Fischer Crystal Bells, a producer of many crystal bells in the United States, has operated under the control of Glen Jones, who has guided the design and production using special equipment.

Many of the company's bells produced over the years started as crystal goblets imported from France, Germany, and other countries. The base of the goblet was removed, the cut edge was smoothed, the blank was decorated or etched, and a clapper was added. Similar bells today are produced with a variety of clappers. Some past bells have been decorated with a design produced by a method called "deep abrasive etching," developed by the company in 1975 using semi-automated machines to do the cutting by an air blast containing grit. The design to be cut on the bell was developed as a mask and placed on the bell blank; a thin layer of the exposed glass surrounding the mask was then removed using the special machine. The first bells produced by this method in 1975 used a clear glass blank.

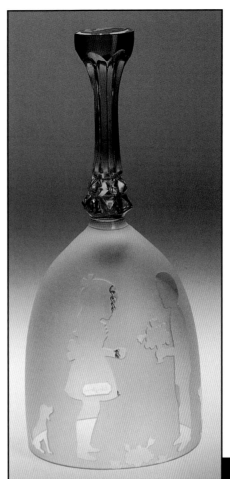

A Fischer Crystal bell in frosted glass with etched children and animals and amethyst glass handle. Signed Glen Jones on the back of the frosted glass. 2-1/2"d. x 6-1/4"h. $50-70.

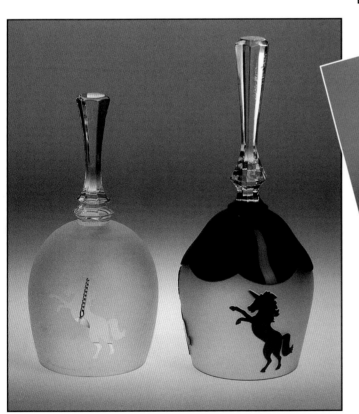

Two Fischer Crystal bells showing a unicorn, issued in the 1980s, made by a deep abrasive etching process on a crystal blank, 2-1/2"d. x 6-1/4"h. $60-70; and on a blue blank, 2-1/2"d. x 7-1/2"h. $140-150. Both signed Glen Jones on the handles.

A cased blank used by Fischer Crystal for some of their sand carved bells. Hummelwerk, Germany made the blank. 2-1/2"d. x 7"h. $15-20.

A Fischer Crystal bell made for Christmas 1972 and cut with stars. 3"d. x 6"h. $25-30.

55

Fostoria Glass Company

Moundsville, West Virginia, 1891-1986

Starting in 1977, the Fostoria Glass Company produced bells for holidays and special events as well as bells to match their stemware patterns.

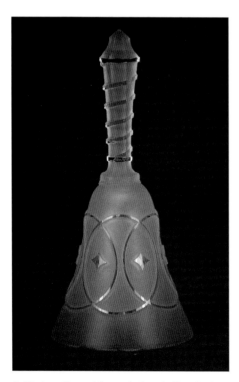

A clear glass bell with frosted glass handle with an American Bell Association medallion used as a clapper. Made by Glen Jones for the author. 2-1/2"d. x 6-1/2"h. $30+.

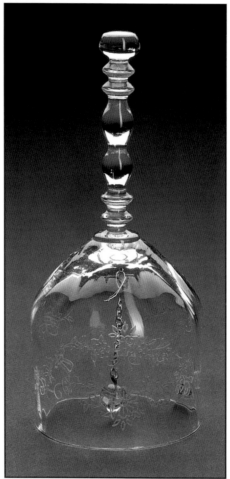

A Fostoria clear glass bell in a "Serenity" pattern on a #6127 stem. 2-1/2"d. x 6"h. $45-55.

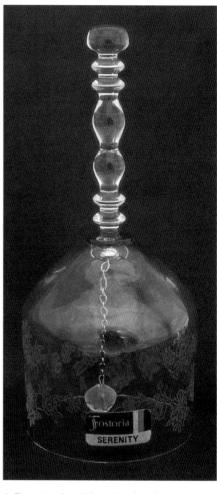

A Fostoria clear blue glass bell in a "Serenity" pattern on a #6127 stem. 2-3/4"d. x 5-1/2"h. $65-75. *Courtesy of Carol and Bob Rotgers.*

A Fischer Crystal frosted glass bell with clear circles and clear band on handle. 2-3/4"d. x 6"h. $60-70. *Courtesy of Gary L. Childress.*

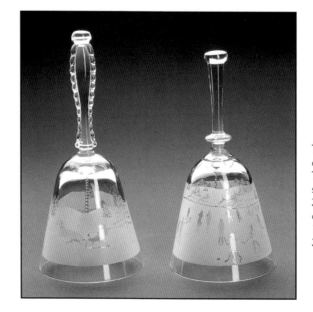

Two Fostoria bells engraved on a frosted background. The left bell, issued in 1977, shows a horse and sleigh. 3-1/2"d. x 7-3/4"h. The bell on the right was issued in 1978 and shows ice-skaters. 3-1/2"d. x 7"h. $30-40 each.

Guernsey Glass Company

Cambridge, Ohio, 1970-

The Guernsey Glass Company has produced reproduction glassware, including bells, using modified Akro Agate Company bell molds. See Chapter Eleven, "Who Really Made These Glass Bells?" for a further presentation.

A frosted glass Fostoria bell with a clear glass handle. 3"d. x 5-3/4"h. $20-25.

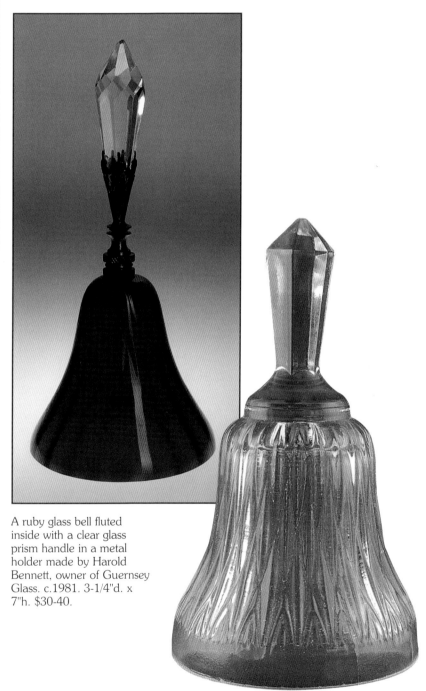

A ruby glass bell fluted inside with a clear glass prism handle in a metal holder made by Harold Bennett, owner of Guernsey Glass. c.1981. 3-1/4"d. x 7"h. $30-40.

A Fostoria clear glass "Sheffield" bell with a gold rim. 3-1/4"d. x 5-1/2"h. $30-40. *Courtesy of Carol and Bob Rotgers.*

A clear colorless Guernsey Glass bell with a "Smocking" pattern made from Akro Agate molds, c.1970s. It is known in several colors and frosted glass. 3-1/4"d. x 5-1/2"h. $20-30.

Hunter Collectible Art Glass

Akron, Ohio

(See Mosser Glass, Inc.)

Imperial Glass Corporation

Bellaire, Ohio, 1901-1984

The Imperial Glass Corporation started as the Imperial Glass Company, but was reorganized in 1931 as a corporation. Lenox, Inc. purchased the company in 1973 and it continued operations under Lenox until 1981 when the company was sold to Arthur Lorch. In 1982, Robert Stahl purchased the company, but it did not prosper and subsequently filed for bankruptcy in 1984.

In the 1950s, the company used superimposed letters I and G on some of its glass. After Lenox purchased the company, an L was added to the IG. Briefly, while Arthur Lorch controlled the company, an A was added to the LIG. During the company's final years, some glass was made with initials NI for New Imperial.

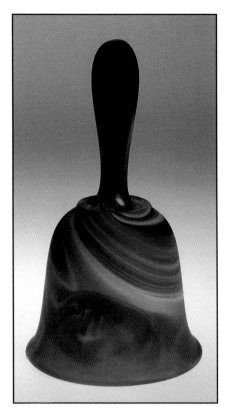

An Imperial satin finish purple slag glass bell in mold #720. 3-1/4"d. x 5-3/4"h. $50-60. The bell is available also in green, caramel, and ruby satin glass.

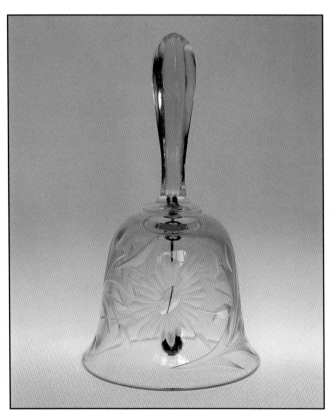

An Imperial Glass green bell with a cut floral design. The solid metal clapper is attached to a wire held in the glass by an imbedded eye screw. The bell is also available in undecorated clear green glass and clear pink glass as well as bells decorated with a colored vintage design. 3-1/8"d. x 5-1/2"h., c.1930s. $50-70. *Courtesy of Sally and Rob Roy.*

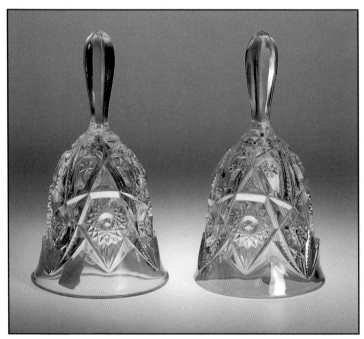

An Imperial glass bell in pattern No.404 in clear colorless glass and in green New Imperial. 3-1/2"d. x 7"h. $20-30 each.

Intaglio Designs Ltd.

Edwardsville, Illinois, 1970s-

Intaglio Designs has made many small glass bells with ceramic handles of animals, clowns, and dolls. Most of the bells have a golden heart clapper.

Five Intaglio "Itty Bitty" clear glass bells with ceramic handles of teddy bears, owl, and Mother Goose in the back row, and a mouse on a pincushion and Easter Rabbit in the front row. 2"d. x 3-1/2"h. to 4-1/4"h. All bells have metal heart clappers. $20-25 each. *Courtesy of Julie Marie Trinidad.*

Four Intaglio "Itty Bitty" clear glass bells with ceramic handles of two dragons and a giraffe in the back row, and a tortoise and snail in the front row. 2"d. x 2-3/4"h. to 4-1/2"h. All bells have metal heart clappers. $20-25 each. *Courtesy of Julie Marie Trinidad.*

Three Intaglio "Itty Bitty" clear glass bells with ceramic clown handles forming a clown band. 2"d. x 4-1/2"h. to 4-3/4"h. $20-25 each. *Courtesy of Julie Marie Trinidad.*

Three Intaglio "Itty Bitty" clear glass bells with ceramic dog or cat handles. 2"d. x 3-1/4"h. to 3-1/2"h. $20-25 each. *Courtesy of Julie Marie Trinidad.*

Five Intaglio "Itty Bitty" clear glass bells with ceramic doll handles. 2"d. x 3-1/2"h. to 4-1/4"h. $20-30. *Courtesy of Julie Marie Trinidad.*

Jefferson Glass Company

Steubenville, Ohio, 1900-1906

Follansbee, West Virginia, 1907-1930

Between 1909 and 1915, the Jefferson Glass Company produced glass bells with a wide gold band along the outside of a raised rim. The mold for the bell originated with the Ohio Flint Glass Company of Lancaster, Ohio. The Jefferson Glass Company obtained the patent rights to the mold in 1908 when the Ohio Flint Glass Company went out of business.

The bell was produced as a souvenir item in three basic colors: custard glass and ruby flashed glass, both with a gold band, and marigold carnival glass. A variation of the custard glass is a translucent greenish yellow glass similar to vaseline glass. A few bells were made with overall ruby flashing and decorated.

The Jefferson Glass Company sold the molds to the Central Glass Works, Wheeling, West Virginia in 1919, and that company produced the bell in clear glass with cut and engraved patterns as part of their Chippendale line. The Chippendale line molds were sold to George Davidson & Company, Ltd., England, in 1933, but it is not known if the bell molds were included.

All the bells have an *eye screw* imbedded in the glass to hold a stiff wire and lead ball clapper. All bells have a tapered hexagonal handle.

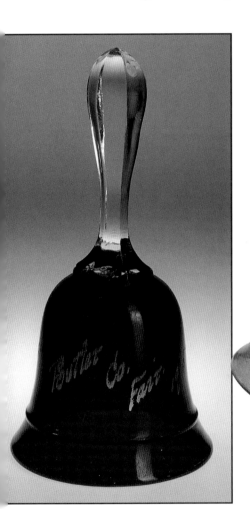

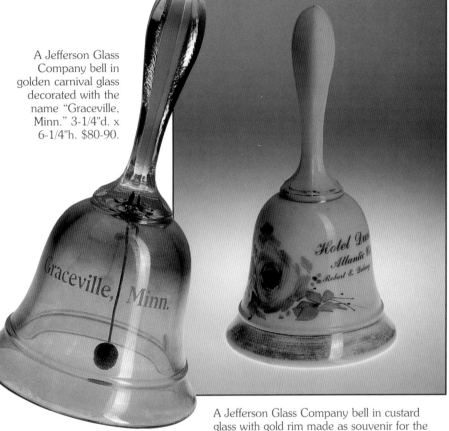

A Jefferson Glass Company bell in golden carnival glass decorated with the name "Graceville, Minn." 3-1/4"d. x 6-1/4"h. $80-90.

A Jefferson Glass Company bell in custard glass with gold rim made as souvenir for the Hotel Dunlop, Atlantic City, New Jersey. 3-1/4"d. x 6-1/4"h. $60-80.

A Jefferson Glass Company bell in flashed ruby glass, etched with "Butler Co. Fair 1915." 3-1/4"d. x 6-1/4"h. $80-90.

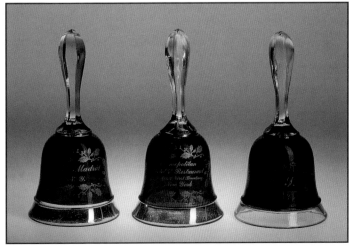

Three Jefferson Glass Company bells in flashed ruby glass decorated as souvenirs of Café Madrid, New York; Cosmopolitan Hotel and Restaurant, New York; and BJ with flowers. 3-1/4"d. x 6-1/4"h. $60-90 each.

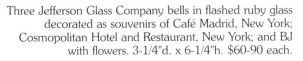

61

Dominick Labino

Grand Rapids, Ohio, 1965-1987

Dominick Labino is considered to be one of the pioneers of the Studio Glass movement in the United States. Several of his works previously have been exhibited in museums throughout the world. Only a few bells are known.

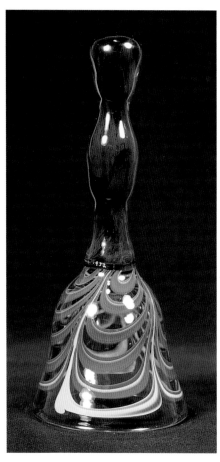

A Dominick Labino clear glass bell with brown and gold festoons and a copper colored clear glass handle. 3"d. x 7-1/4"h. *Courtesy of the Milan Historical Museum, Milan, Ohio.*

Lenox, Inc.

Lawrenceville, New Jersey, 1966-

In 1965, Lenox acquired the Bryce Brothers factory in Mt. Pleasant, Pennsylvania, and produced various glass items previously produced by Bryce as well as new patterns

Lenox produced many glass bells to commemorate events and holidays. Some bells were produced from molds acquired from glass companies who terminated their operations.

The Mt. Pleasant operation ceased production in January 2002, but Lenox continues to import glassware from overseas and sell it under the Lenox label.

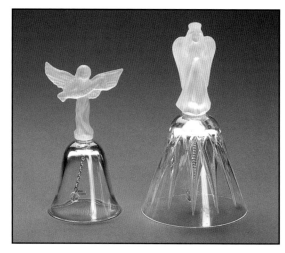

Two Lenox frosted glass angel handle bells. The left bell was made in the Czech Republic in 1999. 2-1/2"d. x 4-3/4"h. The bell on the right was made in 1987. 3-1/2"d. x 6-1/2"h. $30-35 each.

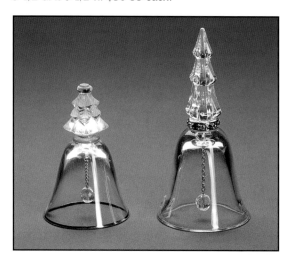

Two Lenox bells with Christmas tree handles. The left bell, 2"d. x 3-1/4"h., has a frosted tree handle and gold rim. The right bell, 2-1/4"d. x 4-3/4"h., has a clear tree handle. $20-30 each.

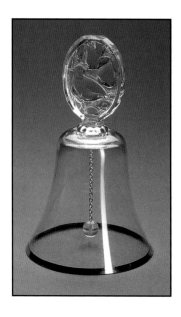

A Lenox clear glass bell with a partridge in a pear tree pressed handle. 3-1/2"d. x 6"h. $20-30.

Libbey Glass Company

Toledo, Ohio, 1892-

At the World's Columbian Exposition of 1893 in Chicago, Illinois, the Libbey Glass Company had a complete glass factory able to produce many types of glass products. Among the souvenir glass available was a series of blown engraved or etched clear colorless glass bells with twisted pressed glass handles. A very few bells are known in clear yellow glass. All these bells have a chain with a hollow ball clapper attached to a loop in a twisted wire imbedded in the glass. There is a star impressed on the top of the handles of all the bells.

While bells etched with World's Fair 1893 and Columbus motifs are well known to collectors, many bells were engraved at the fairgrounds with special inscriptions, names, and initials of those attending the fair.

A Lenox clear glass bell with multiple vertical panels and hexagonal handle. Signed Lenox. 2-3/4"d. x 6"h. $15-25.

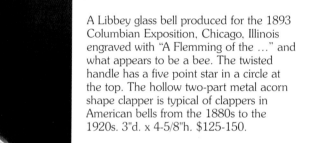

A Libbey glass bell produced for the 1893 Columbian Exposition, Chicago, Illinois engraved with "A Flemming of the ..." and what appears to be a bee. The twisted handle has a five point star in a circle at the top. The hollow two-part metal acorn shape clapper is typical of clappers in American bells from the 1880s to the 1920s. 3"d. x 4-5/8"h. $125-150.

Two Libbey glass bells with names and initials inscribed at the Libbey Glass exhibit at the 1893 Columbian Exposition, Chicago, Illinois. 3"d. x 4-1/2"h. $100-125 each.

The other side of the Libbey bell above, engraved with "World's Fair 1893."

Lotus Glass Company, Inc.

Barnesville, Ohio, 1920s-

The Lotus Glass Company started in 1912 as the Lotus Cut Glass Company. The name was changed to the Lotus Glass Company in the 1920s.

The Lotus Glass Company has never made glass, but only decorated it. The company has purchased glass blanks from many companies including Bryce Brothers, Cambridge, Duncan & Miller, Fostoria, Heisey, and Paden City. The blanks have been decorated by light cutting, engraving, acid etching, painting, and with encrusted gold, silver, and platinum. The company produced many bells to complement stemware. Some bells can be found with the Lotus paper label attached.

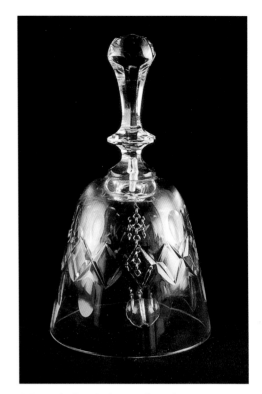

A Lotus bell with diamonds and punties in a "Bristol" pattern. 2-5/8"d. x 4-5/8"h. $40-50.

Lundberg Studios

Davenport, California, 1972-

Lundberg Studios has been noted for its art glass for many years. It was first known for its iridescent glass and Art Nouveau style. In recent years, it has been known for its paperweights. The studio has produced several art glass bells in blue or gold aurene finishes, similar to glass produced by Tiffany, and with a pulled feather design on several bells. Some special bells have been produced in other colors, including gold sateen and a red glass bell with blue swirled stripes. Most bells have a ruffled rim. Some are signed "L. S." with a date.

Two Lotus clear glass bells made from Bryce Brothers blanks in a cut "Sovereign" pattern on the left, 3"d. x 5-1/4"h., and a gold "Bridal Bouquet" pattern on the right, 2-1/2"d. x 5"h. $30-40 each.

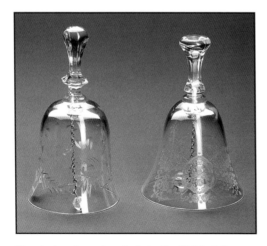

Two Lotus clear glass bells in the "Majesty" pattern on the left, 2-1/2"d. x 5"h., and in the "Bridal Bouquet" pattern on the right, 3"d. x 4-1/4"h. $30-40 each.

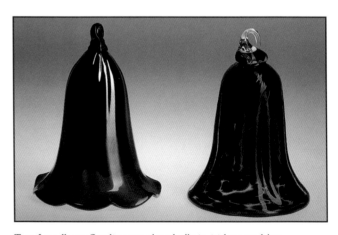

Two Lundberg Studios art glass bells in iridescent blue and cobalt blue glass with loop handles. 3"d. x 4-1/4"h. $40-60 each.

Maslach Art Glass

Greenbrae, California, 1971-

Steven Maslach has made blown art glass bells sought by bell collectors. The bells usually are signed and dated along the inside edge.

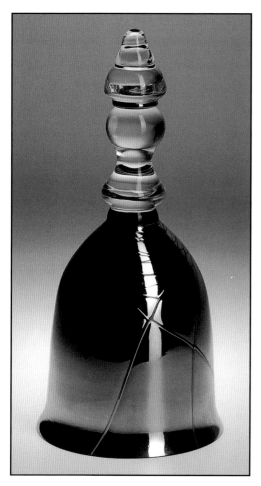

A Maslach iridescent blue glass bell with dark blue swirls and a knobbed clear handle, signed "Maslach 10-80." 3"d. x 6-1/4"h. $75-100.

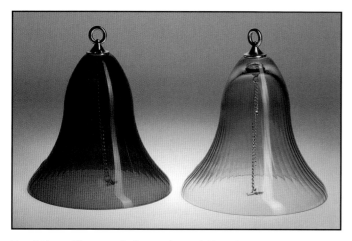

Two Mikasa Christmas bells in ruby and blue glass with internal vertical ribs. Made in Austria. 5"d. x 5-3/4"h. $20-25 each.

McKee Glass Company

Jeannette, Pennsylvania, 1888-1951

The McKee Glass Co. started operations as McKee and Brothers Glass Works in 1853. The firm was originally located in Pittsburgh, Pennsylvania but moved to Jeannette, Pennsylvania about 1888. The only bells produced by the company known to the author are in the "Yutec" pattern made from 1901 to about 1915. Some have molded or etched names of companies as souvenirs.

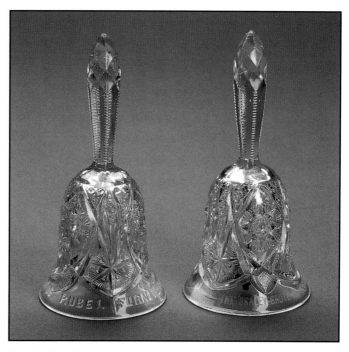

Two McKee Glass Company bells in the "Yutec" pattern with molded "Compliments of Rubel Furniture Co." on the left bell and etched "Braley-Brote Furniture" on the right bell. 2-1/2"d. x 5-1/4"h. $30-40 each.

Mikasa, Inc.

Secaucus, New Jersey, 1948-

Mikasa does not manufacture products, but is known for its many porcelain and glass products produced by companies overseas. The glass products were added to its tabletop diversification in 1978 and they are produced in Europe by various factories. The company has marketed many glass bells made for them in Austria, Germany, and Slovenia. In January 2001, the company merged with J. G. Durand Industries, S. A., the parent company of Arc International, formerly Verrerie Cristallerie d'Arques, and continues to trade under the Mikasa name.

65

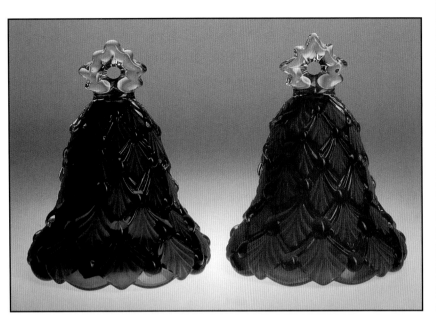

Two Mikasa "Winter Dreams" Christmas tree bells in green and red. Made in Germany. 4-1/2"d. x 5-3/4"h. $20-30 each.

A Mikasa fluted red glass bell with wreath handle. Made in Germany. 3-3/4"d. x 5-1/2"h. $20-25.

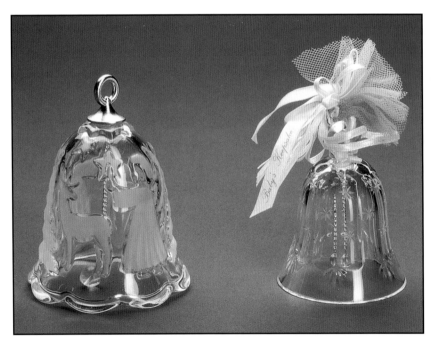

Two Mikasa clear glass bells. The left bell has a frosted angel, star, deer, and tree. 3-1/4"d. x 4-1/4"h., made in Germany. The bell on the right is multi-faceted with cut stars and "Baby's Keepsake., 2-1/2"d. x 3-1/2"h., made in Slovenia. $20-25 each.

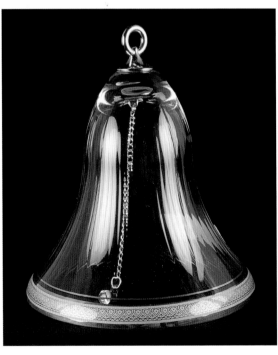

A Mikasa clear glass bell with gold decorated rim in a "Palatial Gold" pattern, made in Austria. 5"d. x 5-1/2"h. $15-20.

C. F. Monroe Company

Meriden, Connecticut, 1901-1916

The Monroe company made some tap bells of Wave Crest Ware glass combined with metal trimmings.

A C. F. Monroe tap bell in decorated opal glass Wave Crest Ware on a bronze base. $1,800-2,200. *Courtesy of Sally and Rob Roy.*

A view of the top of the Wave Crest Ware bell.
Courtesy of Sally and Rob Roy.

Mosser Glass, Inc.

Cambridge, Ohio, 1959-

Mosser has produced reproductions of glassware, including glass bells. Starting in 1979, Mosser produced a series of annual Jenny Doll bells for Vi Hunter, of Hunter Collectable Art Glass, Akron, Ohio. Some sample "test" bells were also made for Vi Hunter in other colors; these are engraved "test Vi" on the inside of the rim. The chart below shows the colors for the Jenny Doll bells produced by Mosser from 1979 to 1988.

Year	Color
1979	Cobalt Blue Carnival
1980	Pearl
1981	Samurai Red
1982	Mistletoe Green
1983	Desert Agate
1984	Cornflower
1985	Bittersweet
1986	Bluebell
1987	Iridized Lavender
1988	Amethyst Slag

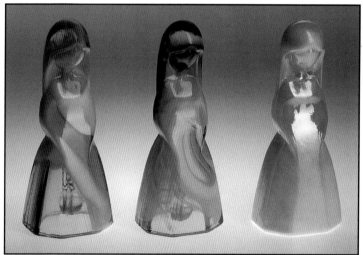

Three Mosser "Jenny" bells. Left to right: Desert Agate, 1983; Mistletoe Green, 1982; and Pearl, 1980. 1-3/4"d. x 4-3/4"h. $20-30 each.

Mount Washington Glass Company

New Bedford, Massachusetts, 1869-1900

Before 1900 and its merger with the Pairpoint Manufacturing Company in 1894, Mount Washington produced some bells in a white lusterless glass, also known as opal satin. These bells have a satin finish produced by giving the white glass a hydrofluoric acid bath. Some bells, in clear glass and painted flowers, are also attributed to Mount Washington.

Some additional bells in Burmese glass are also attributed to Mount Washington. However, Thomas Webb and Sons, England, made many of the Burmese glass bells attributed to Mount Washington under license from Mount Washington.

A bell is known in opal glass decorated with flowers and knobbed glass similar to glass items in Mount Washington's Colonial Ware.

For many years, collectors of glass bells have attributed glass Liberty bells with a molded glass chain handle to Mount Washington. Refer to the Glass Liberty Bells discussion in Chapter Eleven, "Who Really made These Glass Bells?" for further information on the attribution of these bells to the United States Glass Company.

A Mosser amber glass bell in a daisy and button pattern available in several colors. 3"d. x 5-1/4"h. $15-20.

A Mosser "#2 Floral" clear glass bell cut with laurel leaves and berries and upper and lower beading by Sydney Garrett. Square tapered handle with serrated corners. 3-1/4"d. x 5-7/8"h. $20-25.

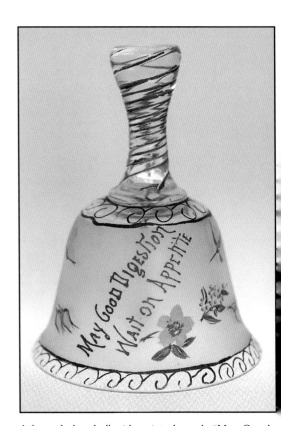

A frosted glass bell with painted words "May Good Digestion Wait on Appetite" and floral decoration. Twisted handle. Attributed to Mt. Washington. 3"d. x 4"h. $50-70. *Courtesy of Sally and Rob Roy.*

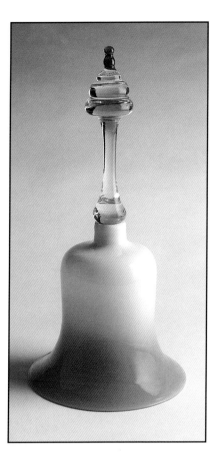

A blown Burmese glass bell attributed to the Mount Washington Glass Company. The bell is shaded from a glossy creamy yellow at the top to a soft rose at the bottom. The handle is of clear glass with five knops, the top two of raspberry color. 6-3/4"d. x 13-1/2"h., c.1885. *Courtesy of the Portland Museum of Glass, Maine. Bequest of Sylvia D. Greenberg. Photo by Melville D. McLean.*

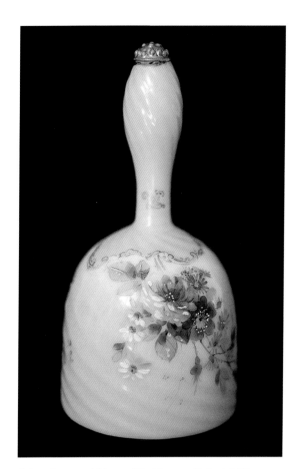

A hand painted Mount Washington Colonial Ware glass bell. The bell is swirled from top to bottom. It has a solid silver clapper and chain, probably furnished by the Pairpoint Corporation. 3"d. x 5-1/4"h. $400-500. *Courtesy of Sally and Rob Roy.*

A blown Burmese glass bell attributed to the Mount Washington Glass Company. The handle and the bell are of creamy yellow shading to a beige-peach tone at the base. The two knop finial and the rim are opaque turquoise over white glass. 6-1/4"d. x 14"h., c.1885-1890. *Courtesy of the Portland Museum of Art, Maine. Bequest of Sylvia D. Greenberg. Photo by Melville D. McLean.*

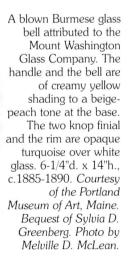

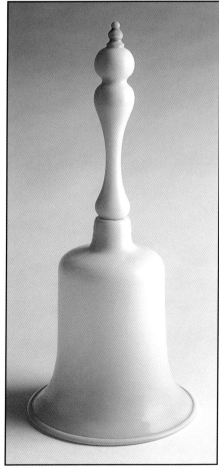

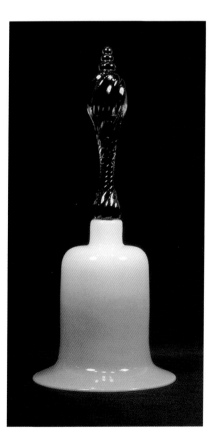

A Burmese glass bell with clear green wrythen handle with three knops attributed to Mount Washington. 4-1/2"d. x 10-1/4"h. *Courtesy of the Milan Historical Museum, Milan, Ohio.*

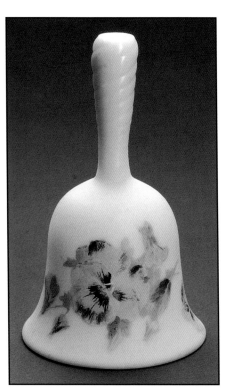

A Mount Washington bell in opal glass with painted daisy and a twisted handle. 3"d. x 5"h. $175-225.

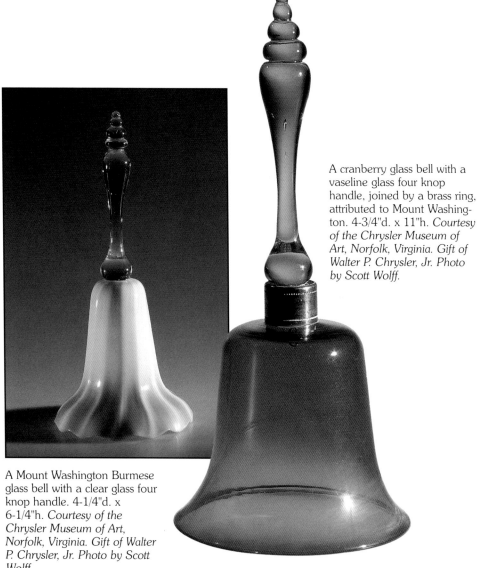

A cranberry glass bell with a vaseline glass four knop handle, joined by a brass ring, attributed to Mount Washington. 4-3/4"d. x 11"h. *Courtesy of the Chrysler Museum of Art, Norfolk, Virginia. Gift of Walter P. Chrysler, Jr. Photo by Scott Wolff.*

A Mount Washington Burmese glass bell with a clear glass four knop handle. 4-1/4"d. x 6-1/4"h. *Courtesy of the Chrysler Museum of Art, Norfolk, Virginia. Gift of Walter P. Chrysler, Jr. Photo by Scott Wolff.*

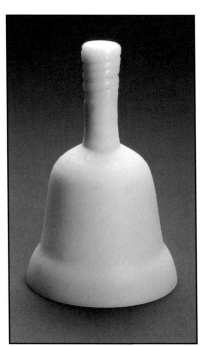

A bell in opal glass attributed to Mount Washington based on the twisted handle and two-part metal clapper. 4"d. x 6-1/4"h. $150-175.

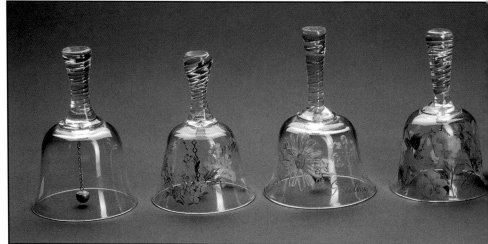

Four glass bells, some painted with flowers, attributed to Mount Washington. All have twisted handles. 3"d. x 4"h. to 5"h. The paint has not been refired so that some paint has flaked off. $30-50 each.

Nouveau Art Glass Company

Roseto, Pennsylvania, 1970s-

The Nouveau Art Glass Company has produced many items in the art nouveau style including bells.

A Nouveau Art Glass Reuven satin glass bell in a swirled colored pattern. 3-3/4"d. x 7-3/4"h. $25-35.

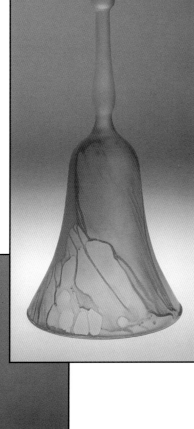

A frosted Nouveau Art Glass bell with etched trees and birds. 2-3/4"d. x 6-1/4"h. $50-60.

Ofnah Crystal

San Antonio, Texas, 1950s-

The Ofnah Trading Company, under the name Ofnah Crystal, provides many crystal products. In the past it is known to have produced many bells in cut, blown, and pressed glass. Bells have been produced for the company in Germany, the Czech Republic, Hungary, and Poland. Some of the earlier bells were made in Czechoslovakia. Most bells have paper labels showing Ofnah and the country of origin.

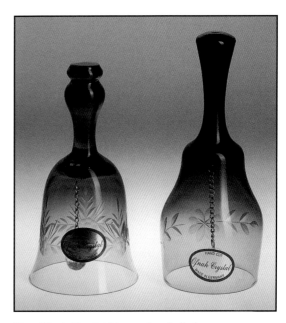

Two Ofnah Crystal blown glass bells from Germany. A clear blue bell on the left, 2-1/2"d. x 5"h., and a clear purple bell on the right, 2-1/4"d. x 5-3/4"h., both engraved with flowers. $20-25 each.

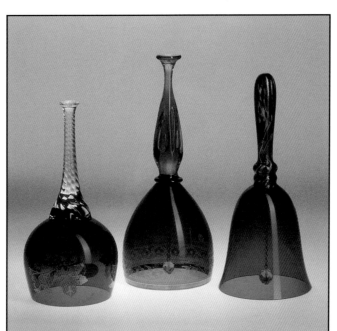

Three cobalt blue Ofnah bells. The left bell has gold painted leaves and a clear colorless twisted glass handle, 2-1/2"d. x 6-1/4"h. The center bell has a clear green glass handle and gold rim and decoration, 2-3/4"d. x 7-1/2"h. The bell on the right has a multi-colored handle, 3"d. x 7"h. All the bells were made in the Czech Republic for Ofnah. $35-45 each.

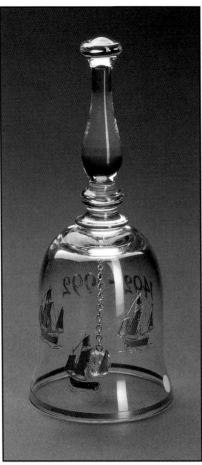

An Ofnah bell made in
the Czech Republic for
the 500 years anniver-
sary of the voyage of
Columbus. The dates
and Columbus' three
ships are shown in gold.
2-3/4"d. x
6-1/2"h. $25-35.

Two Ofnah cut glass bells made in Poland. The left bell is amber
flashed glass with cut to clear punties and clear colorless handle.
2"d. x 5-1/4"h. $20-25. The bell on the right is made of deep purple
flashed glass with cut punties and miters and has a clear colorless
handle. 1-7/8"d. x 3-3/4"h. $20-25.

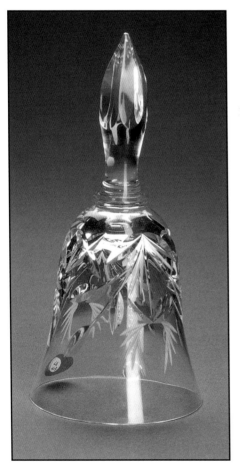

An Ofnah glass bell with cut
berries and leaves and
hexagonal handle, made in
the Czech Republic. 3-1/4"d.
x 6-3/4"h. $25-35.

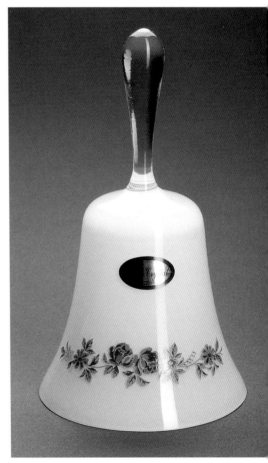

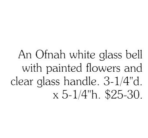

An Ofnah white glass bell
with painted flowers and
clear glass handle. 3-1/4"d.
x 5-1/4"h. $25-30.

Pairpoint Crystal Company, Inc.
Sagamore, Massachusetts, 1988-

Pairpoint Glass Company, Inc.
Spain, 1958-1970; Sagamore, Massachusetts, 1957 and 1970-1988

Gundersen-Pairpoint Glass Works
New Bedford, Massachusetts, 1952-1957

Gundersen Glass Works
New Bedford, Massachusetts, 1938-1952

Pairpoint Corporation/Mount Washington Glass Company, 1894-1938

Pairpoint Manufacturing Company
New Bedford, Massachusetts, 1880-1894

While some Pairpoint bells were made in the 1920s in clear glass and cut or engraved (see Chapter Three), Pairpoint is best known among bell collectors for the beautiful blown glass bells produced since 1970. In the late 1990s, some engraved bells were made with artistic handles and colorful rims. Most Pairpoint bells are signed with a P in a diamond.

Clappers are generally made of glass, occasionally as a prism, and attached to the bell by a metallic seven point star; a six rounded point star has been used on a few bells. On large bells that have the handle of the bell inserted in a collar at the top of the body of the bell, the two are joined by plaster. A wire inserted into the base of the handle holds the chain and clapper. Since the late 1990s, the handles of large bells have been bonded to the body of the bell, with no collar, by an adhesive.

A Pairpoint Collectors Club was formed in 1995 and the company made at least one bell for members each year through 1999.

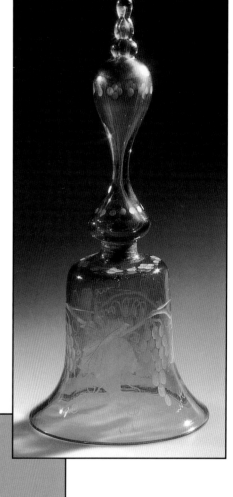

An amber Pairpoint bell with engraved vintage design and hollow handle with three knops. 4-7/8"d. x 11"h. *Courtesy of the Chrysler Museum of Art, Norfolk, Virginia. Gift of Walter P. Chrysler, Jr. Photo by Scott Wolff.*

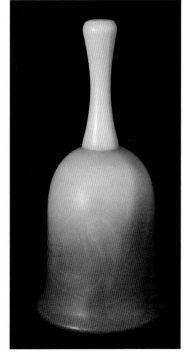

A Gundersen Pairpoint Peach Blow bell. 3-1/8"d. x 6-1/4"h., c.1953. $300-400.

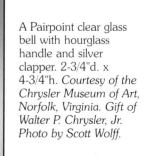

A Pairpoint clear glass bell with hourglass handle and silver clapper. 2-3/4"d. x 4-3/4"h. *Courtesy of the Chrysler Museum of Art, Norfolk, Virginia. Gift of Walter P. Chrysler, Jr. Photo by Scott Wolff.*

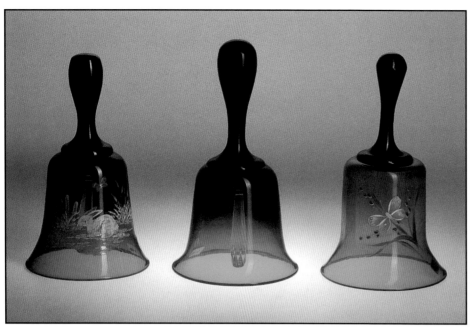

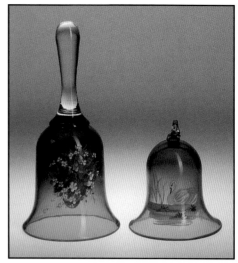

Three Pairpoint teal glass bells with painted rabbit, 3-3/4"d. x 6-3/4"h.; no decoration, 4"d. x 7-1/4"h.; and painted butterfly, 4"d. x 7"h. $60-100 each.

Two Pairpoint teal glass bells. The left bell has painted flowers and is signed "Eileen 2001" for Eileen A. Neery, a Pairpoint decorator. 3"d. x 6-3/4"h. $150-200. The bell on the right has a painted swan and loop handle. 3"d. x 3-1/2"h. $35-50.

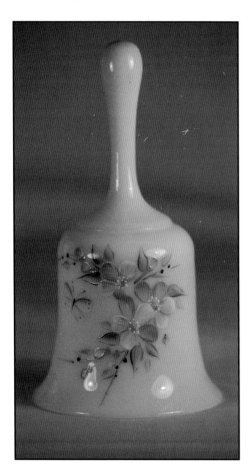

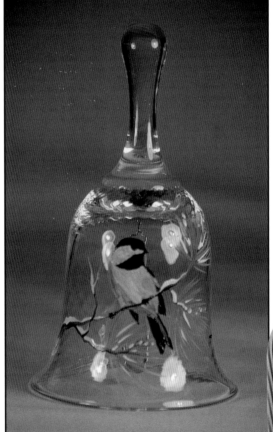

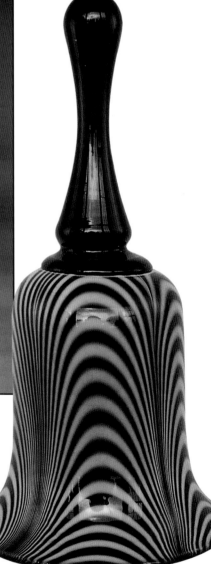

A milk glass Pairpoint bell with painted flowers. 3-3/4"d. x 7"h. $80-100.

A clear glass Pairpoint bell with painted bird on a flowery branch. 3-3/4"d. x 6-3/4"h. $75-90.

A Pairpoint ruby glass bell with white Nailsea type striping and clear ruby handle. 4-1/2"d. x 8-1/2"h. $250-350. *Courtesy of MaryAnn and Don Livingston.*

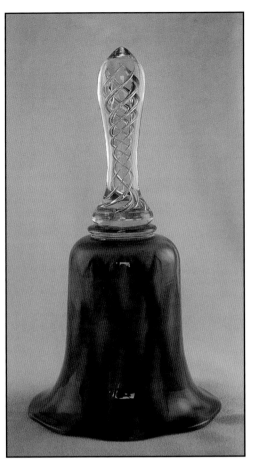

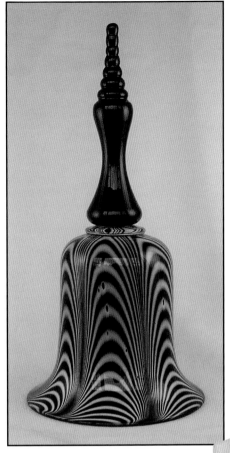

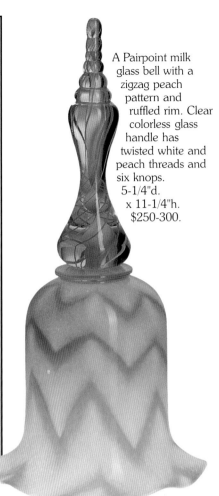

A Pairpoint milk glass bell with a zigzag peach pattern and ruffled rim. Clear colorless glass handle has twisted white and peach threads and six knops. 5-1/4"d. x 11-1/4"h. $250-300.

A Pairpoint purple, pink, and blue bell with a clear air twist handle. 5-1/2"d. x 10-1/2"h. $300-350. *Courtesy of Alvin and Arlene Bargerstock.*

A Pairpoint ruby bell with white Nailsea type striping and ruby handle with seven knops. 5-1/2"d. x 11-1/2"h. $300-400. *Courtesy of MaryAnn and Don Livingston.*

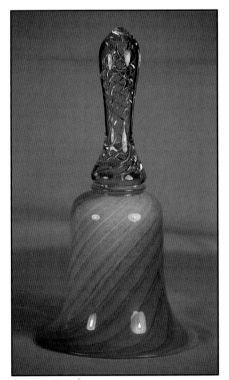

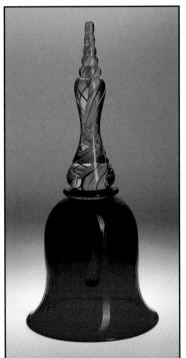

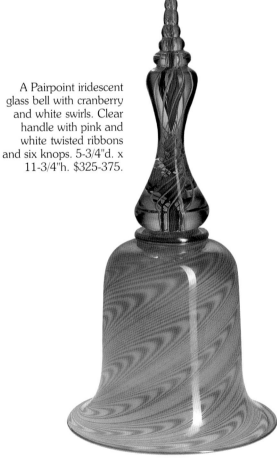

A Pairpoint iridescent glass bell with cranberry and white swirls. Clear handle with pink and white twisted ribbons and six knops. 5-3/4"d. x 11-3/4"h. $325-375.

A red, white, and blue striped Pairpoint bell with a clear air twisted colorless glass handle. 6"d. x 12-1/2"h. $125-150.

A Pairpoint ruby glass bell with clear colorless five knop handle with twisted ruby and white ribbons. 5"d. x 11"h. $225-275.

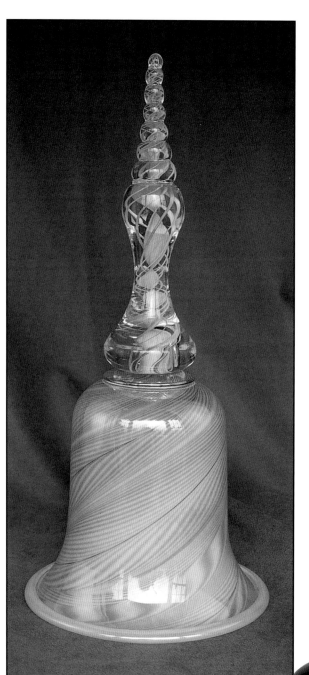

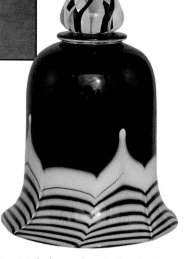

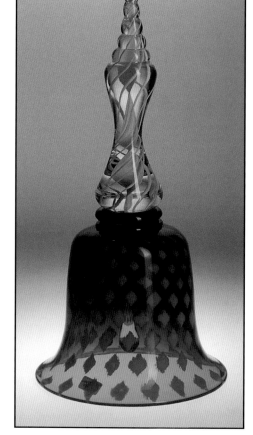

A Pairpoint teal bell with applied clear glass flower and clear seven knop handle with imbedded twisted green and white ribbons. 5-3/4"d. x 11-1/2"h. $400-500. *Courtesy of MaryAnn and Don Livingston.*

A Pairpoint iridescent glass bell with pink and white striping and a clear glass handle with pink and white twisted ribbons and seven knops. 5-1/2"d. x 12"h. $400-500. *Courtesy of MaryAnn and Don Livingston.*

A Pairpoint dark amethyst bell with white striping along a paneled base and clear six knop handle with amethyst and white imbedded ribbons. 4-3/4"d. x 11-1/4"h. $400-500. *Courtesy of MaryAnn and Don Livingston.*

A Pairpoint clear blue glass bell with white diamonds and a clear colorless five knop handle with twisted white ribbon. 5-1/4"d. x 10-3/4"h. $225-275.

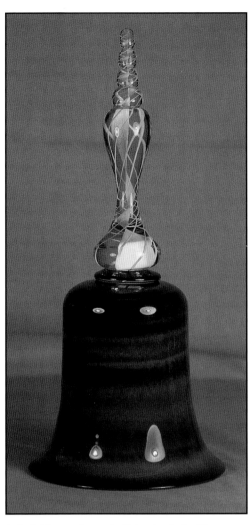

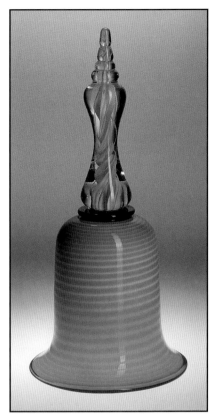

A Pairpoint glass bell with white and blue striping and blue rim. Colorless handle has twisted white ribbon and four knops. 5-1/4"d. x 11-1/4"h. $250-300.

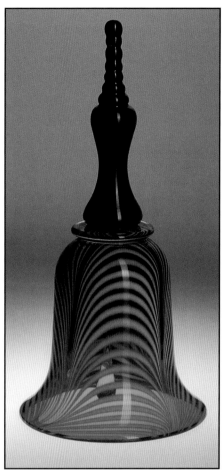

A Pairpoint teal glass bell with white Nailsea type striping and seven knop teal handle. 4-1/4"d. x 9"h. $175-225.

A dark blue and purple Pairpoint bell with a clear five knop handle with encased spiral white ribbons. 5-1/2"d. x 10-3/4"h. $250-300. *Courtesy of Gary L. Childress.*

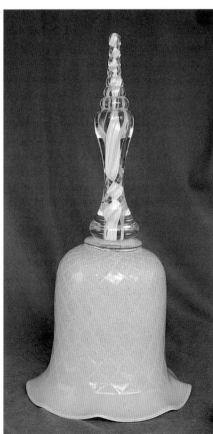

A Pairpoint yellow diamond pattern bell with a scalloped rim and clear seven knop handle with yellow and white imbedded twisted ribbons. 5"d. x 11-1/2"h. $300-400. *Courtesy of MaryAnn and Don Livingston.*

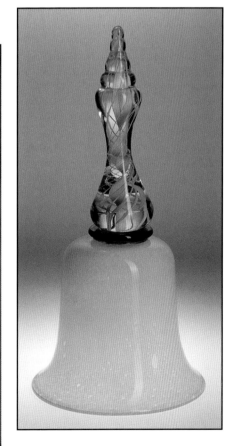

A Pairpoint yellow glass bell with green rim and connecting disk. Clear colorless five knop handle has twisted white ribbon. 5-1/4"d. x 10-3/4"h. $275-325.

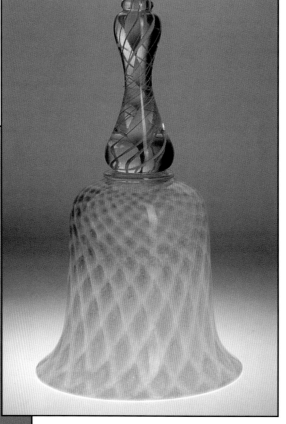

A Pairpoint glass bell with green diamond pattern and clear colorless handle with twisted green and white ribbons and three knops. 5"d. x 10"h. $200-250.

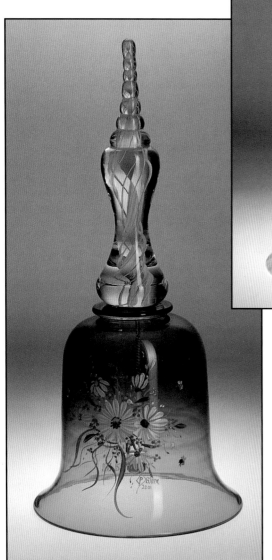

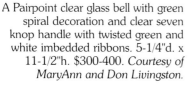

A Pairpoint teal glass bell with painted daisies and clear colorless handle with twisted white ribbon and seven knops. Signed "Eileen 2001". 5"d. x 11"h. $275-325.

A Pairpoint iridescent glass bell with green and pink striping and a seven knop handle with twisted white ribbon. 5"d. x 11"h. $300-350.

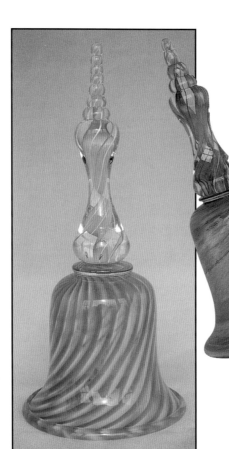

A Pairpoint red, white, and blue striped bell with clear four knop handle with red, white, and blue ribbons. 5-1/4"d. x 11-1/4"h. $300-400. *Courtesy of MaryAnn and Don Livingston.*

A Pairpoint clear glass bell with green spiral decoration and clear seven knop handle with twisted green and white imbedded ribbons. 5-1/4"d. x 11-1/2"h. $300-400. *Courtesy of MaryAnn and Don Livingston.*

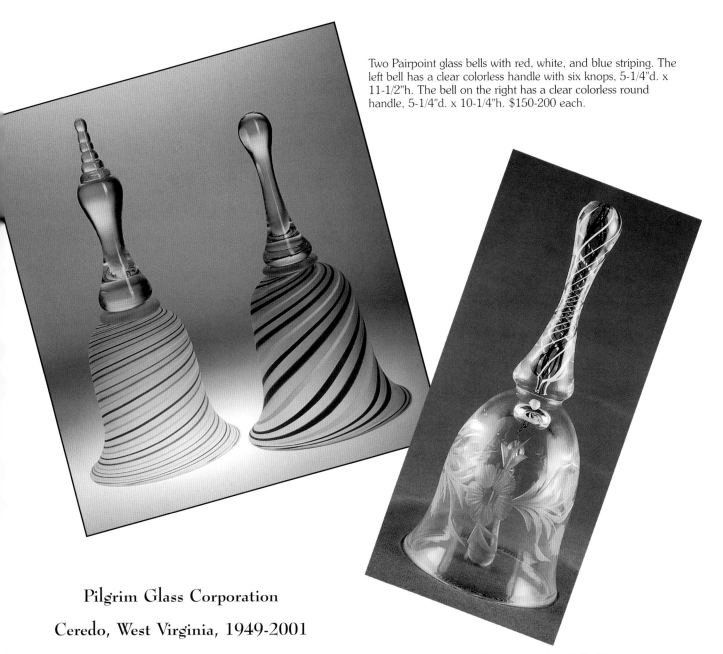

Two Pairpoint glass bells with red, white, and blue striping. The left bell has a clear colorless handle with six knops, 5-1/4"d. x 11-1/2"h. The bell on the right has a clear colorless round handle, 5-1/4"d. x 10-1/4"h. $150-200 each.

Pilgrim Glass Corporation

Ceredo, West Virginia, 1949-2001

Pilgrim Glass is known for its blown bells produced in many colors with molded colorless glass handles joined by plaster. The company also made cranberry colored glass bells with clear glass handles.

A heavy clear glass bell with an engraved floral pattern and a clear glass handle with encased spiral blue and white ribbons. 3"d. x 7"h. Attributed to Pairpoint. $175-200.

A blown glass bell with a handle molded in the shape of a Christmas tree, designed by Mario Sandon of the Pilgrim Glass Company. The clapper is brass. The glass was made in an experimental color never used commercially by Pilgrim. c.1978. 3-7/8"d. x 9-1/2"h. *Courtesy of the Huntington Museum of Art, Huntington, West Virginia.*

Three Pilgrim Glass Company bells made in two parts and held together by plaster. Left to right: Clear green with clear colorless handle; frosted cranberry and yellow with frosted colorless handle; and clear amber with colorless handle. 4"d. x 7-1/4"h. $30-45 each.

Two Pilgrim Glass Company frosted cranberry glass bells with clear colorless handles, part of a series of Frosty Snow Kids. The left bell shows carolers and is signed Kelsey/Pilgrim 1999, PCCC EX GS3075, and is the first of the series. 3-3/4"d. x 7-3/4"h. The bell on the right shows a frosted snowman and is signed K/P 2000, PCCC EX GS2085. 4"d. x 7-1/2"h. $70-90 each.

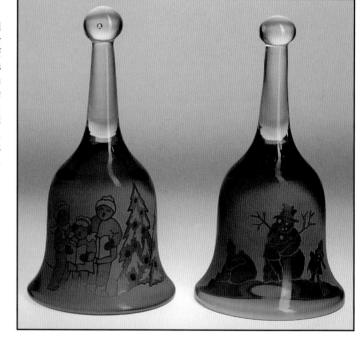

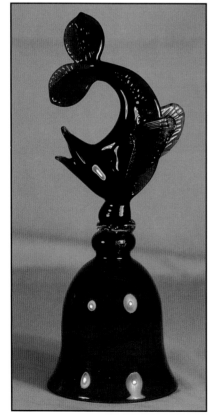

A Pilgrim cranberry glass bell with a dolphin shaped handle. 3-1/2"d. x 10"h. $200-250.

Since 1987, cameo art glass bells using cased glass, designed by Kelsey Murphy, were made at Pilgrim by a sand carving process. These bells are signed, dated, and given a register number. Other single color glass bells also have been made with designs using the sand carving process.

Pilgrim Glass ceased operations in 2001. During the final months of operation, the company made many sand carved designs on cranberry glass and plated glass blanks for bells; many are one-of-a-kind. Apart from the carved cranberry glass bells shown, similar cranberry glass bells are known in carved patterns showing badgers, stringed ornaments, stars and stripes, lotus leaves, a house winter scene, horse and sleigh, as well as others.

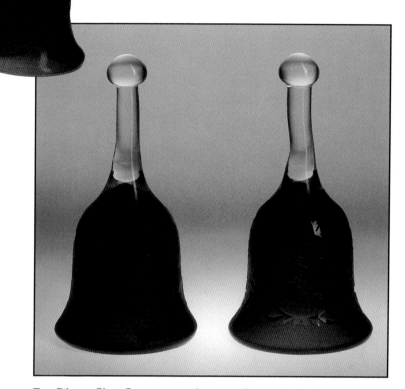

Three Pilgrim Glass Company cranberry sand carved bells. Patterns left to right: carriage and lamppost; ivy and brick wall; horses and tree. All are marked on the inside rim with Kelsey/Pilgrim, GS5000, 2001. 4"d. x 7-3/4"h. $180-220 each.

A Pilgrim Glass Company cranberry/topaz bell, sand carved with oak and maple leaves. Marked on inside rim with Kelsey/Pilgrim #913214, 2000. 1 of 25 produced. 4"d. x 7-3/4"h. $$250-300.

Two Pilgrim Glass Company cranberry sand carved bells. Pattern of birds on left and lady cameo on the right. Marked on the inside rim with Kelsey/Pilgrim GS5000, 2001. 4"d. x 7-3/4"h. $180-220 each.

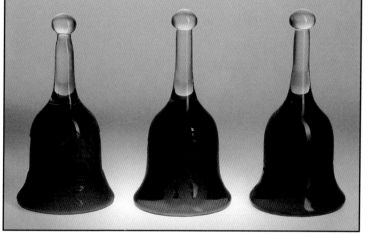

Three Pilgrim cranberry glass bells. The left bell shows a salamander and is signed Kelsey/Pilgrim 2001, GS5000. 3-3/4"d. x 7-1/2"h. The center bell shows a golfer and is signed Kelsey/Pilgrim 2001, GS5000. 4"d. x 7-3/4"h. The right bell shows an angel, tree, and cross and is signed Kelsey/Pilgrim 2001, GS5000. 4"d. x-7 3/4"h. $180-200 each.

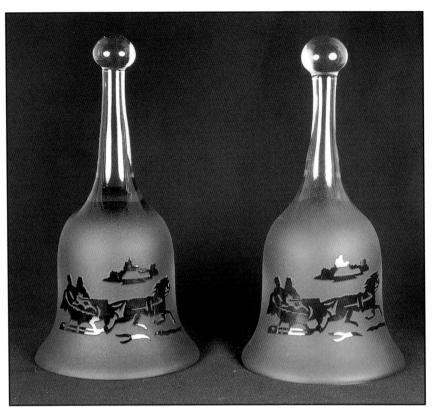

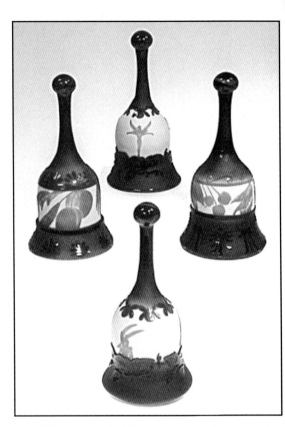

Two Pilgrim glass bells in ruby and cobalt blue glass with sand carved sleigh ride pattern. The ruby bell is marked Kelsey/Pilgrim GS5076, 1997 and the cobalt blue bell is marked Kelsey/Pilgrim GS5074, 1997, both on the inside rim. 4"d. x 7-3/4"h. $150-175 each. The photograph is overexposed to highlight the design.

Four Pilgrim one-of-a-kind cameo glass bells carved in cranberry glass over mocha. The right and left center bells are carved in a Fruit Series and the upper and lower bells are carved in a Fairy Series. 4"d. x 7"h. 2001. $300-400 each. *Courtesy of Kelsey.*

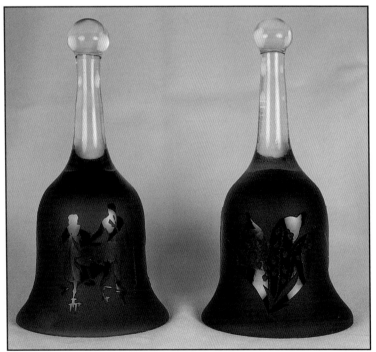

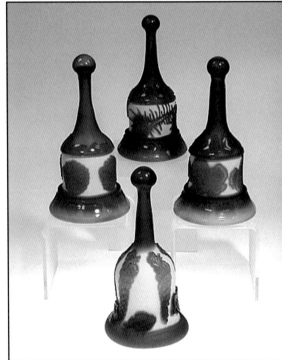

Two Pilgrim glass sand carved bells, green glass with skaters on the left and blue glass with bluebells on the right. Each is marked Kelsey/Pilgrim GS5074, 1997 on the inside rim. 4"d. x 7-3/4"h. $150-175 each.

Four Pilgrim one-of-a-kind cameo glass bells carved in sky blue glass over mocha, all in a Sea Series. 4"d. x 7"h. 2001. $300-400 each. *Courtesy of Kelsey.*

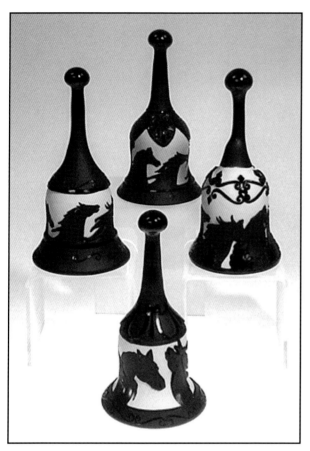

Four Pilgrim one-of-a-kind cameo glass bells carved in black glass over mocha, all in an Equis Series. 4"d. x 7"h. 2001. $300-400 each. *Courtesy of Kelsey.*

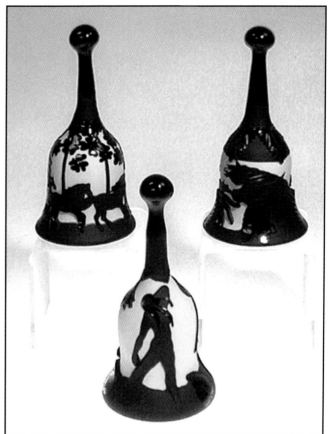

Three Pilgrim one-of-a-kind cameo glass bells. The top two bells are carved black glass over mocha in the Equis Series. The lower bell is carved black glass over mocha with a figurative individual. 4"d. x 7"h. 2001. $300-400 each. *Courtesy of Kelsey.*

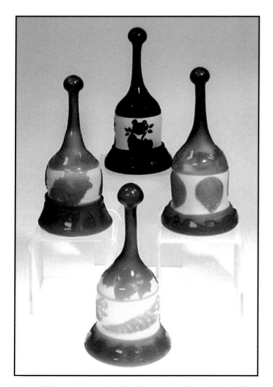

Four Pilgrim one-of-a-kind cameo glass bells. The top bell is a carved black glass Panda over mocha. The other three bells are carved sky blue glass over mocha in the Sea Series. 4"d. x 7"h. 2001. $300-400 each. *Courtesy of Kelsey.*

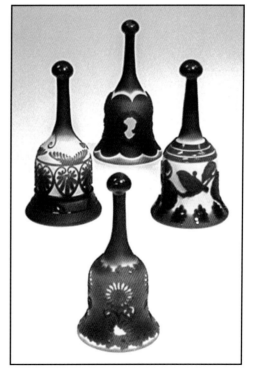

Four Pilgrim one-of-a-kind cameo glass bells in carved cranberry glass over mocha with individual designs. 4"d. x 7"h. 2001. $300-400 each. *Courtesy of Kelsey.*

Raimundas & Raminta Lapsys

Wheeling, Illinois, 1970s-

Raimundas & Raminta Lapsys are glass designers and engravers. The bell shown was an exclusive limited edition made for a catalog company.

Smith's Old Timer Glass

Fort Smith, Arkansas, 1960s-1976

The Smith's Old Timer Glass factory produced many blown glass items, including colored glass bells. A cork in the hollow handle holds the glass teardrop clappers.

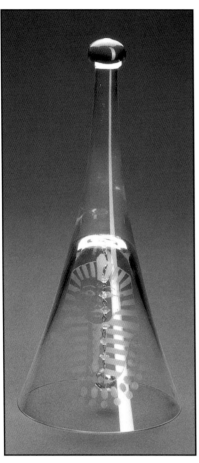

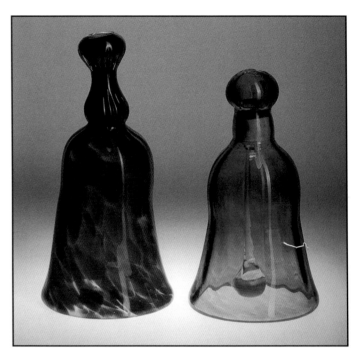

Two Smith's Old Timer Glass bells in red swirl, 4"d. x 8-1/4"h. and green, 4"d. x 7-1/2"h. Both have a clear drop clapper attached to the hollow handle by a cork. $25-35 each.

A clear glass bell engraved by Raimundas Lapsys with the funerary mask of King Tut. Marked '77. 4"d. x 8-1/2"h. $40-50.

Sandwich Co-operative Glass Company

Sandwich, Massachusetts, 1888-1891

The Sandwich Co-operative Glass Company produced some colored blown glass bells during its short period of existence.

A Sandwich Cooperative Glass Company bell in blown opal glass with green, pink, and blue spatters. It has a baluster shaped handle with a ground top. 3-3/4"d. x 7-1/4"h. c.1888-1891. *Courtesy of the Sandwich Glass Museum.*

Steuben Glass Works

Corning, New York, 1903-

Steuben Glass Works produced many items, including bells. Between 1936 and 1962 four bells, shown in the author's book on *Glass Bells*, were made in clear crystal.

Studios of Heaven

East Lynn, West Virginia, 2001-

When the Pilgrim Glass Corporation closed in 2001, Kelsey Murphy left and formed the Studios of Heaven with partner Robert Bomkamp to continue producing carved glass items, including bells, many of which are one-of-a-kind.

The bells shown are all one-of-a-kind and were all made in 2002 from blanks blown by Doug Wellman and with off hand animal handles.

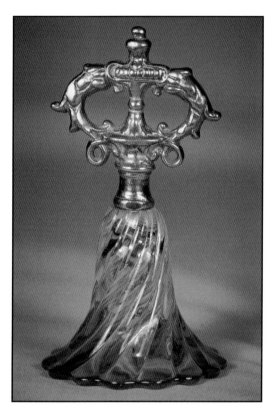

A Frederick Carder Steuben bell in iridescent Rosaline. The interior has a gold finish. 3"d. x 6-1/2"h. $1,500-2,000. *Courtesy of The Pecor Collection.*

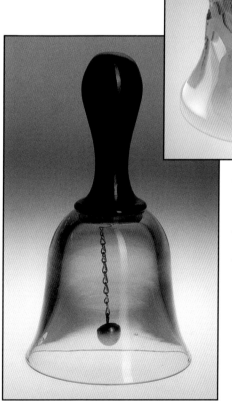

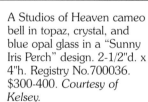

A Studios of Heaven cameo bell in topaz, crystal, and blue opal glass in a "Sunny Iris Perch" design. 2-1/2"d. x 4"h. Registry No.700036. $300-400. *Courtesy of Kelsey.*

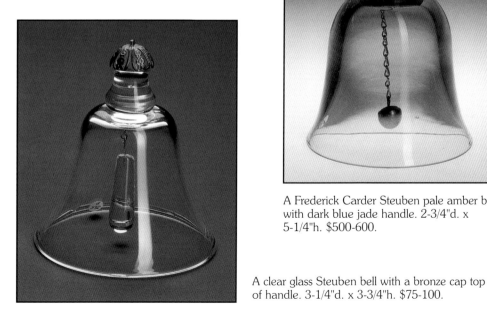

A Frederick Carder Steuben pale amber bell with dark blue jade handle. 2-3/4"d. x 5-1/4"h. $500-600.

A clear glass Steuben bell with a bronze cap top of handle. 3-1/4"d. x 3-3/4"h. $75-100.

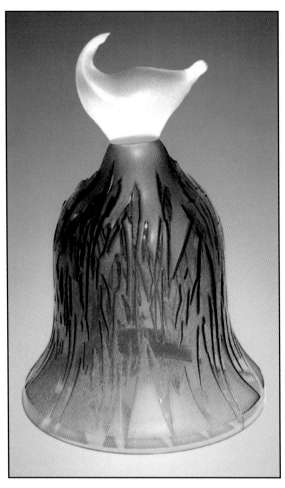

A Studios of Heaven cameo bell in green, crystal, and topaz glass in a "Swan Song" design. 2-1/2"d. x 4"h. Registry No.700037. $300-400. *Courtesy of Kelsey.*

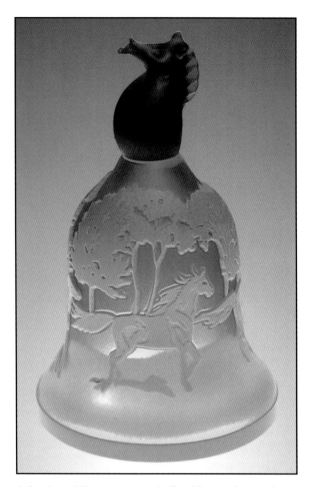

A Studios of Heaven cameo bell in blue opal, crystal, and cobalt glass in a "Blue on Blue" design. 2-1/2"d. x 4"h. Registry No. 700040. $300-400. *Courtesy of Kelsey.*

A Studios of Heaven cameo bell in green and crystal glass, and multi-colored frit in a "Forest Perch" design. 2-1/2"d. x 4"h. Registry No. 700027. $300-400. *Courtesy of Kelsey.*

A Studios of Heaven cameo bell in black, blue opal, crystal, and cobalt glass in a "Zebra Spring" design. 2-1/2"d. x 4"h. Registry No.700039. $300-400. *Courtesy of Kelsey.*

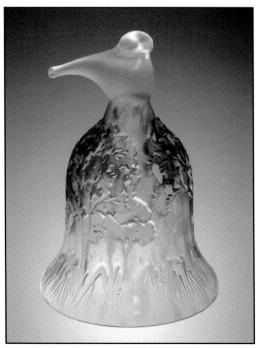

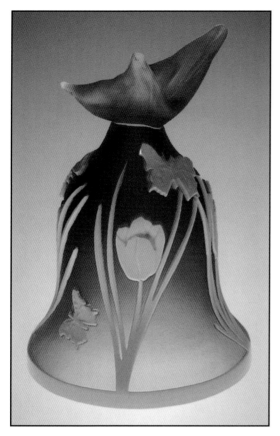

A Studios of Heaven cameo bell in blue opal, crystal, and cranberry glass in a "Cranberry Spring" design. 2-1/2"d. x 4"h. Registry No. 700026. $300-400. *Courtesy of Kelsey.*

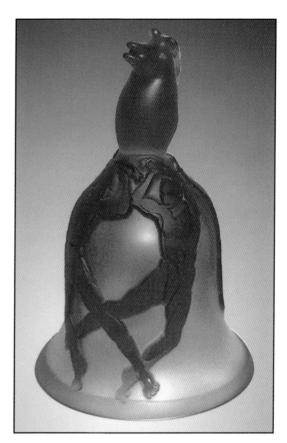

A Studios of Heaven cameo bell in cobalt, crystal, and topaz glass in a "Four Horsemen" design. 2-1/2"d. x 4"h. Registry No. 700028. $300-400. *Courtesy of Kelsey.*

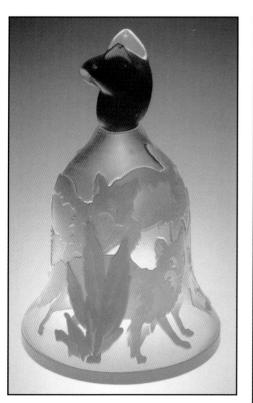

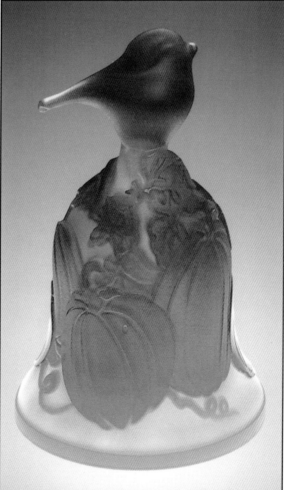

A Studios of Heaven cameo bell in blue opal, crystal, and topaz glass in a "Foxy" design. 2-1/2"d. x 4"h. Registry No. 700029. $300-400. *Courtesy of Kelsey.*

A Studios of Heaven cameo bell in topaz, blue opal, and crystal glass in a "Pumpkin Perch" design. 2-1/2"d. x 4"h. Registry No. 700035. $300-400. *Courtesy of Kelsey.*

A Studios of Heaven cameo bell in green, crystal, and topaz glass in an "Ivy Perch" design. 2-1/2"d. x 4"h. Registry No. 700032. $300-400. *Courtesy of Kelsey.*

Summit Art Glass Company

Rootstown, Ohio, 1972-

The Summit Art Glass Co. produces bells from molds acquired from companies that have gone out of business. Some bells have a molded "V" in a circle for the owner, Russ Vogelsong. Some bells have a paper label.

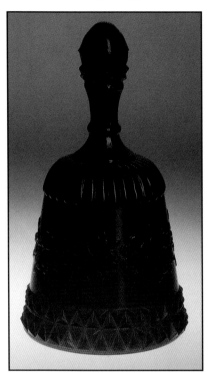

A Summit Art Glass Company bell in a red "Wildflower" pattern. 3-1/4"d. x 6"h. $25-35.

A Studios of Heaven cameo bell in blue opal, crystal, and cranberry glass in a "Pink Dreams" design. 2-1/2"d. x 4"h. Registry No. 700034. $300-400. *Courtesy of Kelsey.*

Tiara Exclusives

Dunkirk, Indiana, 1970-1998

Tiara Exclusives was created as a spin-off of the Indiana Glass Company and functioned as a retail distributor of glass items. Tiara never made any glass objects. Glass they sold was made primarily by the Indiana Glass Company, but also by Dalzell-Viking Glass, Federal, Fenton, Fostoria, Imperial Glass, L. E. Smith, Pilgrim Glass, and the Hazel Atlas companies. Their "Sandwich" pattern in bells is well known.

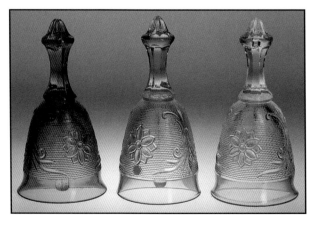

Three Tiara Exclusives bells in amber, blue, and pink glass in a "Sandwich" pattern. 2-3/4"d. x 5-3/4"h. $15-25 each.

Tiffin Glass Company

Tiffin, Ohio, 1888-1984

The Tiffin Glass Company started in 1888 as A. J. Beatty & Sons, when it moved from Steubenville, Ohio to Tiffin, Ohio. A. J. Beatty & Sons merged with the United States Glass Company in 1892, becoming one of the nineteen factories of that corporation and designated as Factory R. While the company remained part of the United States Glass Company through 1962, the Tiffin label started to be used in 1927. After 1962, Tiffin operated under various owners. The company produced many glass items using molds from companies that went out of business. These were used to make a large variety of decorated stemware including matching bells. From 1962 to 1980 some stemware was signed "Tiffin."

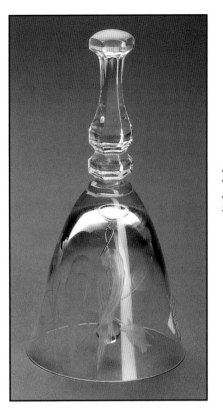

A Tiffin clear glass bell with engraved lovebirds and flowers. 2-3/4"d. x 5-1/2"h. $30-40.

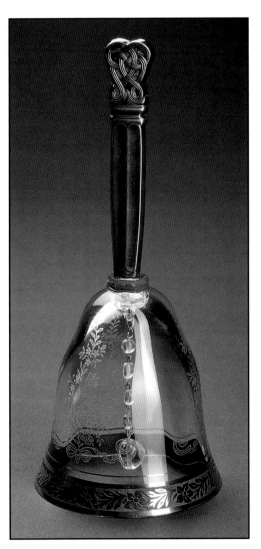

A Tiffin bell in an etched "Melrose" pattern and gold rim with a Towle silver handle made to commemorate the 1979 merger of Tiffin and Towle. 2-3/4"d. x 6-3/4"h. $50-60.

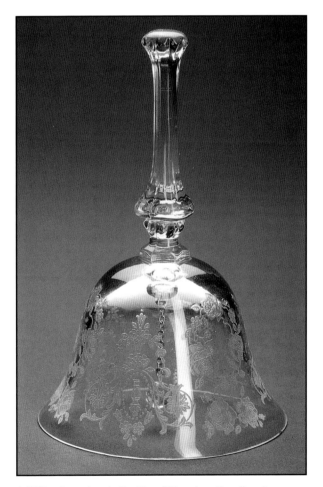

A Tiffin clear glass bell with a "Cherokee Rose" pattern on a #17403 stem. 3-1/4"d. x 5"h. $60-70.

R. Wetzel Glass

Zanesville, Ohio, 1974-1985

Robert Wetzel made Kewpie doll bells and other small bells signed R. Wetzel at the top where the chain holding a crystal clapper is attached. Some bells were made using molds of Tiffin Glass goblets.

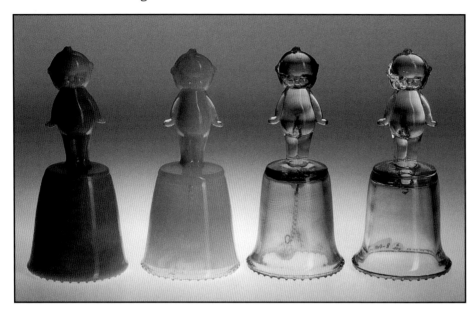

Four Wetzel Kewpie doll handle bells in opaque and clear glass. 2-1/4"d. x 5-1/4"h. $35-45 each.

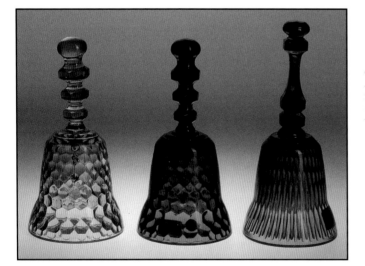

Three Wetzel bells. The amber and blue bells have raised hexagonal knobs on the inside. 2-3/4"d. x 5-1/2"h. The green bell is fluted on the inside. 2-3/4"d. x 6"h. $40-50 each.

L. G. Wright Glass Company

New Martinsville, West Virginia,

1930-1999

The Wright company had other glass companies produce glass items from original and new molds. Bells were produced from the 1960s through the 1980s, primarily in Daisy & Button and Currier and Ives patterns. Many of these were made as covers to candy dishes.

See Chapter Twelve for a recent discovery on the Currier and Ives bell mold.

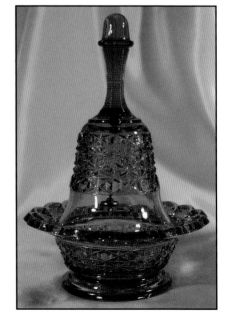

An L. G. Wright amber butter dish, with open edge and bell handle in the "Currier & Ives" pattern. The bell is 4"d. x 7"h. $75-100. *Courtesy of Barbara Wright.*

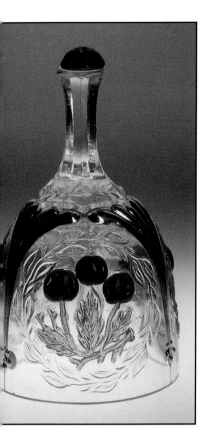

An L. G. Wright bell molded with cherries and gold decoration. 3-1/4"d. x 5-3/4"h. $35-45.

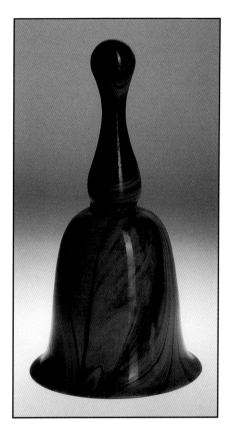

A thick brown slag glass bell of unknown origin, with a clear glass teardrop clapper. 4"d. x 7-1/2"h. $60-70.

American Blown and
Pressed Glass Bells of Unknown Origin

There are some bells believed to be of American origin, but the manufacturer is not known to the author.

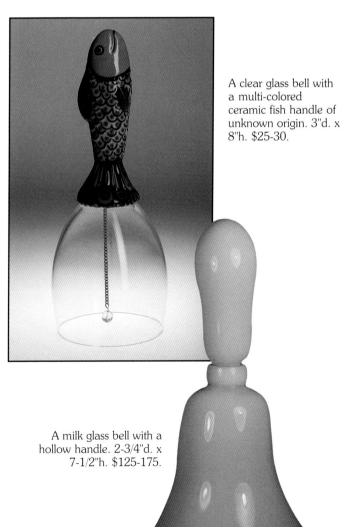

A clear glass bell with a multi-colored ceramic fish handle of unknown origin. 3"d. x 8"h. $25-30.

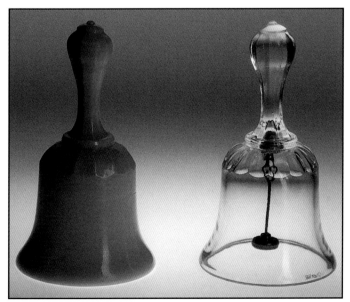

Two molded bells of unknown origin with flat metal clappers on a wire held by a cork inserted in the handle. 3"d. x 5-1/4"h. $30-40 each.

A milk glass bell with a hollow handle. 2-3/4"d. x 7-1/2"h. $125-175.

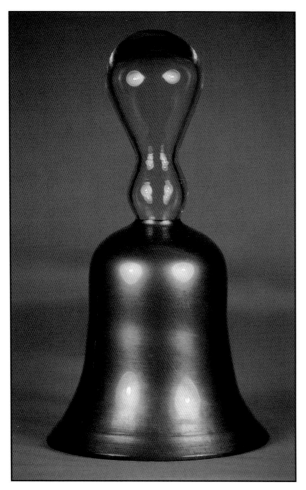

A blown glass bell with gold finish and clear colorless blown hollow handle. 5-3/4"d. x 10-1/2"h. $125-150. *Courtesy of Gary L. Childress.*

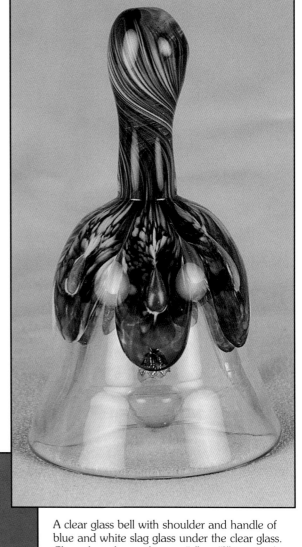

A clear glass bell with shoulder and handle of blue and white slag glass under the clear glass. Clear glass clapper has an "n" or "L" in a circle and is supported by a bronze chain attached by a seven point bronze star. 2-5/8"d. x 4-3/8"h. $50-60.

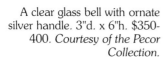

A clear glass bell with ornate silver handle. 3"d. x 6"h. $350-400. *Courtesy of the Pecor Collection.*

References

Anthony, Dorothy Malone. "Bell Markings and Identification." *The Bell Tower Supplement* (June-July 1971): S1-S9.

Barlow, Raymond E. and Joan E. Kaiser. *The Glass Industry in Sandwich, Volume 4.* Windham, New Hampshire: Barlow-Kaiser Publishing Co., Inc., 1983.

Brenner, Robert. *Depression Glass for Collectors.* Atglen, Pennsylvania: Schiffer Publishing Ltd., 1998.

Collins, Louise. "Glass Bells of the U. S. A." *The Bell Tower Supplement* (April 1976): S1-S15.

Finley, Charlie. "Glass Bells." *Glass Collector's Digest* V, no. 4 (December/January 1992): 43-46.

Florence, Gene. *Elegant Glassware of the Depression Era.* Paducah, Kentucky: Collector Books, 1993.

Hammond, Lenore and Curtis. "Collectible Glass and Porcelain Bells." *The Bell Tower Supplement* (April, 1972): S1-S27.

Heacock, William. *Fenton Glass: The Third Twenty-five Years.* Marietta, Ohio: The Glass Press, Inc., 1989 and 1994.

Long, Milbra. "Fostoria Bells." *Glass Collector's Digest III* no. 6 (April/May 1990): 15-17.

Long, Milbra, and Emily Seate. *Fostoria, Useful and Ornamental.* Paducah, Kentucky, Collector Books, 2000.

Measell, James, ed. *Fenton Glass: The 1980s Decade.* Marietta, Ohio: The Glass Press, Inc., 1996.

———. *Fenton Glass: The 1990's Decade.* Marietta, Ohio: The Glass Press, Inc., 2000.

Measell, James. *Fenton Glass: Especially for QVC.* Williamstown, West Virginia: The Fenton Art Glass Company, 2002.

Mularcik, Ruth. "Imperial Bells." *The Bell Tower* 61, no. 1 (January-February 2003): 24.

Nemecek, Sylvia. "Fenton Bells." *The Bell Tower Supplement* 53, no. 6 (November-December 1995): S1-S16.

Trinidad, Jo and Al. "1893 Columbian Exposition Libbey Glass Bells." *The Bell Tower* 44, no. 6 (June-July 1986): 10.

———. "Smocking Glass Bells." *The Bell Tower* 44, no. 6 (June-July 1986): 8.

Trinidad, A. A. Jr. "1893 Columbian Exposition Glass Bells Update." *The Bell Tower* 50, no. 2 (March-April 1992): 18-20.

———. "American Glass Bells." *The Bell Tower* 50, no. 3 (May-June 1992): 14.

———. "Mount Washington Glass Bells." *The Bell Tower* 51, no. 2 (March-April 1993): 10.

———. "Fenton Daisy and Button Glass Bells." *The Bell Tower* 51, no. 6 (November-December 1993): 13.

———. "Carnival Glass Bells." *The Bell Tower* 52, no. 2 (March-April 1994): 18, 19.

———. "Imperial Slag Glass Bells." *The Bell Tower* 52, no. 5 (September-October 1994): 13.

———. "Wide Band Glass Bells." *The Bell Tower* 53, no. 4 (July-August 1995): 10, 11.

———. "Steuben Glass Bells." *The Bell Tower* 54, no. 2 (March-April 1996): 14.

———. "Chocolate Glass Bells." *The Bell Tower* 54, no. 6 November-December 1996): 24.

———. "Victorian Belle Glass Bells." *The Bell Tower* 55, no. 2 (March-April 1997): 11.

———. "Central Glass Works Bells." *The Bell Tower* 57, no. 2 (March-April 1999): 33.

———. "Bells by Glen Jones." *The Bell Tower* 58, no. 1 (January-February 2000):

———. "Libbey Bells from the Columbian Exposition." *Glass Collector's Digest* IX, no. 4 (December/January 1996): 22-26.

Walk, John. *Fenton Bells Compendium, 1970-1985.* Atglen, Pennsylvania: Schiffer Publishing Ltd. 2001.

Glass Bells of Canada

Chalet Artistic Glass, Ltd.

Cornwall, Ontario, 1962-1980

Several master craftsmen from Italy started a glass-blowing business in Cornwall, Ontario in 1960 and their artisans produced Venetian type glass articles. In the 1970s they produced several bells for Riekes Glass, a distributing company. The bells usually have a label with the Riekes Chalet name.

Demaine Glass Studio

Mactaquac, New Brunswick, 1975-1980

Martin Demaine started the Demaine Glass Studio in Mactaquac in 1975. There he made some glass bells. All Demaine bells are unique and distinct in form and decoration. Some match sets of goblets that Demaine also made. Over a six-year period he made about sixty bells.

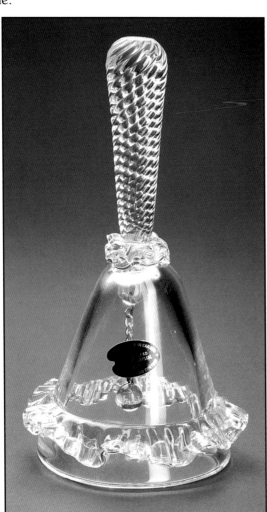

A heavy Chalet Artistic Glass bell, made for Riekes, with a clear ruffled rim and air twist handle. 4"d. x 8-1/4"h. $60-70.

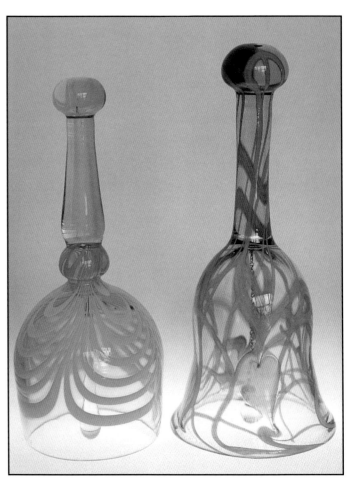

Two Demaine bells. The bell on the left has blue drapes and is signed "Demaine 78" on the outer rim. 3-3/8"d. x 8-1/2"h. The bell on the right has amber and white decoration and is signed "Demaine 77" on the outer rim. 4"d. x 9"h. $60-75 each. *Courtesy of Sally and Rob Roy.*

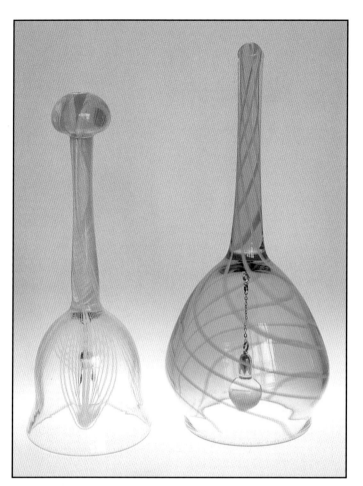

Karl Schantz, 1971-

Karl Schantz produced art glass objects in various glass media starting in 1971. Some glass bells were made.

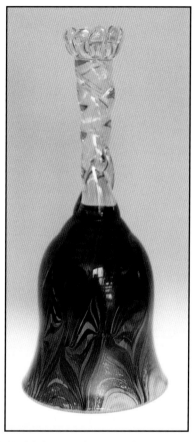

Two Demaine bells. The bell on the left is very pale blue with white leaf design and is signed "Demaine 76" on the outer rim. 2-7/8"d. x 7-3/4"h. The bell on the right is blue with a white swirl pattern. It is signed "Demaine Studio 78" on the outer rim. 4"d. x 8-3/4"h. $60-75 each. *Courtesy of Sally and Rob Roy.*

A Karl Schantz iridescent gold and blue glass bell from the Sheridan School of Design, Mississauga, Ontario. Clear twisted handle. Inscribed "To the Roys No.8, Karl Schantz 3-75." 3-1/2"d. x 8-1/4"h. $75-100. *Courtesy of Sally and Rob Roy.*

Rossi Glass Incorporated

Niagara Falls, Ontario, 1996-

Rossi Glass is noted for its artistic blown glass articles particularly in cranberry glass. Several glass bells have been made.

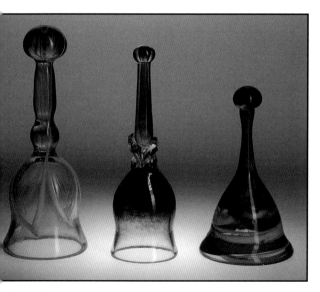

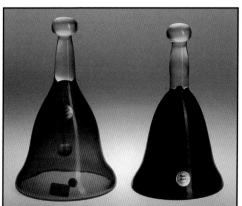

Three Demaine bells. The green bell has a white leaf design and hollow handle and is signed "Demaine 77." 3-1/2"d. x 9"h. The magenta bell has a hollow handle and is signed "Demaine Studio 78." 2-3/4"d. x 8-1/4"h. The bell with brown and white swirls is signed "Demaine 77." 3-3/4"d. x 6-3/4"h. $60-90 each.

Two Rossi Glass Company bells in cranberry glass, 3-1/2"d. x 6"h., and blue glass, 3-1/4"d. x 5-3/4"h. $30-40 each.

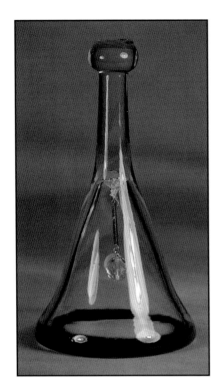

A Rossi Glass Company clear glass bell with dark blue rim. 3-1/4"d. x 6-1/4"h. $30-40.

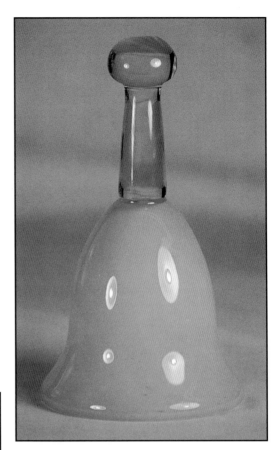

A pale green Rossi Glass Company bell with a clear colorless handle. 3-1/4"d. x 5-3/4"h. $30-40.

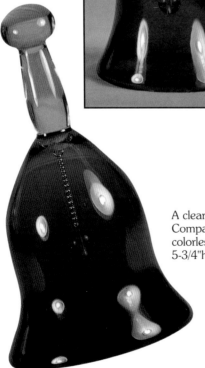

A dark clear green Rossi Glass Company bell with a clear colorless handle. 3"d. x 5-3/4"h. $30-40.

A clear amethyst Rossi Glass Company bell with a clear colorless handle. 2-3/4"d. x 5-3/4"h. $30-40.

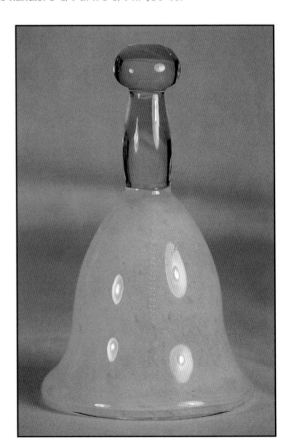

A yellow Rossi Glass Company bell with a clear colorless handle. 3-1/2"d. x 5-3/4"h. $30-40.

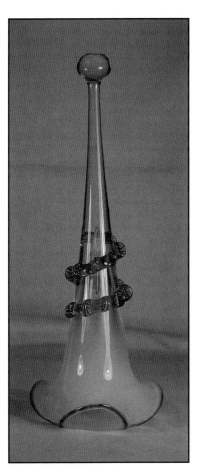

A cranberry swirled glass Rossi Glass Company bell with a clear colorless swirled glass handle. 3-3/4"d. x 6-1/2"h. $40-50.

Canadian Glass Bells of Unknown Origin

Some bells are believed to be of Canadian origin, but their manufacturer is unknown to the author.

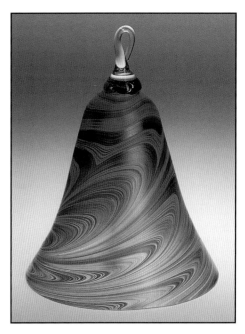

A Canadian multi-colored art glass bell with small clear glass loop handle, unknown origin. 3-3/4"d. x 5-1/4"h. $35-50.

A Rossi Glass Company clear to frosted art glass bell with applied blue decoration and blue ruffled rim. 4-3/4"d. x 13"h. $60-75.

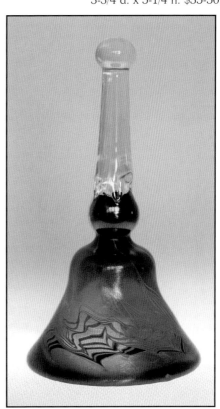

A Canadian iridescent purple glass bell with initials and 84 etched on the inside rim. 3-1/2"d. x 6-1/4"h. $30-40. *Courtesy of Sally and Rob Roy.*

Glass Bells of Europe

Austria

Several Austrian firms have produced bells.

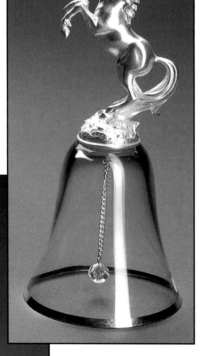

A clear glass bell with a gold rim and silver plated unicorn handle made in Austria for the Franklin Mint in 1988 as "Song of the Unicorn." It has a 24K gold coated horn and two sapphire eyes. The clapper is a faceted crystal. 3"d. x 7"h. $90-100.

A clear glass bell with etched head of liberty and 1886/1986, made in Austria for Villeroy & Boch for the Centennial of the Liberty Bell. 3-3/4"d. x 7"h. $20-30.

J. Loetz Witwe

1913-1939

J. Loetz Witwe (Widow Johann Loetz Glassworks) has been known for many years for the glass produced that is reminiscent of Galle and Tiffany. The company became well known for the bluish-green glass produced in many articles. The bell shown is attributed to Loetz, but it is difficult to confirm because much of their glass is not signed.

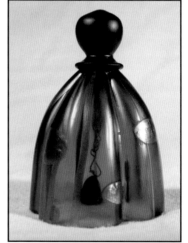

An art glass bell from around the early 1900s, attributed to Loetz, in green iridescent glass with mauve design. A twisted wire rope is inserted in a hole filled with plaster of paris to hold a chain and clapper. 3"d. avg. x 4-1/4"h. $100-150. *Courtesy of Barbara Wright.*

Belgium

A few Belgian companies have produced glass bells.

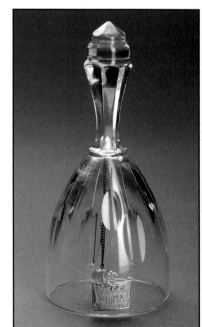

A clear glass bell with punties and a hexagonal handle with a "RUDMA Made in Belgium" label. 2-1/2"d. x 5-3/4"h. $20-30.

Val St. Lambert

Liège, 1825-

Val St. Lambert produced many bells during the period 1939-1977.

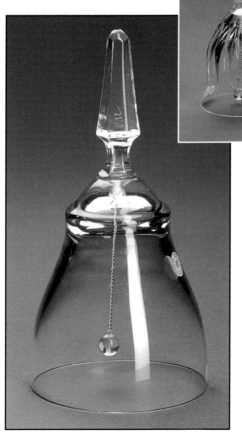

A clear glass Val St. Lambert bell with two disks at base of round handle. NYWF label. #135/39. 2-1/2"d. x 4-1/2"h. $30-35.

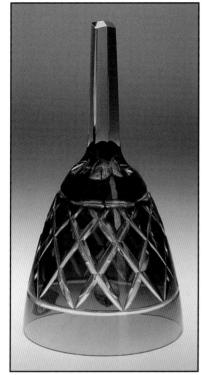

A Val St. Lambert ruby cut to clear glass bell with diamond pattern and clear glass hexagonal handle. Possibly made from a goblet. 3"d. x 5-3/4"h. $60-70.

Three clear glass Val St. Lambert bells. The left and center bells are variations of the "Balmoral V916" pattern. The bell on the right is an "Elegance V915" pattern. It is signed on top of the handle. All are from a 1977 catalog. 2-3/4"d. x 5-3.4"h. $30-40 each.

A clear glass Val St. Lambert bell with a disk handle with hexagonal point. 1970 catalog no.V905 State. 2-3/4"d. x 4-1/2"h. $20-25.

A clear glass Val St. Lambert bell with a tapered hexagonal handle. 3-1/4"d. x 6-1/4"h. $20-30.

Bohemia

Before World War I, many glass factories operated in parts of Czechoslovakia, Austria, Germany, and Poland, generally known as Bohemia. The bells presented here are those primarily made around the middle of the nineteenth century.

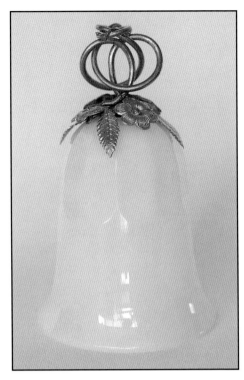

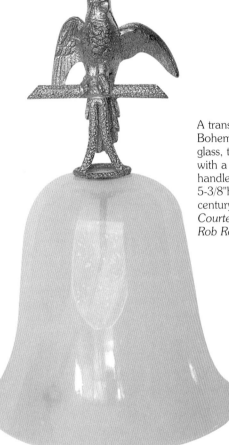

A translucent white, Bohemian bubble glass, ten panel bell with a gilt macaw handle. 3-1/2"d. x 5-3/8"h., nineteenth century. $300-400. *Courtesy of Sally and Rob Roy.*

A Bohemian custard glass twelve panel bell with gilded wire and floral handle. 3-1/4"d. x 5-1/8"h. $300-400. *Courtesy of Sally and Rob Roy.*

A Bohemian clear blue glass, ten panel bell with vase shaped bronze handle. Leather washer separates the handle from the glass. 3"d. x 6-3/8"h. $200-300. *Courtesy of Sally and Rob Roy.*

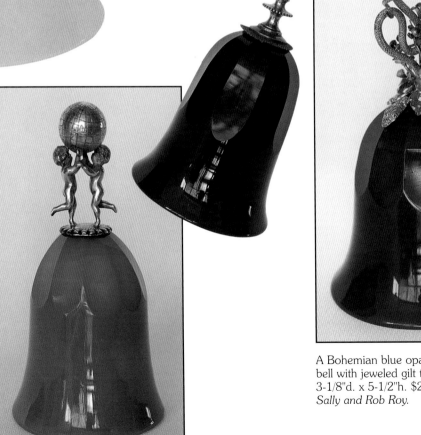

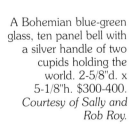

A Bohemian blue-green glass, ten panel bell with a silver handle of two cupids holding the world. 2-5/8"d. x 5-1/8"h. $300-400. *Courtesy of Sally and Rob Roy.*

A Bohemian blue opaque glass, ten panel bell with jeweled gilt twisted wire handle. 3-1/8"d. x 5-1/2"h. $275-325. *Courtesy of Sally and Rob Roy.*

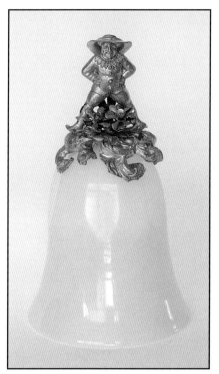

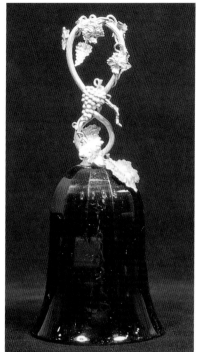

A Bohemian cranberry glass bell with a twisted grapevine gold metal handle. 2-1/4"d. x 6-3/4"h. *Courtesy of the Milan Historical Museum, Milan, Ohio.*

A Bohemian white glass ten panel bell with gilded elf handle and jewels. 2-7/8"d. x 4-3/4"h. $300-350. *Courtesy of Sally and Rob Roy.*

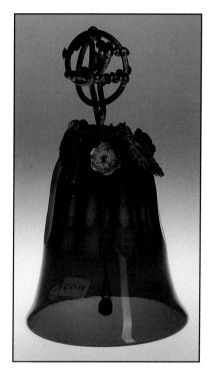

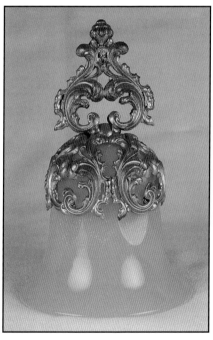

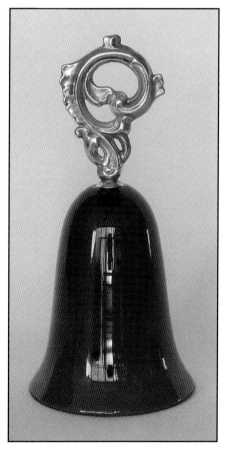

A Bohemian dark blue glass bell with a bronze coiled handle of leaves and flowers. 3"d. x 5-1/4"h. c.1850. $300-350.

A Bohemian translucent green glass bell with elaborate bronze handle. 3-1/2"d. x 5-1/2"h. c.1850. $350-450.

A Bohemian ruby glass bell with silver scroll handle. 3"d. x 6-1/8"h. $300-375. *Courtesy of Sally and Rob Roy.*

A Bohemian ruby glass bell with flared rim, cut panels at the top, and ball shaped metal clapper. The metal handle is in the form of a grapevine with two opaque turquoise blue sets. The stand is a circular wooden shape mounted with a gilt metal rim and slightly domed circular plate, rimmed with standing scrolls, and with a grape cluster at the center. 2-5/8"d. x 5-1/2"h. 1840-1870. *Courtesy of the Corning Museum of Glass, Corning, NY, gift of Mr. & Mrs. Theodore D. Koranye.*

Czechoslovakia

During the time the country was formed after World War I, until the split into the Czech Republic and the Slovakia Republic after World War II, several firms produced colorful glass bells. Some are labeled as made in Bohemia.

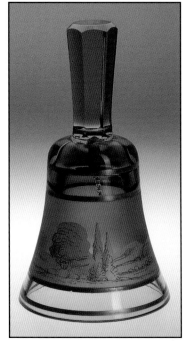

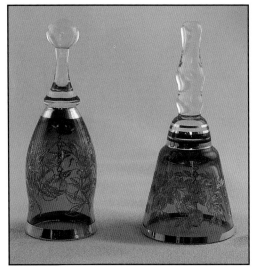

A Czechoslovakian amber glass bell with a pastoral scene. 2-3/4"d. x 5-1/4"h. $30-40.

A Czechoslovakian clear glass bell with vertical cuts alternating with hobstars and punties on the shoulder. The square handle has a flat top. The bell is signed "Czechoslovakia" on the inside rim. 2-1/4"d. x 3-1/2"h. $30-40.

A pair of Czechoslovakian bells in cranberry glass with gold decoration. 1-3/4"d. x 4"h. $40-60 each. *Courtesy of Alvin and Arlene Bargerstock.*

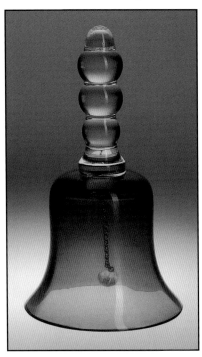

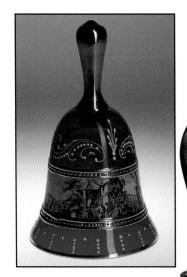

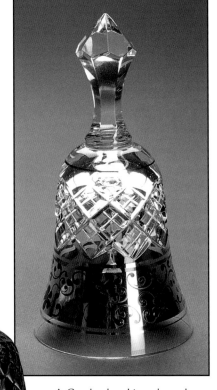

A Czechoslovakian ruby glass bell with white decoration and tapestry design and a gold colored handle. 3-1/4"d. x 5-1/2"h. $25-30.

A Czechoslovakian clear glass bell with a cross-cut diamond pattern with a lower band of gold design. 2-1/2"d. x 5"h. $30-40.

A Czechoslovakian cranberry glass bell with a clear colorless four knob handle. 4"d. x 7"h. $30-40.

A Czechoslovakian bell in an amber diamond pleated glass with clear colorless handle. 3-1/2"d. x 6-1/4"h. $30-40.

M. I. Hummel

Some bells illustrating Hummel figures have been produced in Czechoslovakia.

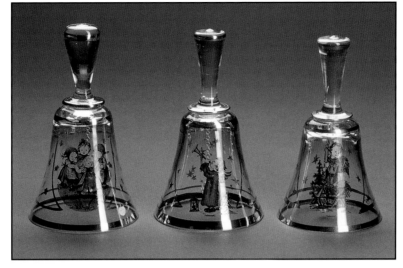

Three Hummel bells with printed Christmas scenes and gold bands along rims, shoulders, and top of handles. 3-1/2"d. x 6"h. The two bells on the right are from issues of 1,000 and the left bell is from an issue of 5,000. $30-40 each.

Czech Republic

After World War II, the Czech Republic was formed and many of the glass companies known in the former Czechoslovakia continue to operate and produce glass bells. Among those well known are Moser and Egermann. Many of the bells are still labeled as being made in Bohemia.

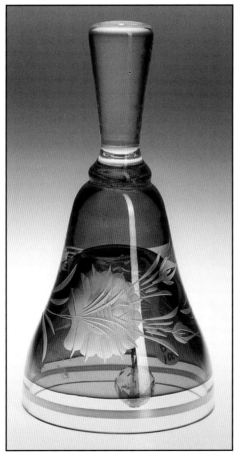

A Czech Republic bell in flashed violet glass with engraved floral design and gold band along the rim. 1-3/4"d. x 3-1/2"h. $25-35. *Courtesy of John and Charmel Trinidad.*

A Czech Republic bell in green glass with gold overlay in upper half and five floral panels. 2-1/4"d. x 3-1/2"h. $50-60.

A Czech Republic bell in ruby flashed glass with bird and castle decoration and gold rim. 2-3/4"d. x 7"h. $30-40.

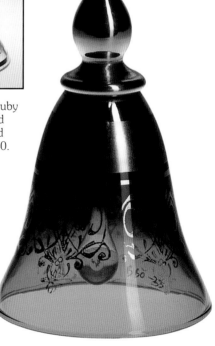

Ceska Inc.

Wyckoff, New Jersey, 1970s-

Ceska Inc. has its main office in the United States, but imports all its crystal from the Czech Republic. Some crystal bells have been made to match patterns of crystal ware.

A Czech Republic clear glass bell with etched deer and trees. 3-1/2"d. x 6-1/4"h. $20-30.

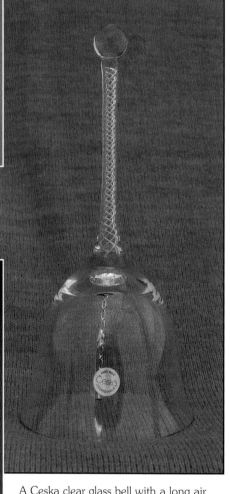

A Ceska clear glass bell with a long air twist handle. 3-1/2"d. x 7-1/2"h. $30-40. *Courtesy of Carol and Bob Rotgers.*

A clear glass Hummel bell with a frosted choirboy handle made in 1994 as the second in a series for Avon. 2-3/4"d. x 5-1/2"h. $20-30.

Egermann-Exbor

Novy Bor, 1867-

Egermann is a manufacturer of hand-made soda-potash glass; their specialty is decorating with red, yellow, and green stain, a technique invented by Friedrich Egermann in 1830. Some well-known bells have been made in paneled glass with gold decoration.

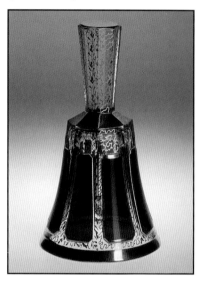

An Egermann paneled flashed glass bell in dark amethyst with gold decorated borders. 2-3/4"d. x 5"h. $60-80.

An Egermann paneled flashed amber glass bell with gold decorated borders. 3-1/4"d. x 5-3/4"h. $80-100.

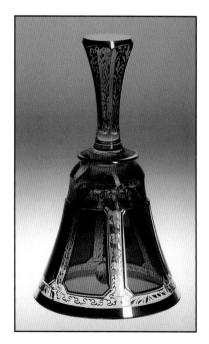

An Egermann paneled glass bell with red stained panels engraved with grapes and leaves surrounded by gold decorated borders and gold rim. 2"d. x 4"h. $70-90.

Martin Cvrček

Zelezny Brod

Martin Cvrček has produced glass items with engraved and sand blasted designs and very few bells.

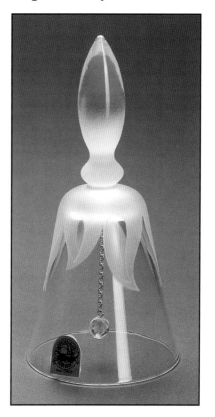

A Martin Cvrček clear glass bell with frosted leaves along the shoulder. 2-3/4"d. x 6"h. $30-40.

An Egermann clear glass bell with frosted decoration and gold design rim. Clear handle with two lower knops. 3"d. x 7-1/4"h. $40-50.

Moser

Karlovy Vary, 1857-

Moser has a large glass factory, museum, and showroom in Karlovy Vary. The company has been a well-known producer of quality glass products for many years.

A clear glass bell with applied gold decoration attributed to Moser. 3"d. x 5-3/4"h. $150-175. *Courtesy of Sally and Rob Roy.*

A Moser ruby glass bell with gold decoration and gold finished metal handle of a boy playing a violin. Signed Moser. 3-1/4"d. x 6-1/4"h. $100-120.

Preciosa AS

Jablonec nad Nisou, 1948-

Preciosa AS and its sister company, Preciosa Figurky s.r.o., have produced cut lead crystal items for many years. A few bells have been produced.

A Preciosa multi-faceted, eight sided, cut crystal bell with integral clapper. 1-1/2"d. x 2-5/8"h. $70-75.

A. Rückl & Sons

Nizbor, 1846-

Rückl has produced many kinds of glassware, and in recent years this has included bells.

A Moser clear glass bell with gold decorated overlay. Signed Moser. 3-1/2"d. x 4"h. $40-50.

A Rückl & Sons cobalt blue glass bell with gold star decoration and gold rim and a clear twisted glass handle. 3-1/4"d. 7-1/4"h. $35-40.

A Rückl & Sons ruby bell with gold vintage decoration and clear spiral twist handle. 3"d. x 6-1/2"h. $35-40.

Denmark

Holmegaard Glassworks

Kastrup, 1965-

Two competing glass houses in Denmark, Kastrup and Holmegaard, united in 1965. The firm has produced some glass bells.

France

There are several well known glass companies that have produced bells in France for many years. It is difficult to determine the attribution of older bells.

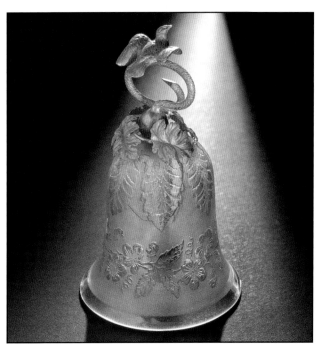

A Second Empire, nineteenth century French crystal bell decorated in foliage with a gold plated bronze handle of a dove with spread wings on a branch and leaves. The clapper is a gold plated bronze ball on a chain. 2-3/4"d. x 4-1/4"h. *Courtesy of the Institut Européen d'Art Musée d'Art Campanaire de l'Isle-Jourdain, France.*

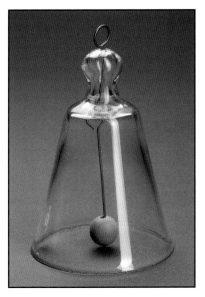

A Holmegaard clear glass bell with wood clapper and wire hanger going through the top of handle. The bell is also known in blue, red, and cobalt blue glass. 3-1/2"d. x 5"h. $20-25.

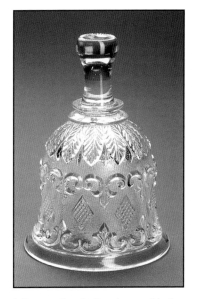

A heavy glass bell with a molded lacy pattern with leaves and diamonds and mottled finish, typical of French lacy glass. 3-3/4"d. x 5-1/2"h. $40-50.

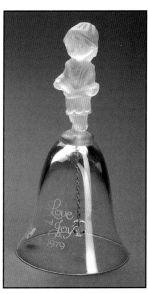

A clear glass bell with etched "Love and Joy 1979" and a frosted glass drummer boy handle, made in France for Hallmark Little Gallery. 3"d. x 5-3/4"h. $20-30.

Cristalleries de Baccarat

Lorraine, 1823-

Two bells were produced by Baccarat in cut clear crystal in the 1950s and a lesser known bell was produced in the late nineteenth century. Some bells with coordinated Vienna bronze handles and clappers, known to collectors as French flint glass bells, have been attributed to Baccarat. See more information on these bells later in this chapter.

Cristalleries Royales de Champagne

Bayel, 1666-

Bayel has made many fine bells in clear glass, some with frosted handles. They are usually labeled Bayel.

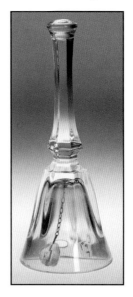

A Bayel bell in clear and flashed amber glass. 1-3/4"d. x 4-3/4"h. The bell is available in several other colors. $20-25.

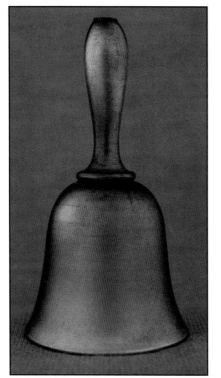

A Baccarat glass swirled pattern bell in clear to pink shaded glass with an ornate gilded handle; late nineteenth century. 3"d. x 5-1/2"h. $250-300. *Courtesy of the late Dorothy Malone Anthony.*

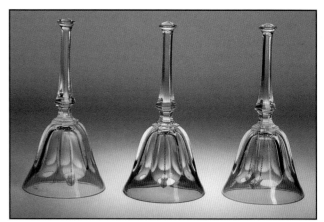

Three Bayel bells in flashed yellow, rose, and amber glass. They usually carry labels with Bayel Cristallin and Golden Crown, E&R, France. 3"d. x 6-1/2"h. $25-35 each.

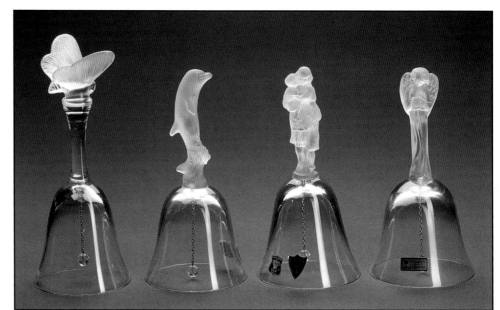

Four Bayel clear glass bells with frosted handles. Left to right: butterfly, 3-1/2"d. x 8-1/4"h.; porpoise, 3-1/2"d. x 7-1/4"h.; mother with two children, 3-1/2"d. x 7"h.; and angel, 3-1/2"d. x 7"h. $25-35 each.

Crystal d'Arques

Arques, 1968-

Crystal d'Arques (Verrerie Cristallerie d'Arques) is a subsidiary of Arc International, S. A., a glass company that has roots back to 1825. The company has produced a few glass bells.

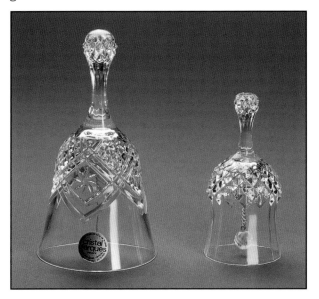

Two Crystal d'Arques bells. The left bell is molded with crosscut diamonds and stars and crosscut diamond top of handle, 3"d. x 6"h. The bell on the right has a crosscut diamond pattern "ancenis," 2"d. x 4"h. $20-25 each.

Cristallerie Daum

Nancy, 1962-

Bells have been produced by Daum in clear lead glass and sometimes etched to commemorate events. All are signed in script "Daum, France," sometimes with a small Cross of Lorraine engraved on the bell. A 5-3/4" high version exists of the bell shown.

A Daum heavy clear glass bell with loop handle and teardrop clapper, signed "Daum France" separated by a symbol for the Cross of Lorraine. 5"d. x 7-3/4"h. $175-200.

Verreries et Cristalleries de St. Denis et de

Pantin Reunies (DeVez)

Denis, 1920-

Around 1920 two French firms, Legras & Cie and Cristallerie de Pantin, merged and continued to produce art glass items. Some cameo glass items were marked with De Vez, a pseudonym of Camille Tutré de Varreux, one of the art directors of the combined firm.

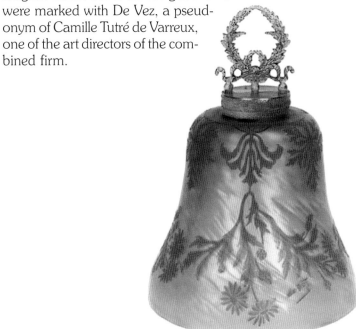

An acid etched, cameo blown, glass pink bell decorated with daisies and foliage. The handle is a mounted gilded metal collar and hanger; the bell has a chain and gilded metal clapper. Signed DeVez on the side. 6-1/2"d. x 10"h. c.1920. At least two other similar bells are known. $2,000+. *Courtesy of O'Gallerie Auctions, Portland, Oregon.*

House of Goebel

Several glass bells have been made in France for the House of Goebel.

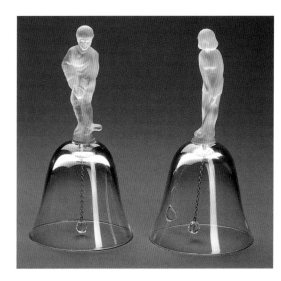

Two House of Goebel clear glass bells with frosted handles of a man hockey player on the left and a woman golfer on the right. 3-1/2"d. x 7-1/4"h. $25-35 each.

Schmid

1976-1995

Several glass bells have been made for Schmid in France.

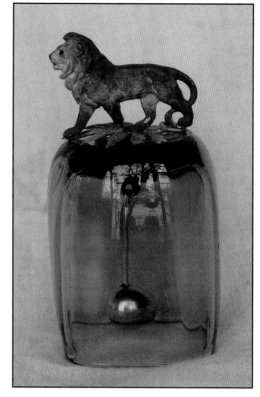

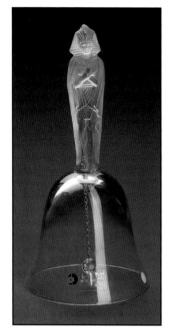

A Schmid clear glass bell with a frosted glass pharaoh handle. A label states "Schmid, France." 3-1/2"d. x 7-1/2"h. $20-30.

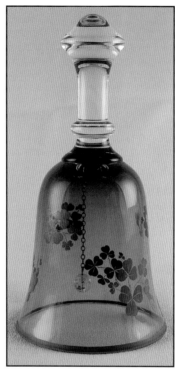

A Schmid clear green glass bell decorated with golden shamrocks and rim, with a clear colorless handle. A label states "Schmid, France." 3-3/8"d. x 6-1/2"h. $25-35.

A green French flint glass bell with a Vienna bronze lion handle and a solid bronze clapper 1-3/4"sq. x 4-3/4"h. $1,000-1,500.

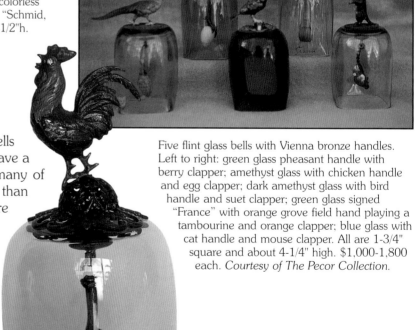

French Flint Glass Bells

Glass bells known as French Flint Glass bells have been attributed to Baccarat. The bells have a square shape with Vienna bronze handles, many of which are coordinated with the clappers. More than thirty variations of the coordinated bells are known. They are believed to have been made in the mid nineteenth century.

Several bells are known with "baccarat" inscribed; more are seen with "France" inscribed. A few bells have been found with "Germany" inscribed and these may be the forerunners of those made in France.

Five flint glass bells with Vienna bronze handles. Left to right: green glass pheasant handle with berry clapper; amethyst glass with chicken handle and egg clapper; dark amethyst glass with bird handle and suet clapper; green glass signed "France" with orange grove field hand playing a tambourine and orange clapper; blue glass with cat handle and mouse clapper. All are 1-3/4" square and about 4-1/4" high. $1,000-1,800 each. *Courtesy of The Pecor Collection.*

A blue French flint glass bell with a Vienna bronze chicken handle and clapper of an egg held by a claw. 1-3/4"sq. x 4-1/4"h. $1,000-1,500. *Courtesy of Sally and Rob Roy.*

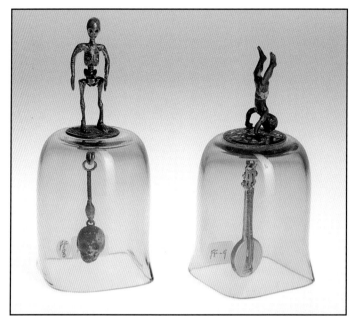

Two green flint glass bells. The left bell has a skeleton handle and a skull clapper, 1-3/4"sq. x 4-1/2"h. The bell on the right has a black man standing on his head as a handle and a banjo as a clapper. 1-3/4"sq. x 4"h. 1,000-1,500 each.

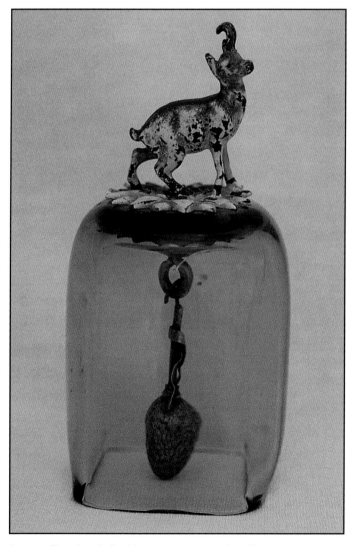

A green flint glass bell with a mountain goat handle and berry clapper. 1-3/4"sq. x 4"h. $1,500-2,000. *Courtesy of The Pecor Collection.*

Germany

Several glass companies in Germany have produced glass bells for collectors. Some bells are known from the eighteenth century. Some modern bells have been made using bell blanks from Hummelwerk.

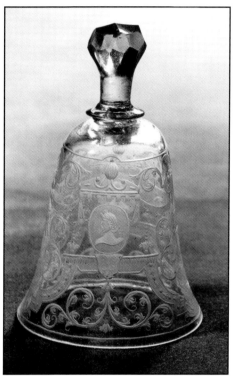

A clear glass bell from the Royal Electoral glass factory, Dresden, Germany, 1715-20. The bell is cut and engraved with two portrait medallions surrounded with floral and other decoration. 3-1/8"d. x 5-1/2"h. *Courtesy of the Kunstgewerbemuseum, Staatliche Kunstsammlungen Dresden.*

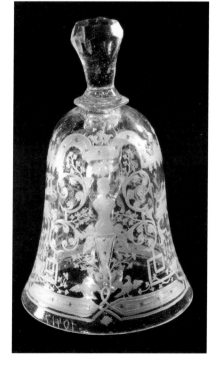

A clear glass bell from the Royal Electoral glass factory, Dresden, Germany, 1715-20. The bell is cut and engraved with two hunting scenes surrounded by various decorations. 3"d. x 5-1/4"h. *Courtesy of the Kunstgewerbemuseum, Staatliche Kunstsammlungen Dresden.*

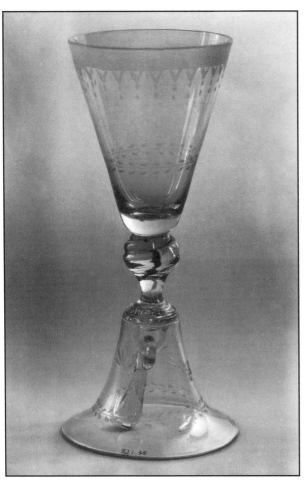

A goblet with a bell base, probably from Saxony. c.1750. 3"d. x 7-1/8"h. *Courtesy of The Metropolitan Museum of Art, Bequest of George White Thorne, 1883.*

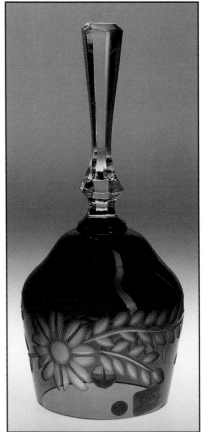

A cased red glass cut to clear with a floral pattern. 2-1/2"d. x 7-1/4"h. $40-50.

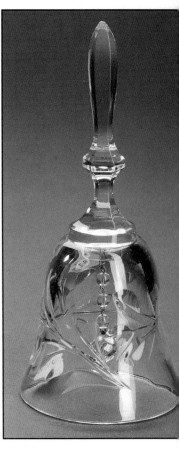

A clear glass bell with a cut rose pattern. 3"d. x 7"h. $20-25.

F & W Goebel Company

Rodenthal, 1871-

Goebel is well known amongst bell collectors for the glass bells with frosted glass figural handles, but many others can be found with the House of Global Art label.

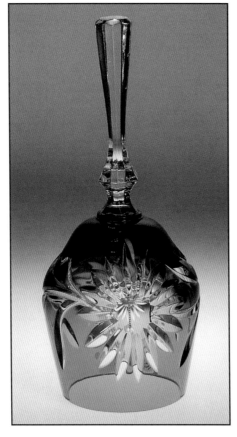

A cased green glass cut to clear with a star pattern on a Hummelwerk blank. 2-1/2"d. x 7-1/4"h. $40-50.

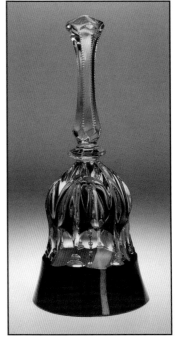

A ruby and clear glass bell, #117042, from the House of Global Art, a division of the House of Goebel Handelsges, Munich. 3-1/2"d. x 8"h. $40-50.

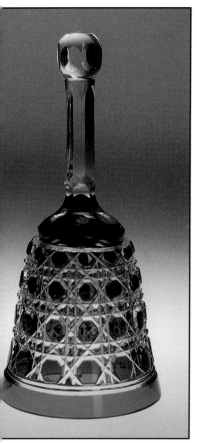

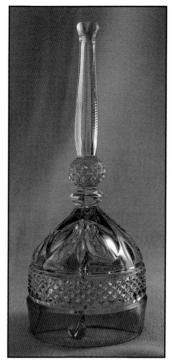

A House of Global Art gold colored glass bell, cut to clear in a strawberry diamond band and radial petal pattern. 2-3/4"d. x 7-3/4"h. $35-45. *Courtesy of Warren and Elizabeth Dean.*

A Goebel flashed teal glass bell with cut to clear hexagonal buttons. 2-3/4"d. 5-3/4"h. The bell is also known in purple and red flashed glass. $50-60.

Hofbauer Crystal

Bavaria, 1980s-1990s

The Hofbauer company produced many pressed glass bells, many as part of their Byrdes Crystal Line. Most bells feature molded and etched designs of birds and animals.

A House of Global Art tall hexagonal shape clear glass bell, #107007. 2-1/4"d. x 8-1/2"h. $30-40.

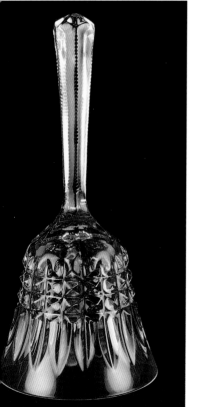

A House of Global Art crystal bell in a pattern similar to #117116. 3-1/4"d. x 7"h. $20-30.

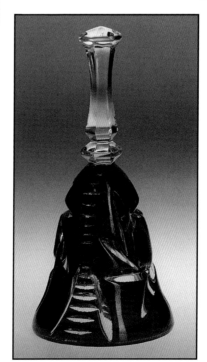

A Hofbauer ruby flashed glass bell cut with pinwheel and horizontal miters and clear hexagonal handle. 2"d. x 4-1/4"h. $20-25.

113

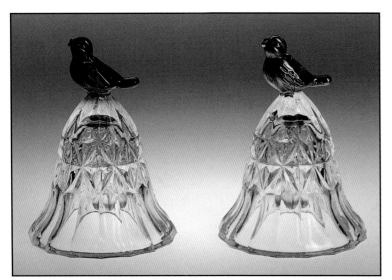

Two Hofbauer clear pressed glass bells with colored glass birds for handles. 2-3/4"d. x 3-3/4"h. The bells are also available with clear glass birds and birds of other colors. $15-20 each.

Rosenthal AG

Selb, 1965-

Rosenthal has produced many tabletop items, including bells. In 1997, the company became a subsidiary of Waterford Wedgwood PLC.

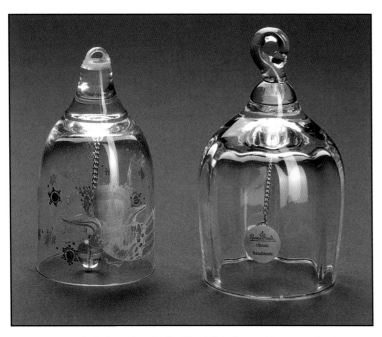

Two Rosenthal clear glass bells. The left bell is a Christmas Studio-line showing a golden angel with harp and stars signed by the designer, Bjorn Wiinblad. 2"d. x 4"h. The bell on the right has a hook handle. 2-1/4"d. x 4-1/4"h. $20-30 each.

Schott Zwiesel, AG

Mainz, 1872-

Schott has operated under various names and places from its founding in 1872 and has manufactured stemware intermittently since 1924. A few glass bells are known.

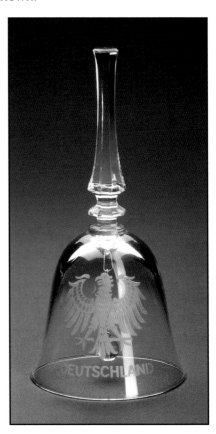

A clear Schott Crystal bell engraved with an eagle and "Deutschland." 3"d. x 6-3/4"h. $15-20.

Great Britain and Northern Ireland

In recent years there have been many changes in ownership and consolidation of glass companies in Great Britain and Northern Ireland, making it difficult to associate some glass bells at the time they were made with specific companies. In more recent years, some of the companies have subcontracted to have some glassware, including bells, made in Eastern Europe.

Caithness Glass Ltd.

Wick, Scotland, 1960-

Caithness has produced bells in clear colorless and colored engraved glass. The company has been known

for its paperweights since 1969. In July 2001, the parent company, Royal Doulton, sold its interest in Caithness Glass to Royal Worcester & Spode Ltd.

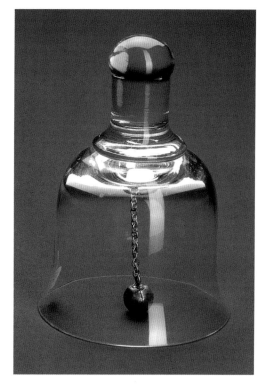

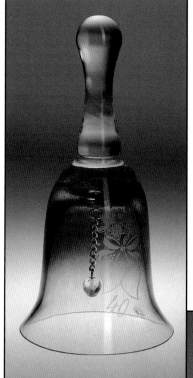

A Caithness ruby glass bell with clear colorless handle made for a fortieth wedding anniversary. 3-1/4"d. x 6-1/2"h. $35-45.

A Dartington clear glass bell with solid handle. 3-1/4"d. x 4-1/2"h. $30-35.

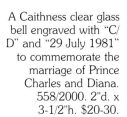

A Caithness clear glass bell engraved with "C/ D" and "29 July 1981" to commemorate the marriage of Prince Charles and Diana. 558/2000. 2"d. x 3-1/2"h. $20-30.

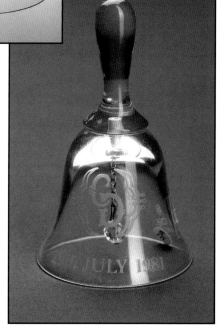

A clear glass Dartington bell issued for the Royal Wedding of Prince Charles and Diana, July 29, 1981. 4"d. x 5-3/4"h. $30-40.

Dartington Crystal Ltd.

Torrington, Devon, 1967-

Dartington is a primary glass manufacturer of many items, with some bells made. In 1982, Wedgwood acquired a half interest in the company, but gave it up when Wedgwood combined with Waterford in 1987.

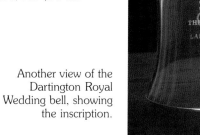

Another view of the Dartington Royal Wedding bell, showing the inscription.

Derwent Crystal Ltd.

Ashbourne, Derbyshire, 1980-

Derwent Crystal produces a variety of hand blown glassware including some bells.

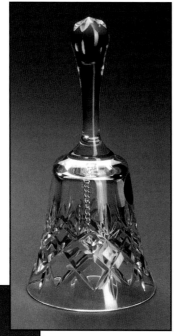

A Derwent Crystal bell cut with diamonds and fans. 3-1/4"d. x 6-3/4"h. $30-35.

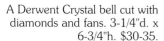

A Derwent Crystal bell cut with diamonds and fans and cut handle. 2-1/4"d. x 4-1/2"h. $25-30.

Edinburgh Crystal Glass Company Limited

Penicuik, Scotland, 1990-

The Edinburgh Crystal Glass Co. started in 1867 as the Edinburgh & Leith Glass Company. In 1921, it was acquired by Thomas Webb and Sons, Ltd., but continued to operate under its own name. The name was changed to the Edinburgh Crystal Glass Company in 1955. In 1964, Crown House Limited acquired the company and Thomas Webb and Sons. In 1987, both firms were incorporated into the Coloroll Group. In 1990, the company became independent as the Edinburgh Crystal Glass Company Limited. Presently, the company imports cut glass items from eastern Europe.

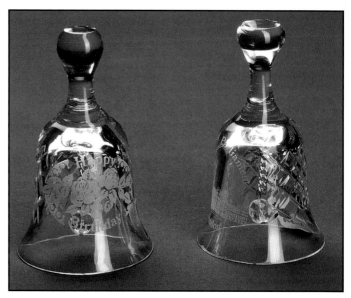

Two Edinburgh Crystal bells. The left bell is etched with roses and "Happy Birthday" and a cut diamond pattern on the other side. The bell on the right is etched with the Houses of Parliament and a cut diamond pattern on the other side. 2-1/4"d. x 3-3/4"h. $30-40 each.

Royal Doulton Crystal

Stourbridge, West Midlands, 1986-

In 1969, Royal Doulton acquired Webb Corbett Ltd. and the Webb Corbett name was not used after 1986. In 1996, Royal Doulton acquired Caithness Glass and sold it in 2001 to Royal Worcester and Spode Ltd.

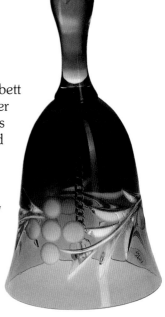

A Royal Doulton cranberry cut to clear bell made by their subsidiary firm, Webb Corbett. The clear handle has a top six-point star. 2-1/2"d. x 4-3/4"h. $25-35.

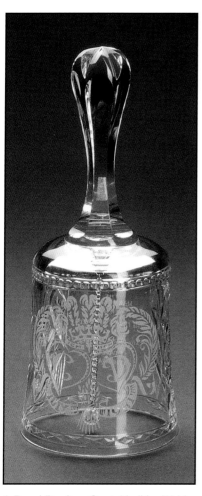

A Royal Doulton Crystal bell by Webb Corbett for the marriage of Prince Charles and Lady Diana Spencer, July 29, 1981. A commemorative inscription is etched on one panel, and on a reverse panel are etched two initialed hearts and the badge of the prince. 3-1/4"d. x 8"h. $60-70.

A Royal Doulton Crystal bell with cut diamonds and fans in a "Felicity Crystal" pattern. 2-1/2"d. x 5-1/2"h. $30-40.

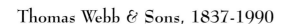

Thomas Webb & Sons, 1837-1990

Thomas Webb & Sons was one of the best known glass houses in England producing high quality types of glass items for over 150 years. In 1919, the firm formed Webb's Crystal Glass Company Limited to acquire the Dennis Glassworks and, in 1921, the Edinburgh & Leith

Flint Glass Company. (Later, it became The Edinburgh Crystal Company.) In 1964, Webb, together with the Edinburgh Crystal Company and Dema Glass Limited, became part of the group controlled by Crown House Limited. In 1987, they became part of the Coloroll Group and, in 1990, Thomas Webb & Sons closed upon the bankruptcy of the Coloroll Group.

Thomas Webb & Sons produced some Burmese glass bells under a license with the Mount Washington Glass Company, New Bedford, Massachusetts in the 1890s. See also the section on English wedding bells in Chapter Nine for more examples of Burmese glass bells.

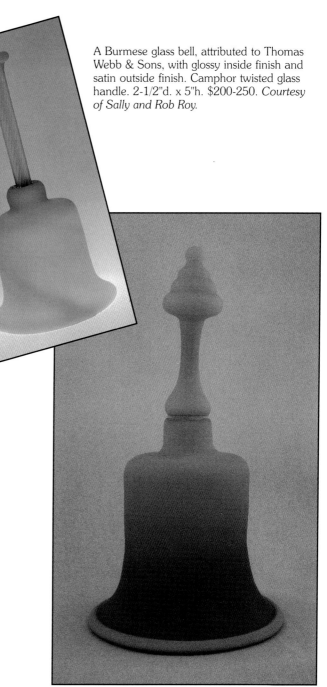

A Burmese glass bell, attributed to Thomas Webb & Sons, with glossy inside finish and satin outside finish. Camphor twisted glass handle. 2-1/2"d. x 5"h. $200-250. *Courtesy of Sally and Rob Roy.*

A Burmese glass bell in a satin finish attributed to Thomas Webb & Sons, 4 1/4"d. x 8"h. $500-1,000. *Courtesy of The Pecor Collection.*

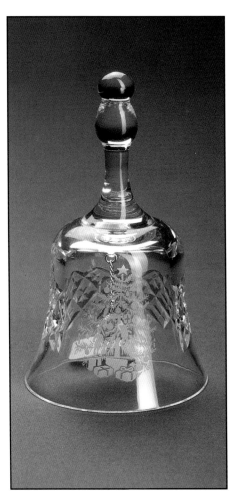

Tutbury Crystal Glass Ltd.
Tutbury, 1981-

Tutbury Crystal has an ownership history that has changed over many years. Thomas Webb and Corbett Ltd. acquired the Tutbury Glass Works in 1906. In 1969, the Royal Doulton Company acquired the Tutbury Glass Works, but Royal Doulton sold it in 1980 when their glassware division became Royal Doulton Crystal. Tutbury Crystal became an independent company in 1981.

A Burmese glass bell with yellow rim and clear glass handle with three yellow knops and three clear knops attributed to Thomas Webb & Sons. 4-1/2"d. x 10-1/2"h. $600-800. *Courtesy of MaryAnn and Don Livingston.*

A Webb clear glass bell with cross-cut diamonds and an etched Christmas tree. 2-1/2"d. x 4-1/2"h. $$40-50.

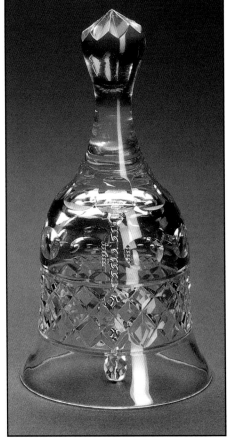

A Tutbury Crystal bell with a diamond and punty pattern and cut star at top of handle. 3"d. x 5-3/4"h. $25-35.

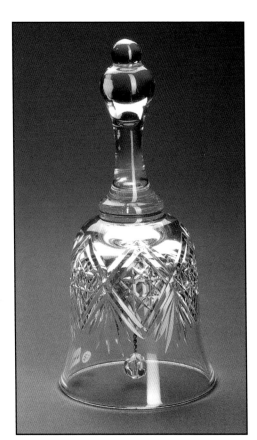

A Thomas Webb clear glass bell with an 8 point star and fan pattern. Signed "Webb England." 3-1/2"d. x 7-1/2"h. $60-70.

Tyrone Crystal Company

Killybrackey, Dungannon, Northern Ireland, 1971-2000

Since 1971, Tyrone Crystal has produced many kinds of cut glass products including bells. A 6" "Bronagh" bell and 4" "Bangor' and "Belfast" bells are known. Tipperary Crystal acquired the company in 2000.

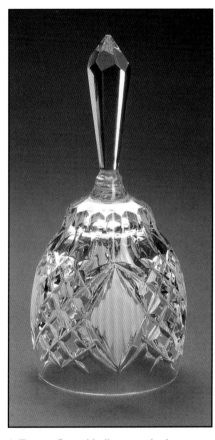

A Tyrone Crystal bell in a quilted diamond pattern with unpolished diamond insets and a hexagonal handle. 3"d. x 7-1/2"h. $25-35.

Webb Corbett Limited, 1953-1986

The company started in 1897 as Thomas Webb and Corbett Limited. They acquired the Tutbury Glass Works in 1906. The name was changed to Webb Corbett Limited in the 1953. In 1969, the Royal Doulton Company acquired Webb Corbett Limited and the Tutbury Glass Works. In 1980, the glassware became known as Royal Doulton Crystal by Webb Corbett, and the Tutbury Glass Works was closed. In 1986, the Webb Corbett name was discontinued and glassware was marketed as Royal Doulton Crystal.

Wedgwood Glass

King's Lynn, Norfolk, 1969-1982

Wedgwood Crystal Ltd., 1982-1988

The Wedgwood Group acquired King's Lynn Glass in 1969 and this division of Josiah Wedgwood & Sons, Ltd. became known as Wedgwood Glass. The company produced blown, cut, engraved, and etched glass bells including some in colored glass.

Glass bells, 6" high, in blue, amethyst, and topaz with clear colorless handles and mounted with Jasper cameos, are well known. Generally, the blue bells have white on light blue Jasper cameos; topaz bells have white on black jasper cameos. The following table provides further detail on the Wedgwood Glass Jasper cameo bells.

Year	Glass Color	Jasper Cameo	Jasper Color	No. Issued
1976	Topaz	George Washington	Black	750
1976	Amethyst	George Washington[1]	Royal Blue	750
1976	Smokey Blue	Olympic Torch Bearer[2]	Pale Blue	500
1976	Blue	Liberty Bell	Light Blue	1,000
1976	Amethyst	Stubbs Horse	Black	
1976	Blue	Stubbs Horse	Blue	
1976	Light Blue	"The Golden Hind" ship[3]	Light Blue	
1976	Topaz	"The Golden Hind" ship	Black	
1976	Blue	Shakespeare	Light Blue	
1977	Amethyst	Queen Elizabeth II[4]	Royal Blue	
1977	Amethyst	Queen Elizabeth II[5]	Lilac	750
1977	Smokey Blue	Queen Elizabeth II[6]	Royal Blue	175
1977	Amethyst	Queen Elizabeth II[7]	Lilac	250
1977	Blue	Cupid and Bow	Blue	

[1] Bicentennial

[2] 1976 Montreal Olympics; for sale in Canada only

[3] Ship of Sir Francis Drake; first English circumnavigation of the world. 1577-1580

[4] Silver Jubilee. 1952-1977

[5] Issued to John Sinclair store

[6] Silver Jubilee. issued to Harrods. Ltd.; royal cipher etched on flat top of handle.

[7] For Commonwealth countries. without etched cipher; to commemorate Royal visit to Australia.

Small tea bells were made to complement stemware in many patterns: Ashbourne, Bakewell, Balmoral, Buckingham, Denford, Matlock, and Windsor. Larger dinner bells were made in the Ashbourne and Denford patterns.

Plain 5-1/2" high Town Crier bells were made in smoky blue, amethyst, topaz, and green colors with clear colorless handles.

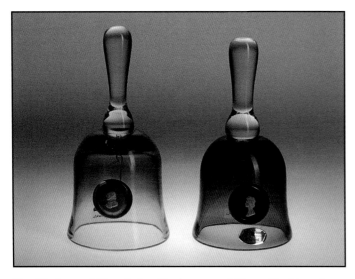

Two Wedgwood Glass bells with Jasper medallions. The blue glass bell has a white on blue Jasper medallion of Shakespeare. The amethyst glass bell has white on blue Jasper medallion of Queen Elizabeth II. 3"d. x 6-1/4"h. $100-125 each.

Three Royal Commemorative bells were also produced. These lead crystal bells were made for the Charles and Diana Royal Wedding and include a bell showing the Prince of Wale's ostrich feathers, a bell showing St. Paul's Cathedral, and an etched bell showing the Royal Wedding double portrait.

Other commemorative bells include a crystal one etched with the figure of Pope John Paul II, made to commemorate his May 1982 visit to Great Britain. Christmas bells, 4-1/2" high, were made in 1982 with holly leaves, and from 1983 to 1986 depicting the first four of the "Twelve Days of Christmas." Mother's Day bells were made from 1980 to 1982.

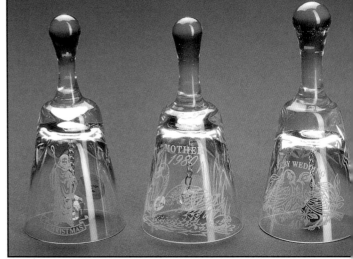

Three Wedgwood clear glass etched bells. The left bell was issued in 1979 and shows "Father Christmas" and cut stars. 2"d. x 3-3/4"h.; The center bell shows a swan and cygnets and "Mother 1980." 2"d. x 3-3/4"h. The bell on the right shows lovebirds, "Ruby Wedding," and "40" with a ruby colored clapper. 2"d. x 4"h. $30-40 each.

In 1974, Wedgwood Glass acquired the assets of the Irish Crystal Glass Company, Galway, Ireland, to form a new company called Galway Crystal Ltd., with Wedgwood having an 80% share. In 1978, this new company produced dinner bells in Burren, Killary, Roscam, and Shandon patterns, plus smaller tea bells in Burren and Roscam patterns.

In 1980, Wedgwood Glass sold its assets in Galway Crystal Ltd. and Galway continued under new ownership.

In 1982, Wedgwood Glass formed a holding Company with Dartington Crystal, of South West England, with the merged firm known as Wedgwood Crystal, Ltd.

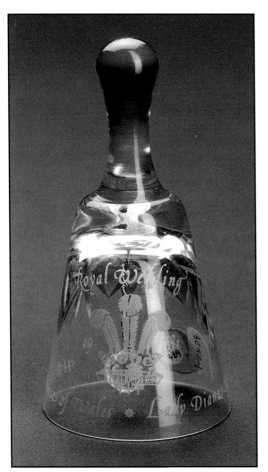

A Wedgwood glass bell issued for the Prince of Wales and Lady Diana Royal Wedding. 2"d. x 4"h. $40-50.

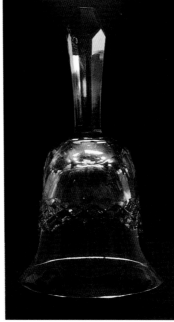

A Wedgwood glass bell by Galway Crystal in the "Killary" pattern, c.1978. 3-1/4"d. x 5-1/2"h. $20-30.

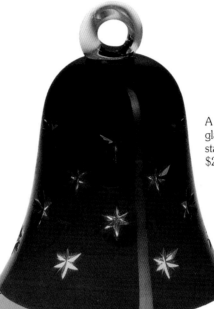

Hungary

Several Hungarian companies have produced glass items including bells.

Wedgwood glass bells made of amber glass, 4"d. x 6"h., and green glass, 4"d. x 4-3/4"h. $40-60 each.

A Hungarian flashed red glass bell with cut to clear stars. 2-1/4"d. x 3"h. $20-25.

William Comyns & Sons, Ltd.

London, 1858-1987

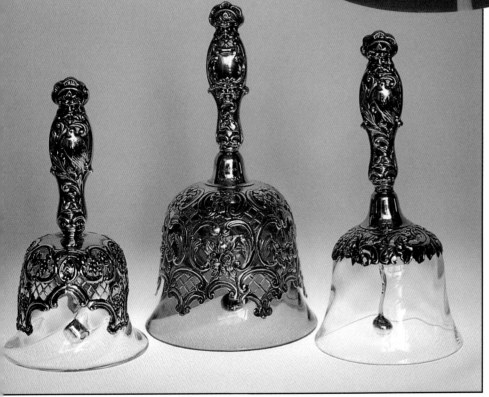

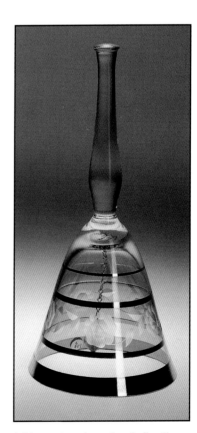

The silver on these three bells was made by William Comyns, while the glass was made by one of the English firms known to have supplied glass to Comyns: J. W. Walsh; Webb Corbett; Powell of London; Stuart; and Stevens and Williams. All the bells are hallmarked with a lion head for London, a standing lion for Sterling, and WC for William Comyns. The bell on the right, 3-3/4"d. x 7"h., is hallmarked in three places (ferrule beneath the handle, clapper, and drape) for 1894. There is also an English Registry Number 221454 for 1893. The middle bell, 3-1/4"d. x 6-1/4"h., also is hallmarked in three places for 1901. The bell on the left, 3"d. x 5-1/2"h., is hallmarked for 1903 on the drape and the clapper. All handles thread through the glass into the clapper. $600-700 for each side bell and $800-1,000 for the center bell. *Courtesy of Sally and Rob Roy.*

A Hungarian clear glass bell with etched roses and gold bands. 3-1/4"d. x 7"h. $20-25.

121

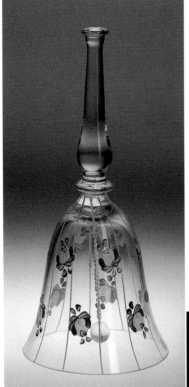

Ireland

There are several glass companies in Ireland that have produced glass items including bells.

A Hungarian clear glass bell with painted vertical stripes and flowers. 3-1/4"d. x 7-1/4"h. $20-25.

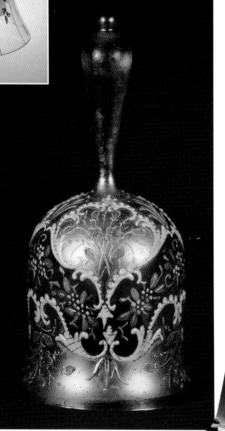

A glass bell washed in gold decoration with small jeweled flowers, attributed to Hungary. 4"d. x 6-1/2"h. $250-300. *Courtesy of the late Dorothy Malone Anthony.*

A clear glass bell with engraved floral design and an air twist handle with two knops. The label says "Failte" and "Full lead crystal handcut in Ireland." 3-1/2"d. x 6-3/4"h. $30-40. *Courtesy of Carol and Bob Rotgers.*

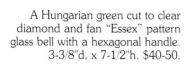

A Hungarian green cut to clear diamond and fan "Essex" pattern glass bell with a hexagonal handle. 3-3/8"d. x 7-1/2"h. $40-50.

Duiske Irish Cut Glass Ltd.

Graiguenamanagh, County Kilkenny, 1974-

Duiske crystal items are produced in various cut patterns, including some bells.

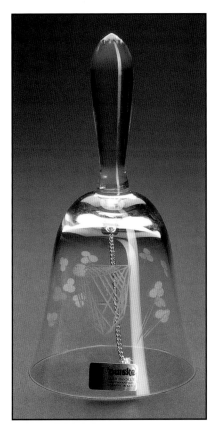

A Duiske glass bell with etched shamrocks and a shield. 3-1/4"d. x 6-3/4"h. $25-30.

A Galway Crystal bell with two bands of diamond pattern and frosted shoulder, signed at top of the handle. 3"d. x 6-3/4"h. $20-25.

Tipperary Crystal

Dublin, 1988-

Tipperary Crystal was started by Waterford Crystal craftsmen. The company has produced many cut glass items, including heavy crystal bells. In 2000, the company acquired Tyrone Crystal of Northern Ireland.

Galway Irish Crystal

Galway, 1980-

Galway produced bells in several patterns, some in two sizes: "Leah," "Galway," "Marriage," and "Claddagh."

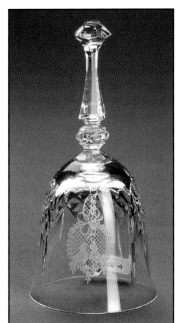
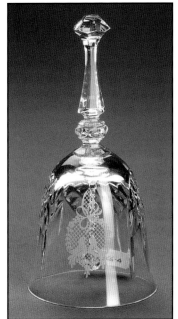

A Galway Crystal bell with etched doves and cut diamonds. 2-3/4"d. x 5-1/2"h. $35-40.

A Tipperary crystal bell in a diamond pattern with a hexagonal pattern handle. 2-3/4"d. x 6"h. $30-40.

Waterford Crystal Ltd.

Kilbarry, Waterford, 1947-

Many bells have been produced by Waterford since its beginning in 1947. Most bells are cut on a heavy crystal blank. The bells shown are two of many produced by the company.

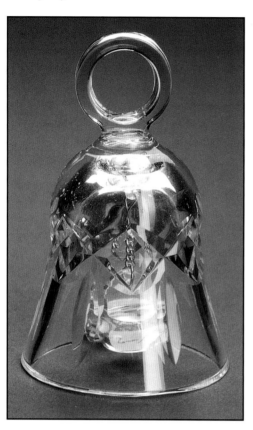

A Waterford Crystal bell with a diamond cut pattern and ring handle. 2-1/4"d. x 3-1/4"h. $45-55.

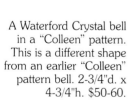

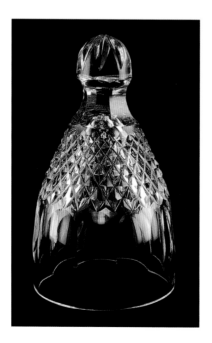

A Waterford Crystal bell in a "Colleen" pattern. This is a different shape from an earlier "Colleen" pattern bell. 2-3/4"d. x 4-3/4"h. $50-60.

Italy

Many glass bells have been made in Italy, some with paper labels listing the island of Murano as the origin.

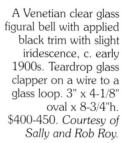

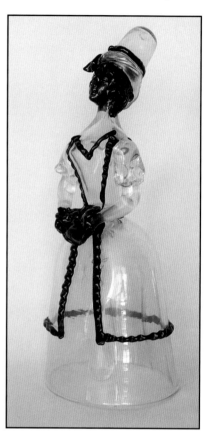

A Venetian clear glass figural bell with applied black trim with slight iridescence, c. early 1900s. Teardrop glass clapper on a wire to a glass loop. 3" x 4-1/8" oval x 8-3/4"h. $400-450. *Courtesy of Sally and Rob Roy.*

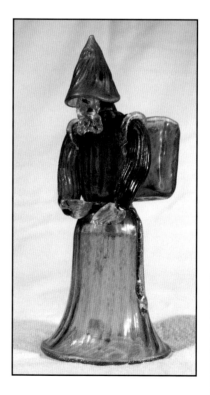

A Venetian mauve glass bell in the shape of a monk with golden beard, hands, belt, and straps. Clear glass clapper on a wire. This may have been a figurine converted to a bell. 3-1/4"d. x 8"h. $100-175. *Courtesy of Barbara Wright.*

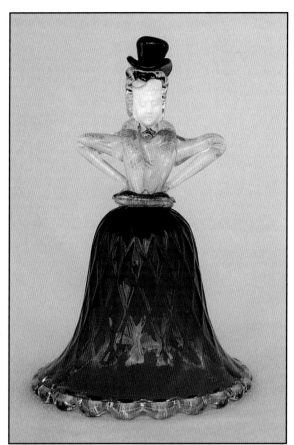

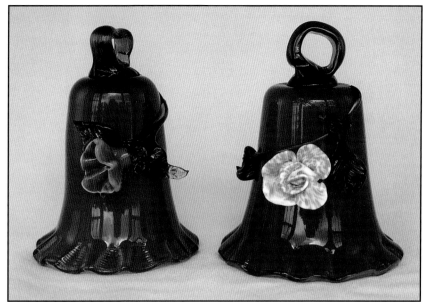

A pair of glass bells with applied flowers and leaves and scalloped rims. 4"d. x 5-3/4"h. and 4-1/2"d. x 6"h. $100-125 each. *Courtesy of MaryAnn and Don Livingston.*

A diamond pattern cranberry bell with clear ruffled rim and handle shaped as a body with clear glass folded arms, a face of milk glass, and a cranberry hat. The clear glass has some gold speckles. 4"d. x 6"h. $200-300. *Courtesy of MaryAnn and Don Livingston.*

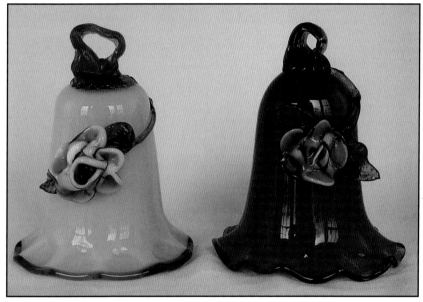

A pair of glass bells with applied flowers and scalloped rims. 4-1/2"d. x 5-1/2"h. $100-125 each. *Courtesy of MaryAnn and Don Livingston.*

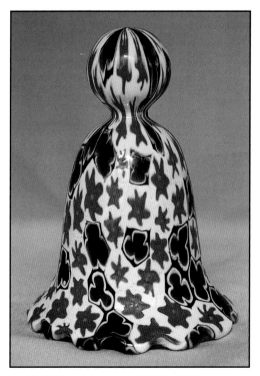

A red and purple on white millefiore bell. 4"d. x 5-1/2"h. $75-100. *Courtesy of MaryAnn and Don Livingston.*

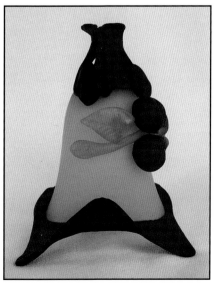

A blue satin glass bell with applied fruit and red three-way support and handle. 4-1/2"d. x 6"h. $90-125. *Courtesy of MaryAnn and Don Livingston.*

125

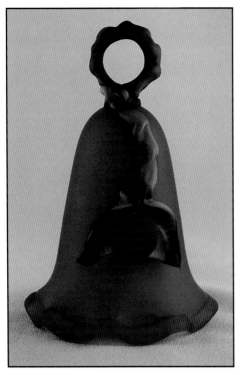

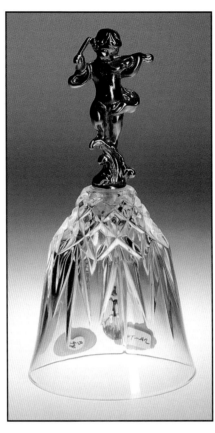

A clear glass bell with diamond and fan pressed pattern and gold finish metal handle of a boy playing a violin. 3"d. x 6-1/4"h. $30-40.

A blue satin glass bell with gold scalloped rim and applied cherry. 4"d. x 5-3/4"h. $70-90. *Courtesy of Alvin and Arlene Bargerstock.*

A pink and blue latticino glass bell with gold flecked swan handle. 3-3/4"d. x 6-1/4"h. $120-140.

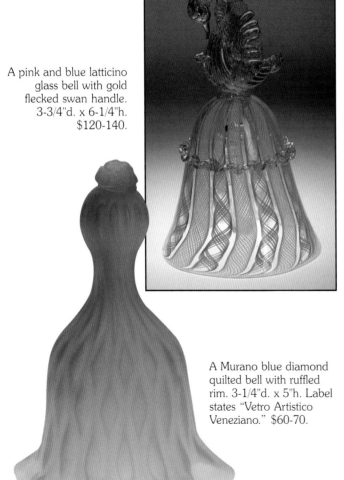

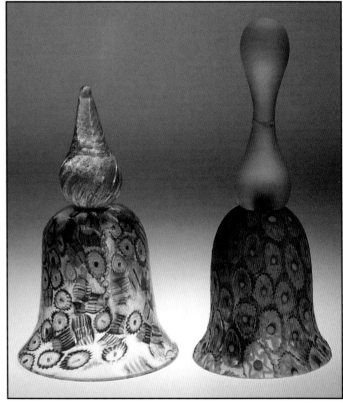

A Murano blue diamond quilted bell with ruffled rim. 3-1/4"d. x 5"h. Label states "Vetro Artistico Veneziano." $60-70.

Two millefiore bells. The left bell has red, white, and blue canes and a conical winding gold-flecked handle. 3-1/4"d. x 5-1/2"h. The bell on the right has yellow canes with a frosted handle. 2-3/4"d. x 6-3/4"h. $60-80 each.

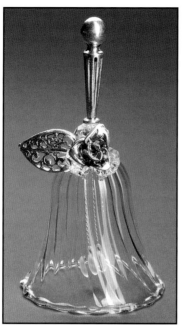

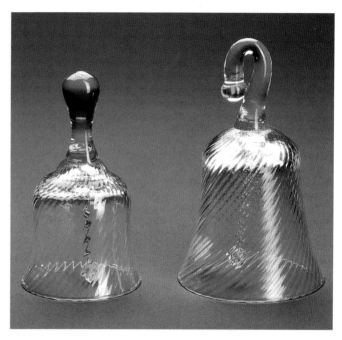

An opalescent glass bell with gold flecked handle and teardrop clapper. 3"d. x 5-1/2"h. $90-100.

A swirled pattern glass bell with pewter handle, silver flower and leaf, and Swarovski crystal attachment, assembled by Carlucci Crystal. 2-3/4"d. x 5-1/4"h. $30-40.

Two clear glass bells with a swirl pattern. The bell on the left measures 2-1/2"d. x 4-1/2"h. and is c.1980. $20-30. The bell on the right has a clear hook handle, measures 3-1/2"d. x 5"h. and is c.1984. Made by Cristallerie Antonio Imperatore, known for making Disney figurines. $30-40 each.

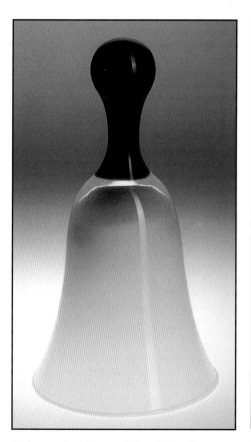

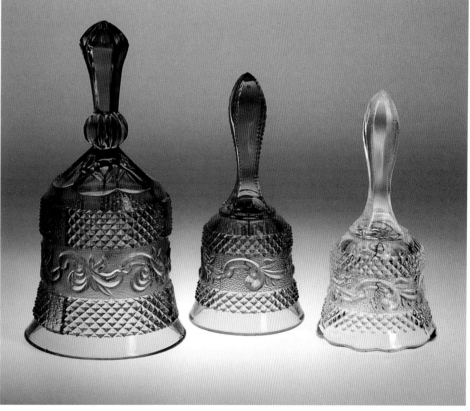

A clear and white cased glass bell with a brown handle. 3-1/2"d. x 6-1/4"h. $40-50.

Three molded bells in amber and clear colorless glass. A 4"d. x 7-1/2"h. bell on the left and two 3"d. x 6"h. bells on the right. $15-25 each.

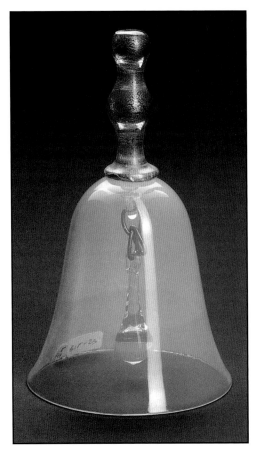

A millefiore angel bell with gold flecked clear glass arms and halo. 2-1/4"d. x 5-1/4"h. $60-70.

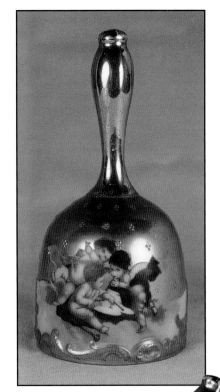

A Florentine gold washed glass bell with cherub prints, possibly nineteenth century. 2-3/4"d. x 5-1/2"h. $130-150.

An opalescent glass bell with gold flecked handle and teardrop clapper. 3"d. x 5-3/4"h. $80-90.

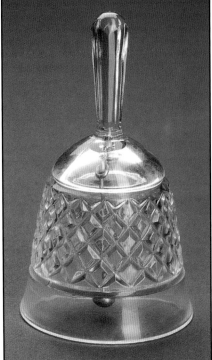

A clear glass bell with pressed diamond pattern. 2-1/4"d. x 4"h. c.1974. $20-25.

The other side of the Florentine bell.

A millefiore bell with frosted rabbit handle. 2"d. x 5-1/2"h. $50-60.

Colle SRL

Siena, Colle Val d'Elsa, 1968-

Some bells have been made in the area around Colle Val d'Elsa, south of Florence. Colle SRL, a subsidiary of the Bormioli Rocco Group, produces many kinds of glassware including some small bells. The labels on the bells, showing a red triangle and COLLE, identify their Crystaldesign® Hill brand.

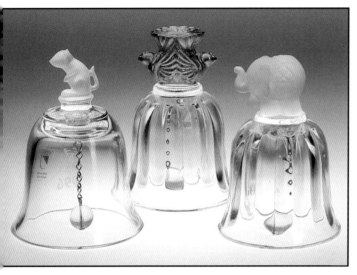

Three Colle bells with animal handles. The left bell with a frosted rat handle was produced for the Year of the Rat, 1996. The center bell has amber lovebirds as a handle. The bell on the right has a frosted elephant handle. 2-1/4"d. x 3-1/4"h. $25-35 each.

Cre.Art SRL

Martignana, Empoli, 1973-

Cre.Art produces cut and decorative glassware, sometimes with gold or silver overlay. Several bells are known.

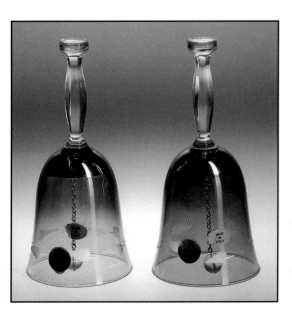

Two Cre.Art bells in green and red with etched leaves and 24k gold shoulders. 2-1/2"d. x 5-1/2"h. $30-40 each.

Mario Cioni & C.

Capraia, 1958-

Mario Cioni is well known for its crystal products, but few bells have been made.

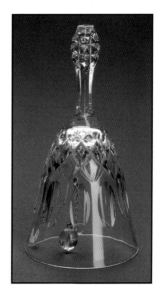

A Mario Cioni clear glass bell with a diamond and oval pattern and a hexagonal handle. 2-3/4"d. x 5-1/4"h. $20-25.

Liechtenstein

Some glass bells have been made with "Liechtenstein" engraved or cut on the bell. The author presently does not know if they were produced in Liechtenstein or made in another country and sold as souvenirs in Liechtenstein.

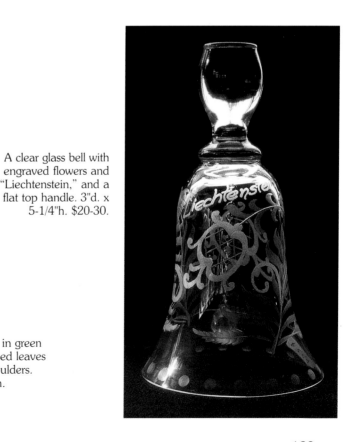

A clear glass bell with engraved flowers and "Liechtenstein," and a flat top handle. 3"d. x 5-1/4"h. $20-30.

Netherlands

Royal Leerdam

Leerdam, 1953-

Royal Leerdam started making transparent and colored glass in 1876 as the United Glassworks Leerdam. Upon celebrating its seventy-fifth anniversary in 1953, the honorary title of Royal was bestowed and the name was changed to Royal Leerdam.

Between 1944 and 1986, the chief designer was Floris Meydam. In 1948, he designed the bell shown for the Society for Publicity.

In 2002, Royal Leerdam was acquired by Libbey, Inc.

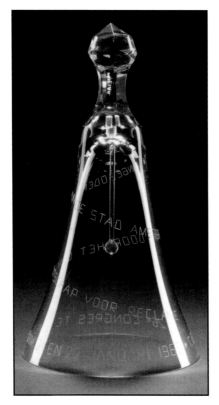

A clear glass Royal Leerdam bell designed by Floris Meydam. It has a faceted knob handle and glass clapper. The translated inscription around the body reads "Offered to the City of Amsterdam by the Society of Publicity." Around the rim is inscribed "On the occasion of the 26th Congress in Amsterdam, 21st and 22nd of January, 1965." 4-3/8"d. x 6-7/8"h. *Courtesy of the Amsterdams Historisch Museum.*

Norway

Magnor Glassworks

Magnor, 1896-

The Magnor Glassworks is close to the border with Sweden and the company is affiliated with the Swedish Johansfors Glasbruk.

A Magnor Glassworks "Bonderoser" glass bell with multi-color floral decoration, gold rim, and three knop handle. 3-1/4"d. x 6-1/2"h. $80-90.

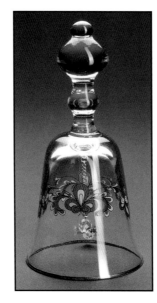

Poland

Several companies in Poland are producing glass bells under their own name for companies in Western Europe.

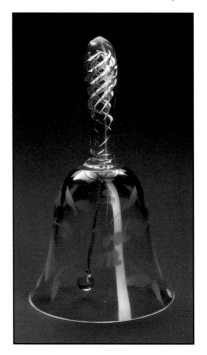

A clear glass bell etched with berries and leaves and "Noel 1972" with an air twist handle. 4-1/2"d. x 8-1/4"h. $20-30.

Krosno S. A.

Krosno, 1923-

Krosno manufactures technological and table glassware and has produced several bells in blown and pressed glass.

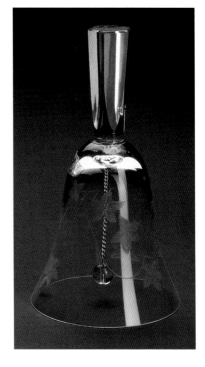

A clear glass Krosno bell engraved with a vintage pattern. 3-3/4"d. x 7"h. $20-30.

Violetta Crystal Glassworks, Ltd.

Stronie Slaskie, 1864-

The Violetta Crystal glass factory is the largest manufacturer of glassware in Poland. The company has blown glassware for other companies, including Waterford. Several glass bells have been produced.

Portugal

Since the 1960s, clear colored glass bells with air twist handles and cut glass bells have been produced in Portugal.

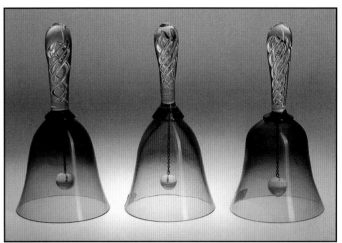

Three bells with air twist handles in green, amber, and blue glass. 3"d. x 6-1/4"h. $20-30 each. *Courtesy of John and Charmel Trinidad.*

Atlantis S. A.

Alcobaça, 1997-

This company was founded in 1944 under the name Crisal-Cristais de Alcobaça to produce chandeliers. It has since branched out to produce many kinds of crystal and glass, including a few bells.

The company is a division of Salton, Inc., as is Block China and Crystal.

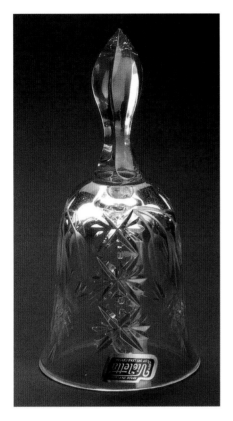

A Violetta clear glass bell with cut stars and roses and a hexagonal handle. 3"d. x 6-1/4"h. $20-30.

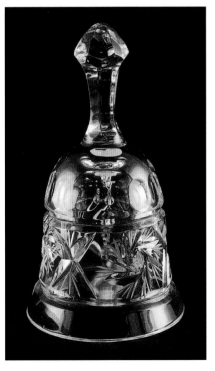

A Violetta clear glass bell with pinwheel, fans, and punties. 2-1/2"d. x 4-1/2"h. $20-30.

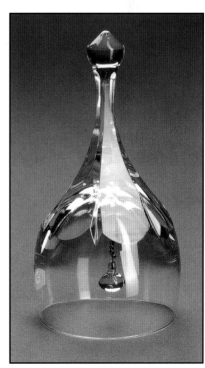

A clear glass Atlantis bell hand cut for Block Crystal. Hexagonal handle facets carry down onto the shoulder. 2-3/4"d. x 5-3/4"h. $20-30.

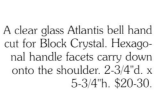

A clear glass Atlantis bell cut for Block Crystal. Hexagonal handle and diamond pattern. 3"d. x 5-3/4"h. $20-30.

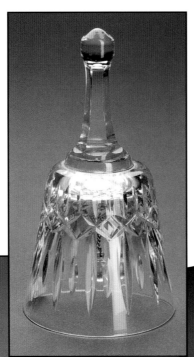

A Romanian clear glass bell with a swirled satin glass spiral handle. 3-1/4"d. x 7-1/2"h. Made by Padurea Neagra. $20-30.

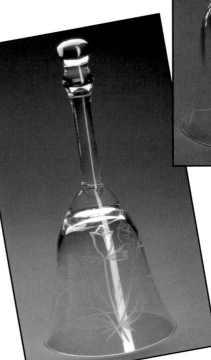

A clear glass Atlantis diamond pattern bell cut for Block Crystal. 1-1/2"d. x 3-3/4"h. $20-30.

A Romanian clear glass bell with etched flowers and a clear two knop handle. 4-1/4"d. x 9-1/2"h. $20-25.

Romania

Several Romanian companies have produced glass items including bells.

A Romanian clear glass bell with engraved flowers and a handle with two knops at the base. 3-1/2"d. x 7-1/4"h. $20-25.

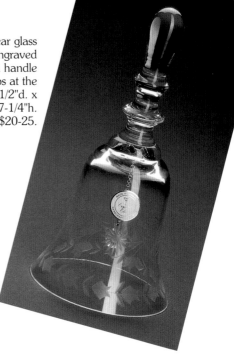

A Romanian multi-colored panels bell. 3"d. x 6-1/2"h. $25-35.

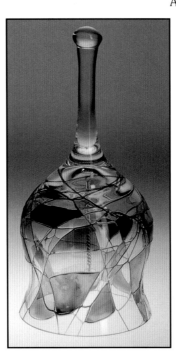

Slovenia

Rogaska Glassworks

Rogaska Slatina, 1927-

The Rogaska Glassworks has been noted for fine glass for many years, including some blown and cut glass bells. The company is licensed to produce some glassware for Waterford.

A clear glass bell with a diamond pattern and etched flowers and a ring handle from Rogaska Glassworks. 2"d. x 2-3/4"h. $20-25.

A blue threaded glass bell attributed to Spain. 3-1/4"d. x 7-1/4"h. $200-350.

Sweden

Mantorp Glassworks

Mantorp, 1969-

The Mantorp Glassworks is one of seven glassworks in the Småland area of Sweden. A few bells are made.

Spain

Very few glass bells are attributed to Spain. Some were found at the Spanish Pavilion at the 1964-65 New York World's Fair and are attributed to a Spanish manufacturer.

An amber threaded bell attributed to Spain, as similar bells were sold in the Spanish Pavilion at the 1964-65 New York Worlds Fair. 4"d. x 8"h. $100-200. *Courtesy of Barbara Wright.*

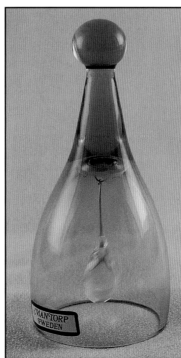

A Mantorp peach colored clear glass bell. 1-5/8"d. x 3-5/8"h. $25-35.

133

Orrefors Kosta Boda

Orrefors, 1990-

The Kosta Glassworks, established in 1742, merged with the Boda Glassworks and Afors Glasbruk to form Kosta-Boda. These companies, together with Johansfors, became part of the Afors Group in 1970, the largest glass producing company in Sweden. Orrefors, Kosta, and Boda joined together in 1990. A few glass bells are known to have been made during recent years.

Yugoslavia

Several Yugoslavian companies produce glass items and some have produced bells. Some bells were produced in Slovenia, a province of Yugoslavia before it became an independent country (see page 133).

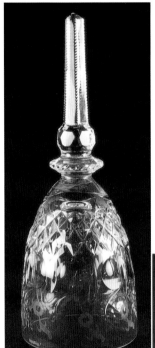

A Yugoslavian clear glass bell cut in a "Gallia" pattern with a hexagonal handle, made by Rogaska and signed. 2-3/4"d. x 7-1/4"h. $20-30.

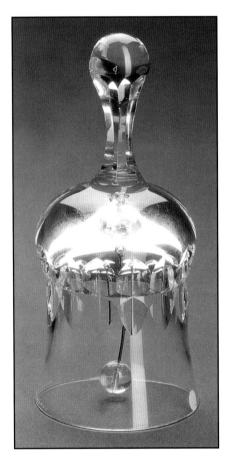

A clear bell with a cut double row of diamonds and a hexagonal handle with rounded top. Signed "Kosta 96/89." Designed by Ana Wärff. 2-1/2"d. x 6"h. $40-50.

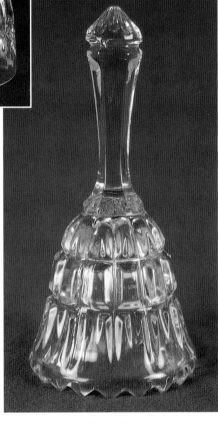

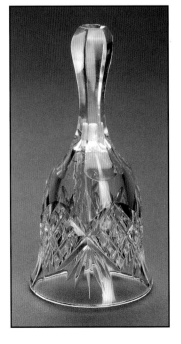

A clear glass bell with a strawberry diamond and fan pattern. The hexagonal handle has a flat top signed "Boda." 2-3/4"d. x 5-1/2"h. $30-40.

A Yugoslavian bell in a "Vienna" pattern #330102, produced for Crystal Clear Industries. 2-1/2"d. x 5-1/4"h. $15-20.

European Glass Bells
of Unknown Origin

Some bells have come from Europe with no attribution of manufacturer known at this time.

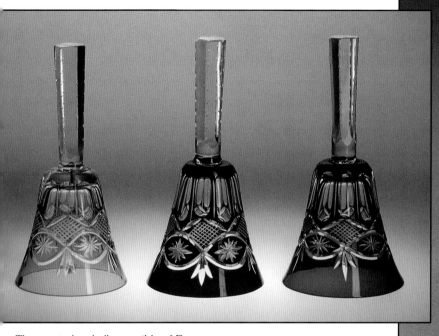

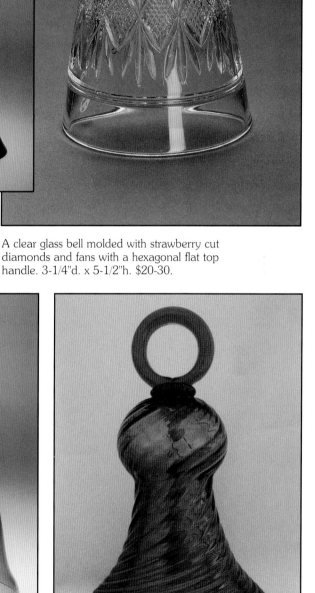

Three cut glass bells, possibly of European origin. 3-3/4"d. x 7-1/2"h. $25-40.

A clear glass bell molded with strawberry cut diamonds and fans with a hexagonal flat top handle. 3-1/4"d. x 5-1/2"h. $20-30.

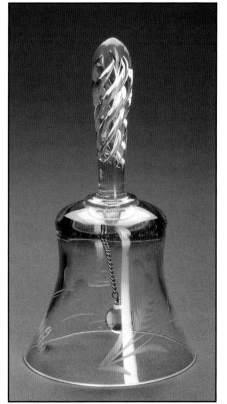

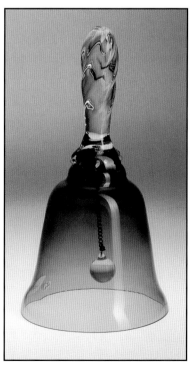

A clear glass bell with engraved berries and an air twist handle. 3-1/4"d. x 6-1/4"h. $20-25.

A clear green glass bell with a clear colorless twisted handle. 3-1/2"d. x 6"h. $20-25.

A golden color swirled pattern glass bell with a ring handle and teardrop clapper of unknown origin. 4-1/2"d. x 8"h. $77-100.

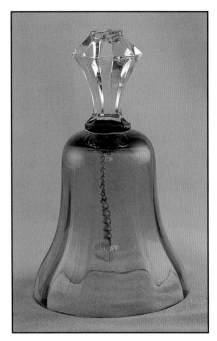

A green glass bell with a clear, cross shaped cut handle, 3-1/2"d. x 5-3/4"h. $75-100. *Courtesy of Alvin and Arlene Bargerstock.*

A clear glass bell with floral decoration, 4"d. x 6-3/4"h. $125-150. *Courtesy of Alvin and Arlene Bargerstock.*

Two amber blown glass bells with similar gold floral decoration and clear colorless air twist handles. 3"d. x 6-1/4"h. $40-50; and 4-1/4"d. x 8"h. $80-90.

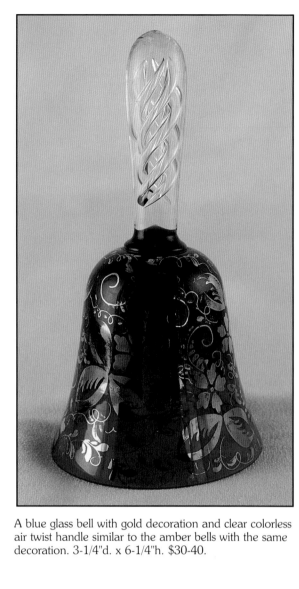

A blue glass bell with gold decoration and clear colorless air twist handle similar to the amber bells with the same decoration. 3-1/4"d. x 6-1/4"h. $30-40.

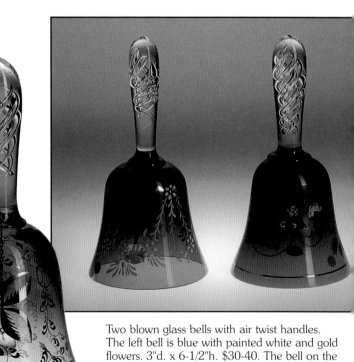

Two blown glass bells with air twist handles. The left bell is blue with painted white and gold flowers. 3"d. x 6-1/2"h. $30-40. The bell on the right is of cased amethyst over white glass with painted flowers. 3-1/4"d. x 6-1/4"h. $50-60.

136

A clear glass bell with multifaceted cut shoulder and handle. 2-1/2"d. x 5"h. $80-90.

A clear glass bell with a cross-cut diamond and fan pattern and air twist handle. 3-1/4"d. x 6-1/4"h. $30-40. *Courtesy of John and Charmel Trinidad.*

Glass Bells of Other Countries

China

Not many glass bells from China are known to the author. A relatively new bell is known with a reverse painted scene on the inside of the glass.

A Chinese frosted glass bell with reverse painted scene and gold colored metal shoulder. 2-1/4"d. x 5-1/4"h. $30-40.

Egypt

Trejour Company

Cairo, 1990s

Trejour has produced scent flasks, vases, and ornaments of Pyrex glass for many years and periodically some bells.

Two Trejour Company blown molded glass bells made of German Pyrex and decorated in gold. The bell on the left is 2-1/2"d. x 7-1/2"h.; the bell on the right is 2-1/2"d. x 5"h. $35-45 each.

Japan

Sasaki Crystal, Inc.

Several Sasaki bells are known to collectors.

A clear glass Sasaki bell with a gold band along the rim and shoulder and a hexagonal handle. 3-3/4"d. x 7-3/4"h. $20-30.

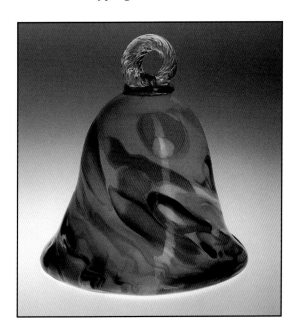

Venezuela

ICET Art Murano

Potrerito, 1950s-

Some glass bells are known that were made by Murano craftsmen who migrated to Venezuela in the 1950s and formed a company there to produce Murano type glass.

An ICET Murano multi-colored cased glass over milk glass bell with twisted ring clear glass handle and teardrop clear glass clapper. 4"d. x 4-1/2"h. $60-70.

A Sasaki clear glass bell with a frosted glass bird handle, c.1978. 3-3/4"d. x 5-1/2"h. $30-40. *Courtesy of Carol and Bob Rotgers.*

United Soviet Socialist Republics

The author is aware of very few glass bells made in the U.S.S.R.

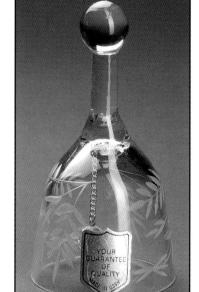

A clear glass bell with engraved leaflets and round handle, made in the U.S.S.R. 2-1/2"d. x 4-1/2"h. $20-25.

References

Peffer, Becky. "French Flint Glass Bells." *The Bell Tower Supplement.* Eight pages.

Lange, Anselm. *Europäische Tischglocken.* Hannover, Minner-Verlag, 1981.

Tobin, Susan. *Wedgwood Glass.* Queensland, Australia: Fergies, Hamilton, 2001.

Trinidad, A. A. Jr. "Val St. Lambert Bells." *The Bell Tower* 51, no. 4 (July-August 1993): 14-18.

———. "Ask a Question - Get an Answer." *The Bell Tower* 53, no. 2 (March-April 1995): 13.

Wedding Bells

"Wedding bell" is a term that has been used generally by bell collectors for relatively large, blown glass bells, primarily of English origin, made in two parts and joined together by plaster of paris. From the mid eighteenth century to the early twentieth century (when most of these bells were made), they were sometimes given as wedding presents. Sometimes a pair, known as lady and gentleman bells, was given. Clappers were usually of a glass teardrop variety, in clear glass or various colors, attached to a stiff U-shaped wire imbedded in the plaster. Because most clappers were attached loosely, many bells today have no clappers or have replacements. The tops of the handles usually end with a finial of one to seven graduated balls or layers of glass known as knops. The knops are sometimes colored to match or complement the color of the bell.

English Wedding Bells

In England in 1745, an excise tax was imposed that was based on the weight of the glass and the weight of its ingredients. This tax was increased gradually, so that light, blown glass articles were popular, while heavier, lead glass articles could be afforded only by the affluent. Because of this tax, the output of glass bells was greatest between 1820 and 1850, when the demand for light weight, blown colored glass was at its peak. Many of the bells were produced by glass blowers in companies that made window glass and bottles. The tax was repealed in 1845 and some heavier glass bells were made thereafter. The bells gradually were produced commercially by glass houses in England through the end of the nineteenth century.

The earlier bells were known as "friggers," because they were thought to have been produced by glass workers on their own time using glass remaining in the pots at the end of the workday. A Newcastle, England newspaper in 1830 reported a procession of the Guild of Glassmakers carrying their wares through the streets of the city. It said, "Some carried a glass bell which they rang lustily."

The earliest English bells were made between 1750 and 1850. Although two English towns are associated with these bells, they are known primarily for the window glass and colored glass bottles they produced. The town of Nailsea had the Nailsea Glassworks for eighty-five years, from 1788 to 1873, and nearby Bristol had about fifteen glass houses, primarily between 1750 and 1850.

A characteristic of Nailsea glass is latticinio type loops, colored or white, distributed on clear or colored glass in a lace-like effect. Today, any glass with these loops is known as Nailsea type glass. Similar loops, making a herringbone decoration, are sometimes known as Northwood pull-ups because John Northwood, an English glassmaker, c.1880, invented a machine to make this decoration in glassware by pulling glass threads embedded in a molten glass object.

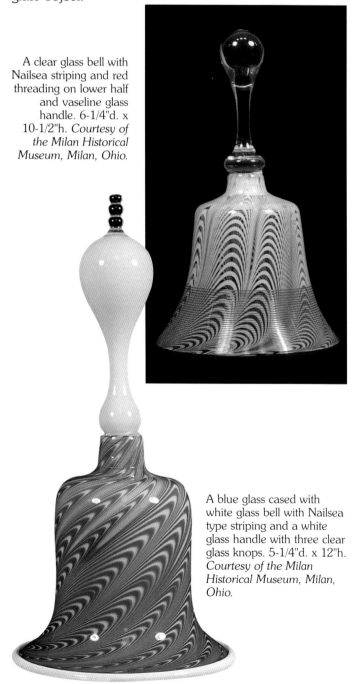

A clear glass bell with Nailsea striping and red threading on lower half and vaseline glass handle. 6-1/4"d. x 10-1/2"h. *Courtesy of the Milan Historical Museum, Milan, Ohio.*

A blue glass cased with white glass bell with Nailsea type striping and a white glass handle with three clear glass knops. 5-1/4"d. x 12"h. *Courtesy of the Milan Historical Museum, Milan, Ohio.*

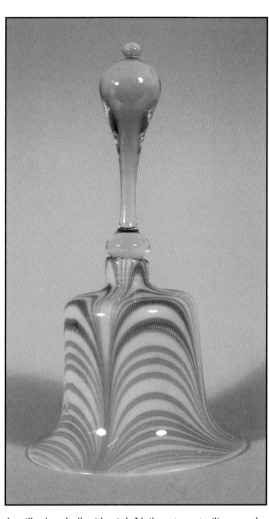

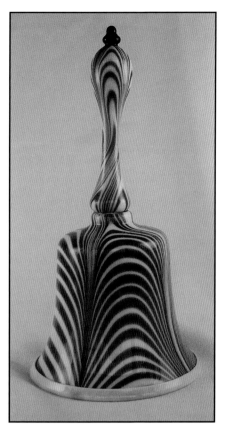

A milk glass bell with red Nailsea type striping, white rim, and milk glass handle with blue striping and two knops. 4-3/4"d. x 9-1/4"h. $400-500. *Courtesy of MaryAnn and Don Livingston.*

A milk glass bell with pink Nailsea type trailings and clear glass one knop handle. 5-3/4"d. x 10"h. *Courtesy of the Bristol Museums and Art Gallery.*

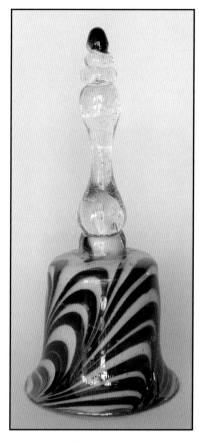

A white glass bell with mauve colored Nailsea type striping. Colorless handle has three knops, the top one colored mauve. 3-5/8"d. x 8"h. $300-400. *Courtesy of Sally and Rob Roy.*

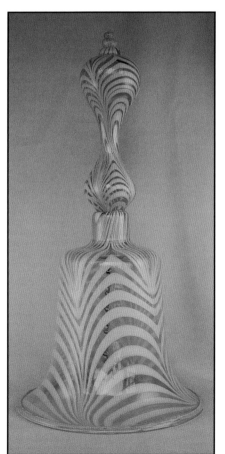

A clear glass bell with aqua Nailsea type striping on the entire bell including the hollow three knop handle. 7-1/2"d. x 14-1/2"h. $600-700. *Courtesy of MaryAnn and Don Livingston.*

A cranberry glass bell with white Nailsea type striping and clear colorless glass three knop handle with white and cranberry striping. 5"d. x 10-1/2"h. $300-400. *Courtesy of Barbara Wright.*

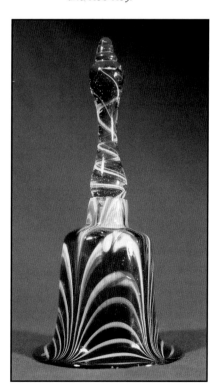

141

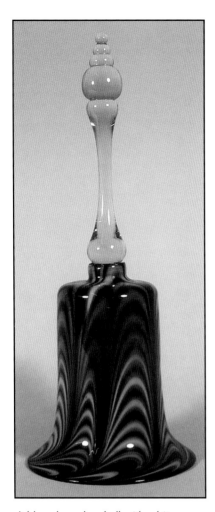

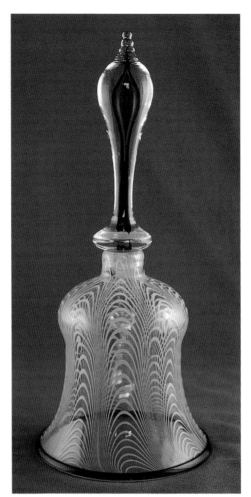

A clear glass bell with white Nailsea looping and ruby rim and a clear glass handle with ruby bubble and four knops, 4-1/4"d. x 9-3/4"h. $800-900. *Courtesy of Alvin and Arlene Bargerstock.*

A blue clear glass bell with white Nailsea type trailings and clear three knop handle. 5"d. x 12-1/4"h. *Courtesy of the Bristol Museums and Art Gallery.*

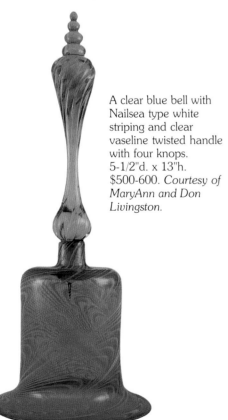

A clear blue bell with Nailsea type white striping and clear vaseline twisted handle with four knops. 5-1/2"d. x 13"h. $500-600. *Courtesy of MaryAnn and Don Livingston.*

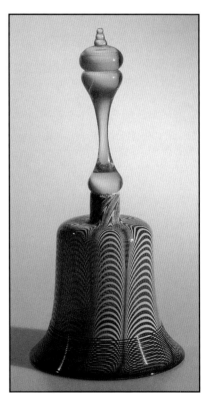

A ruby glass bell with white Nailsea type striping and red trailing along the rim. The clear colorless glass handle has three knops. 5 1/4"d. x 10-5/8"h. *Courtesy of the Chrysler Museum of Art, Norfolk, Virginia. Gift of Walter P. Chrysler, Jr. Photo by Scott Wolff.*

A clear glass bell with white Nailsea type striping, red rim, and clear one knop handle. 4-1/2"d. x 10-3/4"h. $300-400.

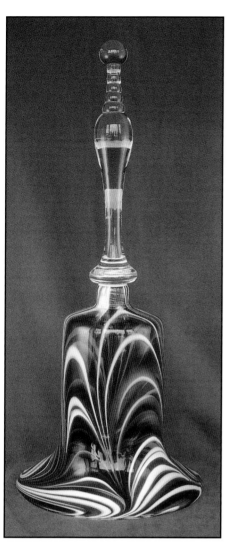

A multi-paneled ruby glass bell with a hollow clear glass handle with Nailsea type striping and three knops. 7"d. x 13-1/2"h. $700-800. *Courtesy of Bruce Millstead.*

A swirled green glass bell with white Nailsea type decoration on a hollow three knop handle. 5-3/4"d. x 11-1/2"h. $300-400. *Courtesy of Sally and Rob Roy.*

A cranberry glass bell with Nailsea type striping and a clear six knop handle. 6-3/4"d. x 15"h. $400-500. *Courtesy of MaryAnn and Don Livingston.*

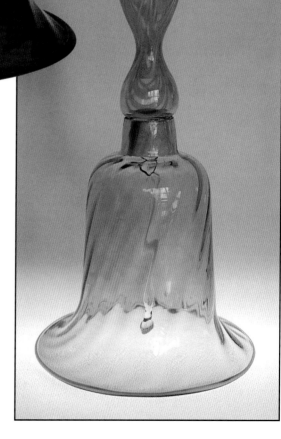

A clear teal bell with white Nailsea striping and clear three knop handle with imbedded teal ribbon. 5"d. x 10"h. $300-400. *Courtesy of MaryAnn and Don Livingston.*

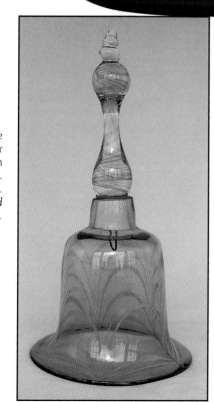

Bristol glass houses produced articles in many colors, but their most famous was Bristol Blue, a dark clear royal blue that was popular in the second half of the eighteenth century. They were also known for a ruby red and an opaque white glass. Bells with a diamond quilted pattern and made around 1880 are associated with Bristol.

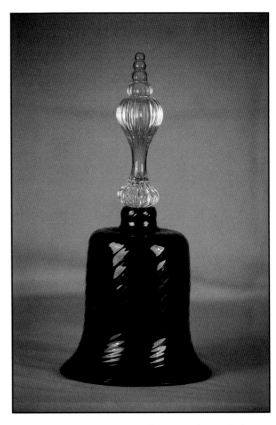

A cobalt blue spiral glass bell with a clear colorless ribbed four knop handle. 5-1/2"d. x 11-3/4"h. $350-450. *Courtesy of Gary L. Childress.*

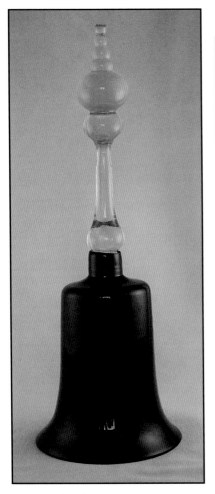

A blue bell with a four knop vaseline glass handle. 5-1/2"d. x 14-1/2"h. $400-500. *Courtesy of Alvin and Arlene Bargerstock.*

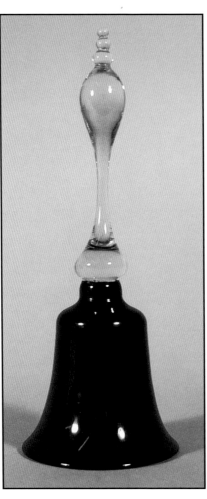

A blue clear glass bell with clear three knop handle. 3-3/8"d. x 8-1/2"h. *Courtesy of the Bristol Museums and Art Gallery.*

A lightly ribbed, ruby clear glass bell with a milk glass three knop handle. 4-1/4"d. x 9-1/8"h. *Courtesy of the Bristol Museums and Art Gallery.*

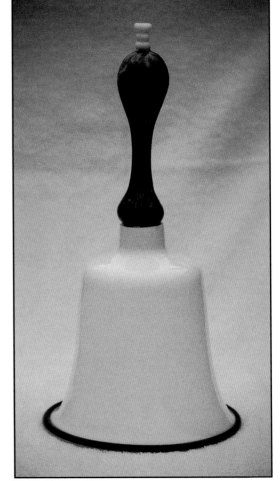

A milk glass bell with blue rim and handle with three milk glass knops. 7"d. x 13-3/4"h. $400-500. *Courtesy of Bruce Millstead.*

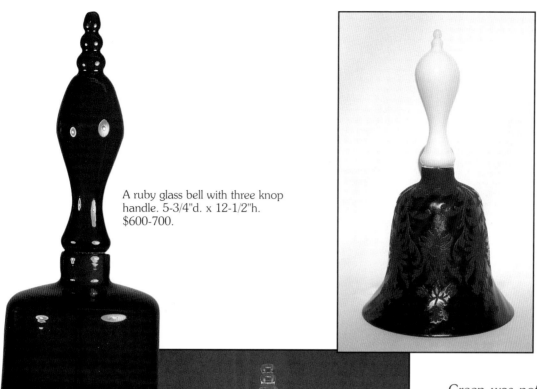

A ruby glass bell with three knop handle. 5-3/4"d. x 12-1/2"h. $600-700.

A ruby glass bell with acid etched floral design and glossy white handle with two knops. 6-1/4"d. x 11-1/4"h. $500-600. *Courtesy of Sally and Rob Roy.*

Green was not a popular color and fewer bells are seen in that color. The rarer colors for wedding bells are believed to be yellow, orange, and purple. The most common colors are red and cranberry.

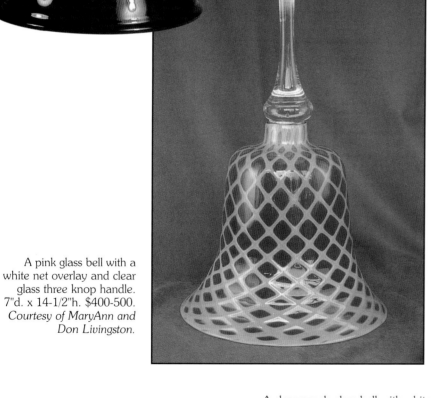

A pink glass bell with a white net overlay and clear glass three knop handle. 7"d. x 14-1/2"h. $400-500. *Courtesy of MaryAnn and Don Livingston.*

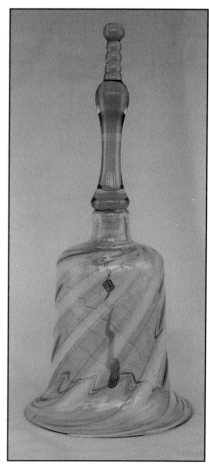

A clear peach glass bell with white stripes and clear green handle with five knops. 5-1/2"d. x 11-3/4"h. $300-500. *Courtesy of MaryAnn and Don Livingston.*

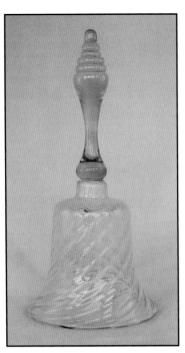

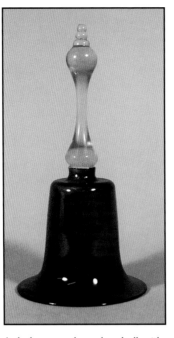

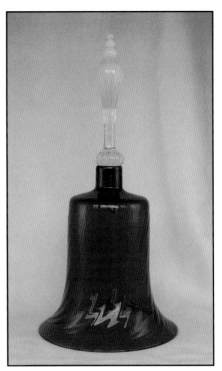

A clear twisted yellow glass bell with five knop vaseline glass handle. 3-3/4"d. x 8"h. $200-300. Courtesy of MaryAnn and Don Livingston.

A dark green clear glass bell with clear three knop handle. 4-3/8"d. x 8-1/2"h. Courtesy of the Bristol Museums and Art Gallery.

A cranberry twisted glass bell with three knop vaseline handle. 6-1/2"d. x 13-3/4"h. $500-600. Courtesy of MaryAnn and Don Livingston.

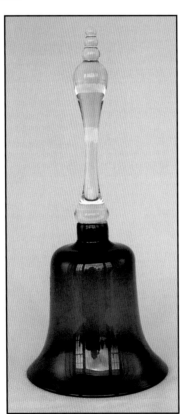

A teal glass bell with clear three knop handle. 4-1/4"d. x 10"h. $300-400. Courtesy of MaryAnn and Don Livingston.

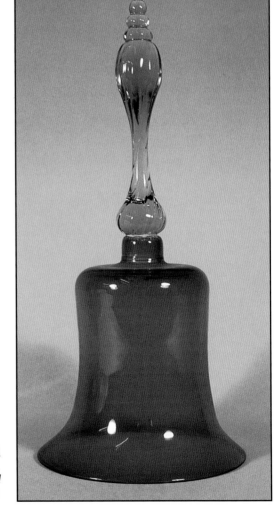

A ruby clear glass bell with ribbed four knop clear glass handle. 6-1/4"d. x 13-1/2"h. Courtesy of the Bristol Museums and Art Gallery.

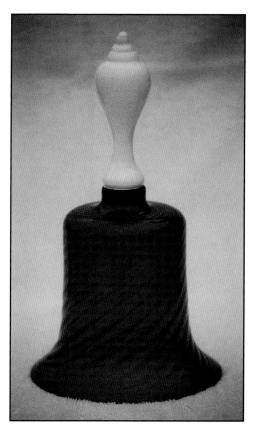

A red twisted glass bell with three knop milk glass handle. 6"d. x 10-1/2"h. $400-500. *Courtesy of Bruce Millstead.*

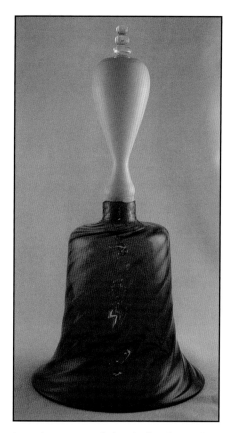

A cranberry twisted glass bell with a milk glass handle with three clear glass knops. 6"d. x 11-3/4"h. $600-700. *Courtesy of Alvin and Arlene Bargerstock.*

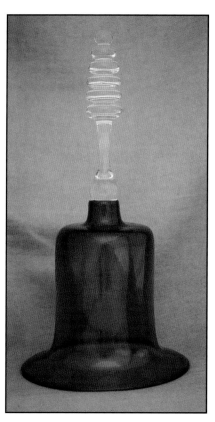

A cranberry glass bell with clear colorless handle with six knops. 6-1/2"d. x 12"h. $500-600. *Courtesy of the Pecor Collection.*

Handles generally have an inverted balustrade shape and are mostly found in a clear glass, often colored. Some bells and handles have a twisted ribbing pattern known in England as a wrythen pattern. Often a thin thread of glass is applied to the outer surface in a random or regular pattern known as threading. Sometimes the threading has been added to the partially blown base glass and the glass then rolled on a metal bed before being fully blown to produce a smooth surface. On English glass, with a uniformly spaced threading produced by machine, the spacing of threads is usually between 20 and 22 threads per inch.

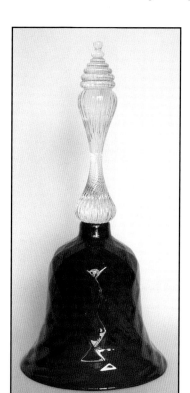

A quilted red bell with clear colorless wrythen handle with seven knops. 6-1/4"d. x 13-3/4"h. $300-400. *Courtesy of Sally and Rob Roy.*

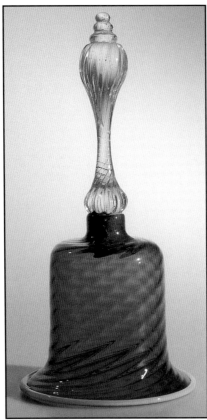

A ruby twisted glass bell with milk glass rim and clear colorless glass wrythen handle with three knops. 5-1/8"d. x 10-1/2"h. *Courtesy of the Chrysler Museum of Art, Norfolk, Virginia. Gift of Walter P. Chrysler, Jr. Photo by Scott Wolff.*

A ruby glass bell with white spiral trailing and clear colorless three knop handle with white and ruby striping. 4-1/2"d. x 10-3/4"h. $300-350.

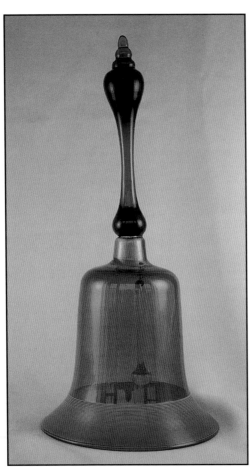

A clear orange bell with white trailing and teal handle with three knops. 6"d. x 12-1/2"h. $600-700. *Courtesy of MaryAnn and Don Livingston.*

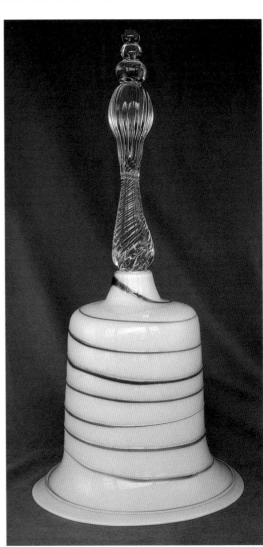

A milk white glass bell with ruby trailing and clear three knop handle with a wrythen mold. 6-1/2"d. x 14"h. $400-500. *Courtesy of MaryAnn and Don Livingston.*

Some bells are found with red, white, and blue colors and are thought to have been produced to celebrate patriotic events. Some have the three colors as a glass ribbon imbedded in a clear glass handle. These may have been produced for the Great Exhibition of 1851 in the Crystal Palace in London, considered to be the first World's Fair.

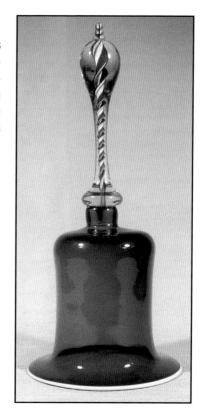

A blue bell with white rim and clear glass handle with red, white, and blue swirls in the handle and into the three knops. 5"d. x 12"h. $350-400. *Courtesy of Barbara Wright.*

A clear ruby glass bell with clear glass three knop handle with red, white, and blue imbedded ribbons. 4-3/4"d. x 11"h. $300-500. *Courtesy of MaryAnn and Don Livingston.*

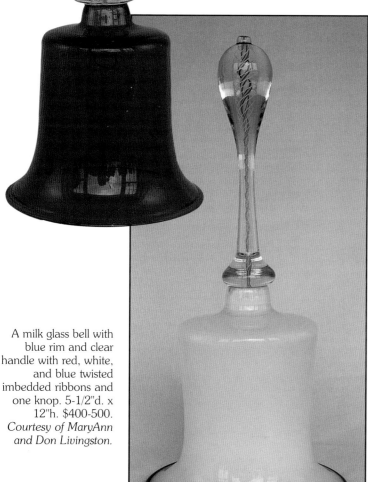

A milk glass bell with blue rim and clear handle with red, white, and blue twisted imbedded ribbons and one knop. 5-1/2"d. x 12"h. $400-500. *Courtesy of MaryAnn and Don Livingston.*

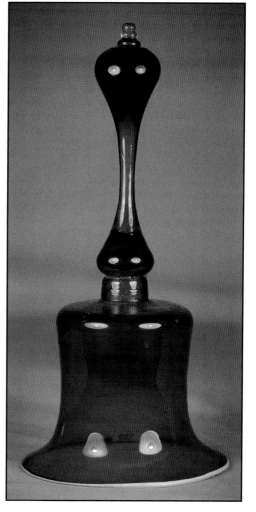

A ruby glass bell with white rim and hollow blue handle with three knops. 5"d. x 10-3/4"h. $400-500. *Courtesy of Gary L. Childress.*

In 1885, the Mount Washington Glass Company of New Bedford, Massachusetts patented a pink to yellow colored glass known as Burmese. The glass was licensed by Mount Washington to Thomas Webb and Sons to be produced in England. See Chapter Five for bells that have been attributed to Mount Washington but may have been produced by Webb.

Very large wedding bells are believed to have been produced late in the Victorian era. Towards the end of the nineteenth century, some bells were made having a diameter up to 18" at the base. The bells of that era usually have many knops and their shape is sometimes exaggerated. At that time also, the handle or the finial of the handle was sometimes a hand, foot, bird, or flowers.

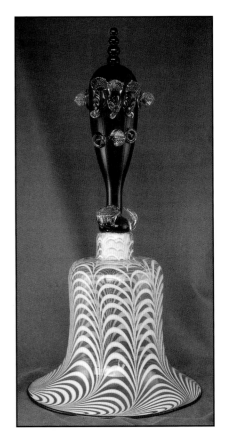

A clear glass bell with white Nailsea striping and ruby rim. The hollow ruby glass handle with four knops and clear glass base has applied clear glass leaves. 9"d. x 17-1/4"h. $1,000-1,500. *Courtesy of MaryAnn and Don Livingston.*

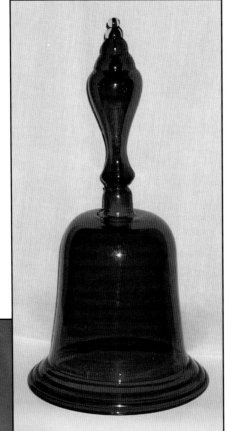

A large cranberry glass bell with raised rim and hollow four knop handle on exhibit at the Hammond Museum of Bells, Eureka Springs, Arkansas. 10-3/4"d. x 21"h. *Courtesy of the Hammond Museum of Bells, Eureka Springs, Arkansas.*

A cranberry glass bell with scalloped rim and clear glass handle with a chicken finial. 5"d. x 10-3/4"h. $900-1,000. *Courtesy of Alvin and Arlene Bargerstock.*

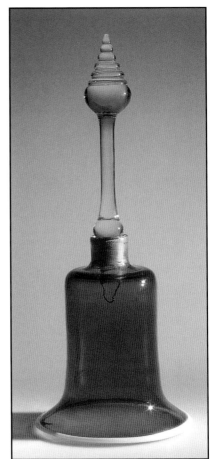

A cranberry glass bell with milk glass rim and clear colorless six knop handle. 5-1/4"d. x 12-3/8"h. *Courtesy of the Chrysler Museum of Art, Norfolk, Virginia. Gift of Walter P. Chrysler, Jr. Photo by Scott Wolff.*

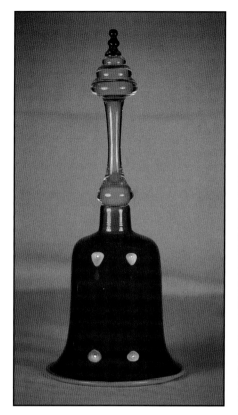

Smaller wedding bells under 9" in height, with the handle less in height than the body of the bell, are believed to be the oldest — dating from the eighteenth century. On some of the bells from the second half of the eighteenth century, the handles have a clear grayish cast.

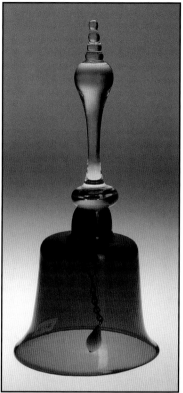

A cranberry glass bell with clear colorless four knop handle. 3"d. x 6-3/4"h. $ 250-300.

A cranberry glass bell with milk glass rim and clear colorless handle with three cranberry knops and three clear knops. 5-1/4"d. x 12-3/4"h. $500-600. *Courtesy of Gary L. Childress.*

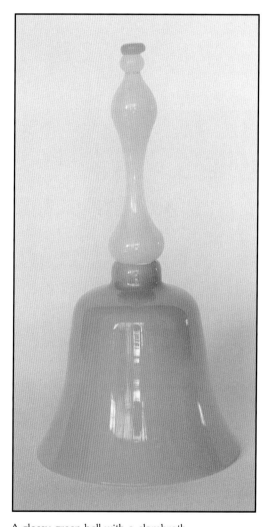

A glossy green bell with a clambroth handle with two knops, the top one green. 3-1/2"d. x 6-5/8"h. $300-350. *Courtesy of Sally and Rob Roy.*

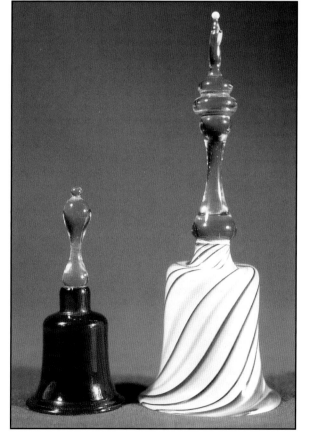

A pair of English wedding bells. On the left, a cranberry glass bell with clear colorless one knop handle. 1-3/4"d. x 4"h. $150-200. On the right, a milk glass bell with alternating blue and pink striping. The clear colorless glass handle has three clear glass knops and one milk glass knop separated by a clear glass column. 2-3/4"d. x 7"h. $250-300. *Courtesy of Barbara Wright.*

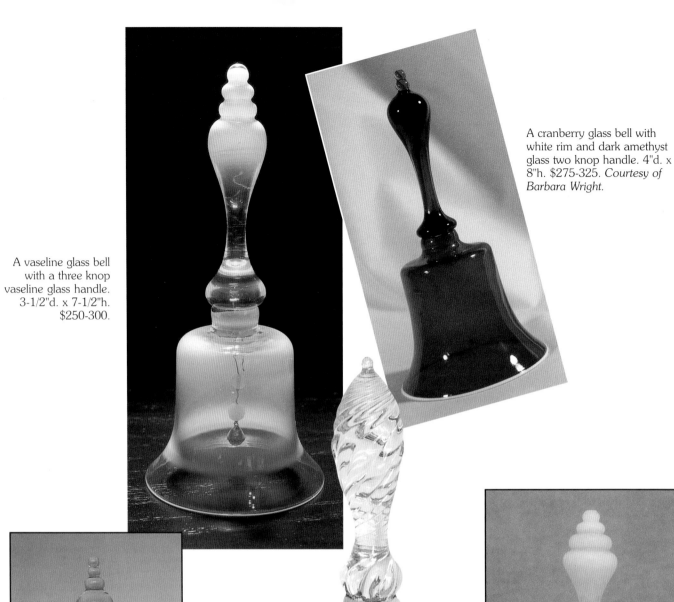

A vaseline glass bell with a three knop vaseline glass handle. 3-1/2"d. x 7-1/2"h. $250-300.

A cranberry glass bell with white rim and dark amethyst glass two knop handle. 4"d. x 8"h. $275-325. *Courtesy of Barbara Wright.*

A clear blue glass bell with clear colorless three knop handle. 3-3/4"d. x 8-1/4"h. $250-350. *Courtesy of MaryAnn and Don Livingston.*

A quilted vaseline glass bell with clear colorless wrythen handle with one knop. 6"d. x 11"h. $300-400. *Courtesy of Sally and Rob Roy.*

A twisted cranberry glass bell with a three knop opaline glass handle. 4-1/8"d. x 8-1/4"h. $500-600. *Courtesy of the Pecor Collection.*

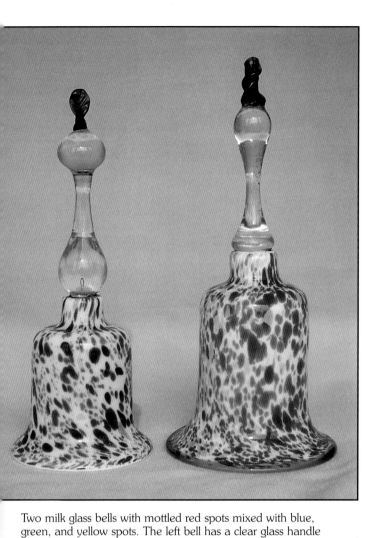

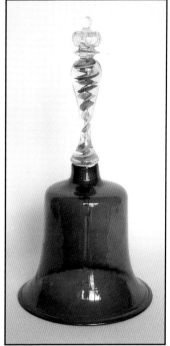

A green bell with clear colorless handle having pink and white swirls and a crown top. 4-1/4"d. x 8-1/2"h. $300-400. *Courtesy of Sally and Rob Roy.*

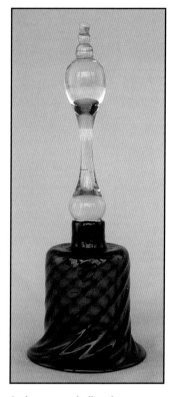

Two milk glass bells with mottled red spots mixed with blue, green, and yellow spots. The left bell has a clear glass handle with a twisted green knop, 2-3/4"d. x 6-3/4"h. The bell on the right has a green rim and clear glass handle with an elongated green spiral top, 3-1/2"d. x 7-1/2"h. $300-400 each. *Courtesy of MaryAnn and Don Livingston.*

A clear green bell with a spiral shape and clear colorless handle with three knops. 3"d. x 8"h. $200-300. *Courtesy of MaryAnn and Don Livingston.*

A milk white glass bell with amethyst zipper striping and a dark green handle. Knops missing. 4-1/2"d. x 8-1/2"h. $250-350. *Courtesy of MaryAnn and Don Livingston.*

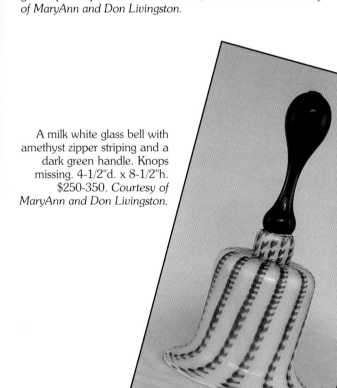

A clear colorless and opaque white glass bell decorated with Nailsea type white festoons with a solid clear three knop handle, c.1800. A chain supports a glass bead. 3-1/4"d. x 7-1/4"h. *Courtesy of the Corning Museum of Glass, Corning, NY, gift of Mrs. William Esty.*

153

Some writers on English glass state that cut glass handles on wedding bells first appeared in 1783 and associate cut glass handles with the eighteenth century.

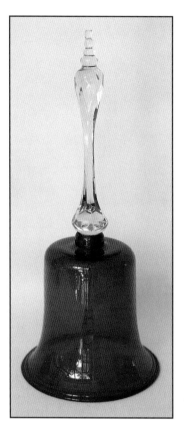

A cranberry glass bell with clear cut glass handle with four knops. The base of the bell has a double ridge rim. 5-1/2"d. x 12-1/2"h. $400-500. *Courtesy of Sally and Rob Roy.*

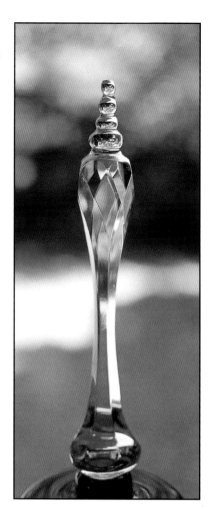

Another view of the clear six-sided cut glass handle for the cranberry bell at left. The cutting stops just below the four top knops. *Courtesy of Sally and Rob Roy.*

There are also a variety of English wedding bells that are difficult to classify in the above categories.

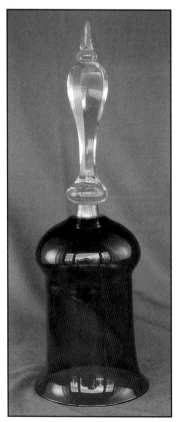

A clear blue bell with clear colorless handle with cut sides and a one knop and spire top. 4-1/4"d. x 13"h. $400-500. *Courtesy of MaryAnn and Don Livingston.*

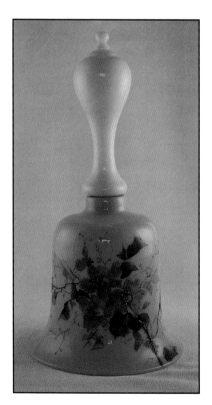

A blue bell decorated with flowers and a milk glass two knop handle. 5-1/2"d. x 11"h. $700-800. *Courtesy of Alvin and Arlene Bargerstock.*

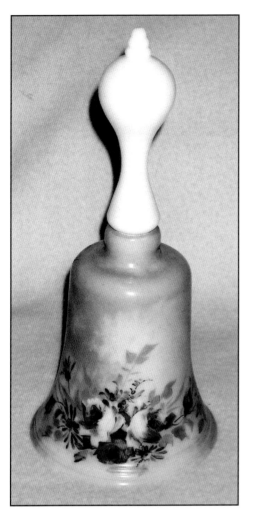

A milk glass bell with painted floral design and three knop handle. 6-1/4"d. x 13-1/4"h. $700-800. *Courtesy of Bruce Millstead.*

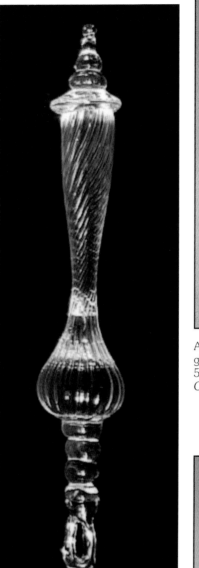

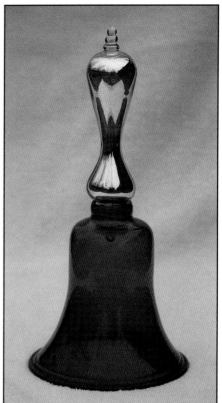

A red glass bell with a hollow mercury glass handle with three colorless knops. 5-1/2"d. x 11-1/2"h. $400-500. *Courtesy of Bruce Millstead.*

A blue and white latticino glass bell with unusual clear wrythen glass handle with four knops. The base of the bell is ground flat. 5-1/4"d. x 12-3/4"h. $400-450. *Courtesy of Sally and Rob Roy.*

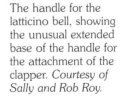

The handle for the latticino bell, showing the unusual extended base of the handle for the attachment of the clapper. *Courtesy of Sally and Rob Roy.*

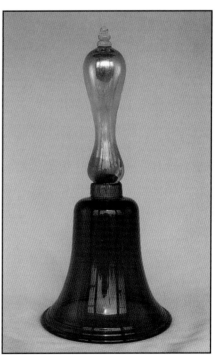

A cranberry bell with a mercury finish hollow handle with three knops. 5-1/2"d. x 11-1/2"h. $400-500. *Courtesy of MaryAnn and Don Livingston.*

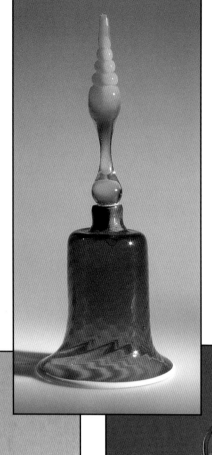

A cranberry twisted glass bell with milk glass rim and vaseline glass handle with three knops and a spire. 4-7/8"d. x 12"h. *Courtesy of the Chrysler Museum of Art, Norfolk, Virginia. Gift of Walter P. Chrysler, Jr. Photo by Scott Wolff.*

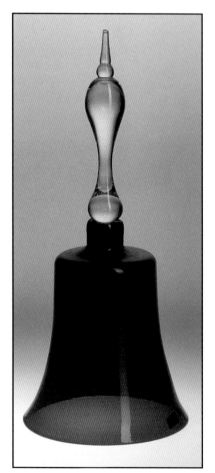

A ruby glass bell with clear glass handle with blue, green, pink, and frosted white twisted ribbons and four knops. 5-3/4"d. x 11"h. $400-500.

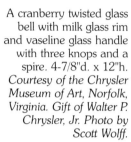

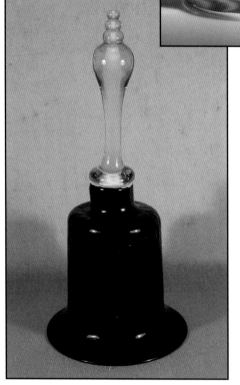

A cobalt blue glass bell with clear glass handle with a central column of milk glass and three knops. 4-1/2"d. x 10"h. $350-400. *Courtesy of Bruce Millstead.*

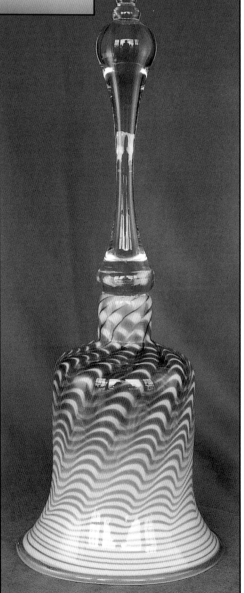

A red and white undulating stripes bell with clear three knop handle. 5-1/4"d. x 13-3/4"h. $500-600. *Courtesy of MaryAnn and Don Livingston.*

A coffee colored bell with clear colorless glass handle with one knop and a spire. 4-1/4"d. x 12-3/4"h. $225-250.

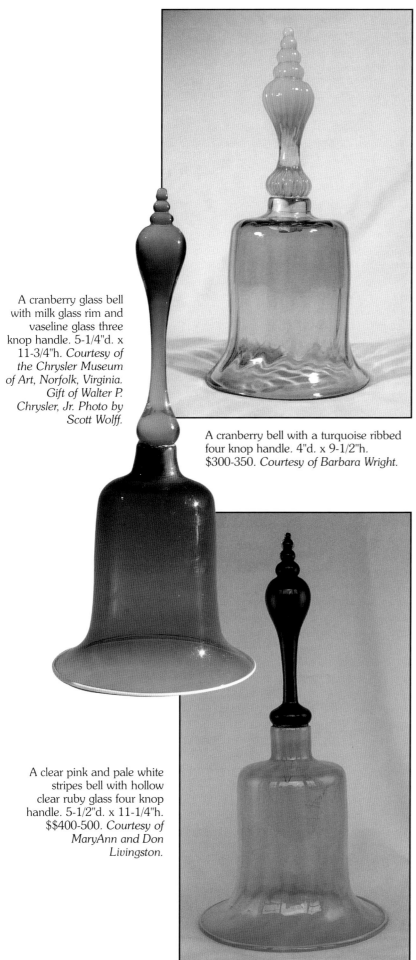

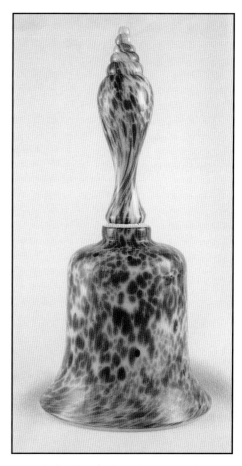

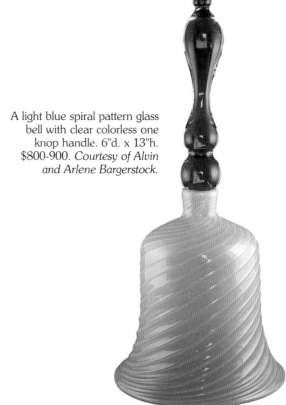

A cranberry glass bell with milk glass rim and vaseline glass three knop handle. 5-1/4"d. x 11-3/4"h. *Courtesy of the Chrysler Museum of Art, Norfolk, Virginia. Gift of Walter P. Chrysler, Jr. Photo by Scott Wolff.*

A cranberry bell with a turquoise ribbed four knop handle. 4"d. x 9-1/2"h. $300-350. *Courtesy of Barbara Wright.*

A mottled red and white glass bell with blue spots and five knop handle. 4"d. x 9-1/4"h. $400-500. *Courtesy of MaryAnn and Don Livingston.*

A clear pink and pale white stripes bell with hollow clear ruby glass four knop handle. 5-1/2"d. x 11-1/4"h. $$400-500. *Courtesy of MaryAnn and Don Livingston.*

A light blue spiral pattern glass bell with clear colorless one knop handle. 6"d. x 13"h. $800-900. *Courtesy of Alvin and Arlene Bargerstock.*

157

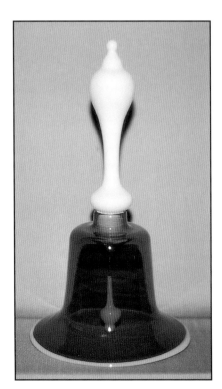

A cranberry bell with white splatter and milk white handle with three knops. 6-1/4"d. x 12-1/2"h. $400-500. *Courtesy of MaryAnn and Don Livingston.*

American Wedding Bells

American wedding bells by several companies are known, but like the English bells it is difficult to determine their attribution.

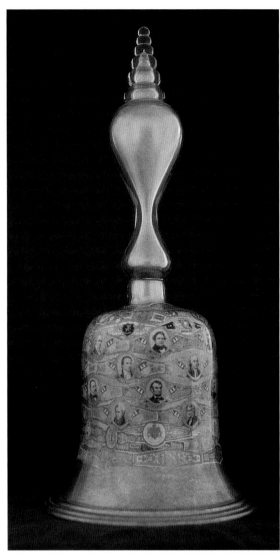

A clear glass bell decorated with cigar bands showing pictures of United States presidents from George Washington to Theodore Roosevelt, c.1901-1909. 8-1/2"d. x 18-1/2"h. $1,000+. These bells are reputed to have been made for a cigar company, six of the size shown for regional offices, and twelve smaller bells for twelve district offices. *Courtesy of The Pecor Collection.*

A ruby glass bell with white rim and custard glass one knop handle and clapper. 6-1/8"d. x 10-3/4"h. $300-350.

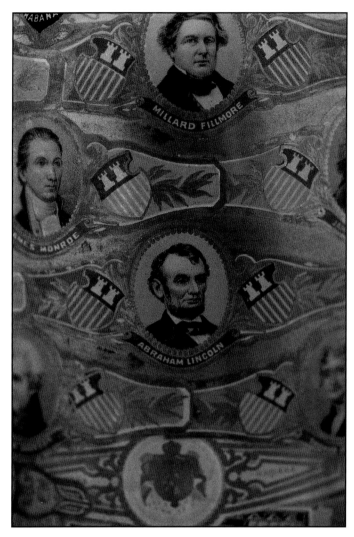

An enlargement of a portion of the cigar band bell.
Courtesy of The Pecor Collection.

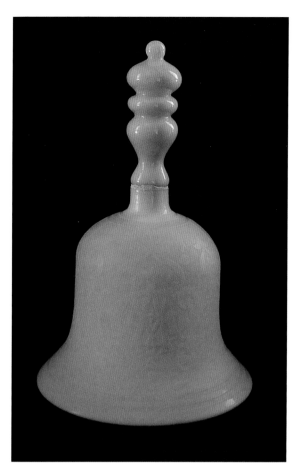

A custard glass bell attributed to Frederick Carder with acid etched A, M, and C initials in an interwoven design. Glossy finished handle with four knops. 7-5/8"d. x 11-1/4"h. $700-800. *Courtesy of Sally and Rob Roy.*

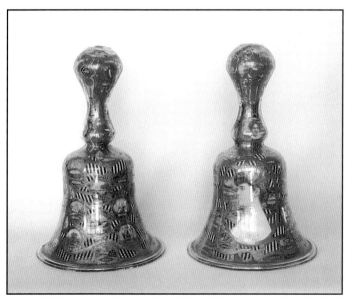

Two clear glass bells with cigar labels applied on the inside, then painted with gold. The back of each bell has a picture of the man who did the work and his wife. 5-3/8"d. x 8-3/8"h. $300-400 each. *Courtesy of Sally and Rob Roy.*

Detail of the initial design on the Carder bell. *Courtesy of Sally and Rob Roy.*

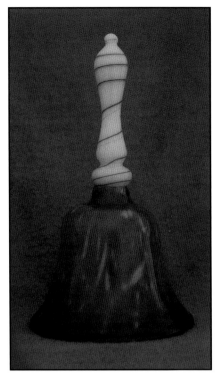

A pink bell attributed to Steuben with a white one knop handle with a blue swirl. 4-1/2"d. x 7-1/2 "h. $1,200-1,500. *Courtesy of The Pecor Collection.*

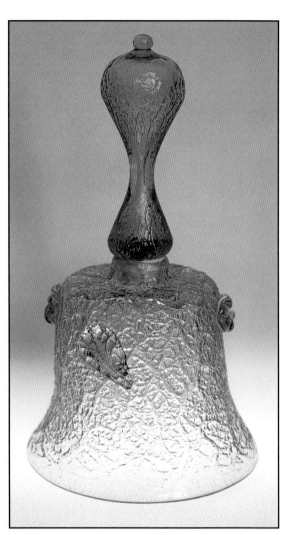

A clear blue bell, also with a pressed "Tree of Life' type pattern and applied molded leaves, possibly made by the Portland Glass Co., Portland, Maine. Hollow one knop handle. 5-1/4"d. x 9-1/8"h. $600-700. *Courtesy of Sally and Rob Roy.*

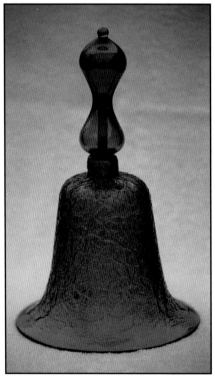

A "Tree of Life" gold-amber pattern glass bell patented in 1869 by William O. Davis for the Portland Glass Co., Portland, Maine. The Davis name is interwoven in the vine like tracery. The one knop handle is hollow. 6-3/4"d. x 11"h. $1,000-1,200. *Courtesy of Bruce Millstead.*

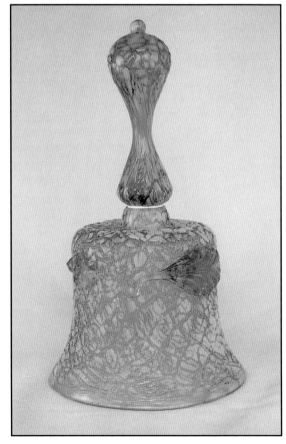

A pale blue pressed pattern bell with applied green leaves and flowers and one knop hollow handle. Similar to a "Tree of Life" design. 6"d. x 16-1/2"h. $900-1,000. *Courtesy of MaryAnn and Don Livingston.*

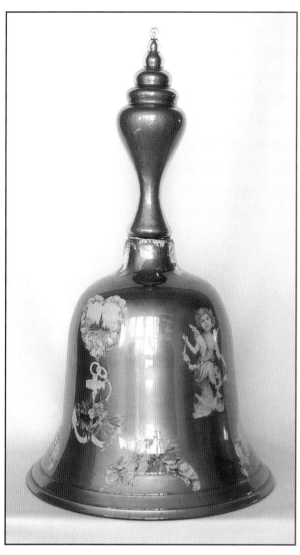

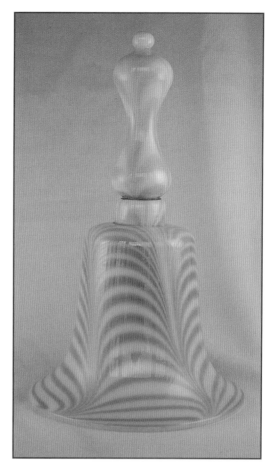

A milk glass bell with gold Nailsea type striping. The white handle has yellow striping and one knop. 7-1/4"d. x 12-1/4"h. $500-600. *Courtesy of MaryAnn and Don Livingston.*

A bell attributed to the Libbey Glass Company. Valentines have been applied to the interior, and then painted gold. 11-1/4"d. x 19-1/4" h. $500-600. *Courtesy of Sally and Rob Roy.*

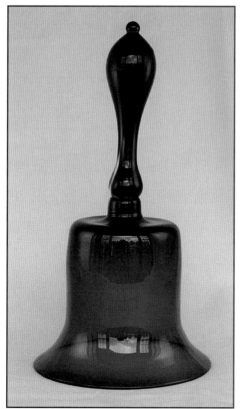

A teal bell with a one knop cobalt blue handle, attributed to American origin. 5-1/4"d. x 10-1/2"h. $400-500. *Courtesy of MaryAnn and Don Livingston.*

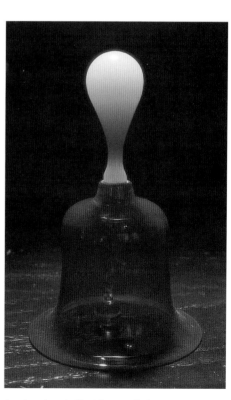

A ruby glass bell with rounded green handle attributed to an American firm. 3-5/8"d. x 5-5/8"h. $250-300.

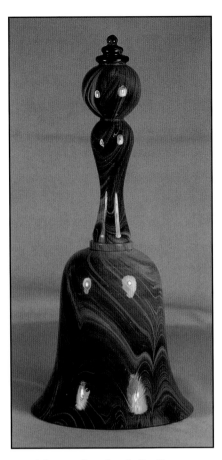

A brown slag glass bell with a bulbous and three knop handle attributed to an American company. The handle and main body of the bell are separated by a flat brown slag disk. 5-1/2"d. x 13"h. $700-800.

A pair of gold ruby glass bells with applied knobs and opalescent milk glass rim. Swirled clear over yellow cased glass handles with four cased glass knops. Attributed to John J. Klumpp for the Macbeth-Evans Glass Company, Charleroi, Pennsylvania, c.1898. One bell is 10"d. x 17-1/2"h. and the other is 9-3/4"d. x 18"h. *Courtesy of the Corning Museum of Glass, Corning, NY, gift of John F. Klumpp.*

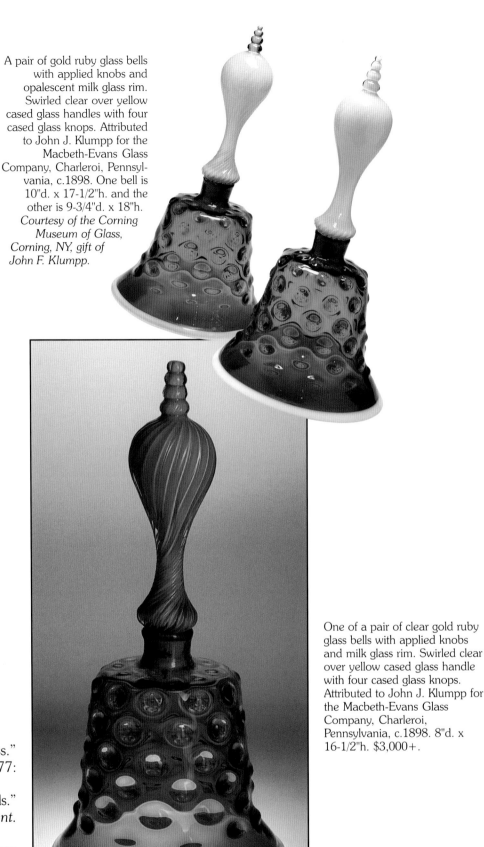

One of a pair of clear gold ruby glass bells with applied knobs and milk glass rim. Swirled clear over yellow cased glass handle with four cased glass knops. Attributed to John J. Klumpp for the Macbeth-Evans Glass Company, Charleroi, Pennsylvania, c.1898. 8"d. x 16-1/2"h. $3,000+.

References

Boyle, Julia. "Novelties in Glass." *Collectors' Guide.* July 1977: 58, 59.

"Butler Art Museum Wedding Bells." *The Bell Tower Supplement.* June 1970: 5 pages.

Duesselmann, Ethel. "English Glass Bells." *The Bell Tower.* November 1965: 1-7

Mosley, Lillian. "Nailsea Glass." *The Bell Tower.* October 1977: 12-14.

Stacey, Allan. "Coloured Glass Bells." *Antique Collector.* 49, no. 12 (December 1978); 86, 87.

Chapter Ten
Are These Glass Bells?

There are many glass items which initially look like bells, but upon investigation are found to be bells made from other glass objects that have had a clapper or handle added and thus converted into a bell. The author considers a converted object a true bell if it was made into a bell by the manufacturer of the glass.

T. G. Hawkes, for example, was in the business to make money and they converted many broken stems to bells by adding a clapper and attaching a sterling silver handle to the broken end of the stem. They started doing this in the 1890s and continued through the 1950s. Some of the Hawkes bells made from converted stems are shown in Chapter Three.

The apparent glass bell shown here with the handle of a hand holding a bar was sold to the author at an auction sight unseen as a bell without a clapper. Upon receiving it and doing further investigation, the author determined that this was the cover for a sugar bowl of a well known pattern of the 1880s, the "hand" or "Pennsylvania" pattern made by the O'Hara Glass Company of Pittsburgh, Pennsylvania.

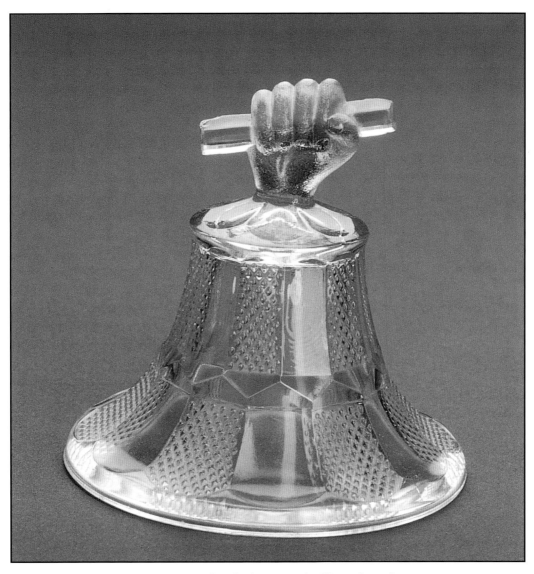

A bell shape with a "hand" pattern handle. Also known as the "Pennsylvania" pattern by the O'Hara Glass Company, c.1880. 3-1/2"d. x 3-1/2"h. $45-55.

A beautiful 7" high bell with a bronze handle has been passed from one collector to another for several years. The glass is calcite glass made by Frederick Carder Steuben with an acid etched design of a Roman head and other decoration. Investigation reveals that it is a Steuben lampshade converted to a bell by the addition of the handle. It has no clapper. As a Steuben shade, it is still an excellent collectible.

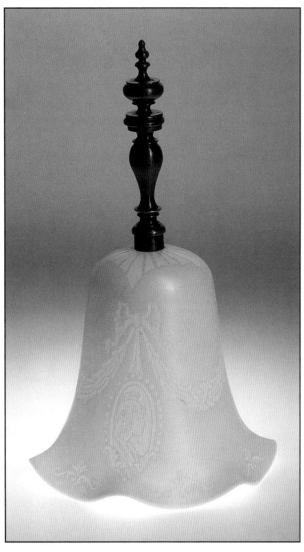

A Carder Steuben calcite glass bell shape with acid etched roman head silhouette and bronze handle. No clapper. 5-1/4"d. x 7"h. $400-500.

The beautiful bell shaped, blue glass object also shown here was identified at a glass show as a candle snuffer or smoke bell. Upon careful examination, it becomes apparent that the handle was cut into its present shape and was probably made from a broken vase.

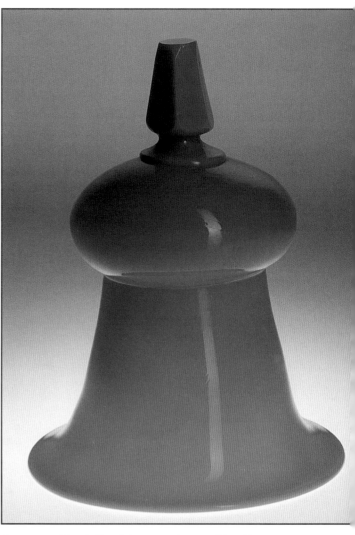

An opaque blue bell with hexagonal tapered handle and no clapper. 4-3/4"d. x 6-1/4"h. $100-125.

A ruby stained glass bell shape inscribed with "Worlds Fair 1893" and a name has been passed as a bell. However, examination reveals that the inscription is upside down, the top of handle has been ground, and there is a very poor attempt to install a clapper attachment to the glass. It is certain that this object started as a souvenir goblet.

The 7" high "bell" with a cast bronze handle has an opal glass body that has been beautifully hand painted by an artist who signed it T. Dye. It is probably very old, but a look at the modern screw holding the handle to the glass reveals it to be a marriage made from an old lampshade.

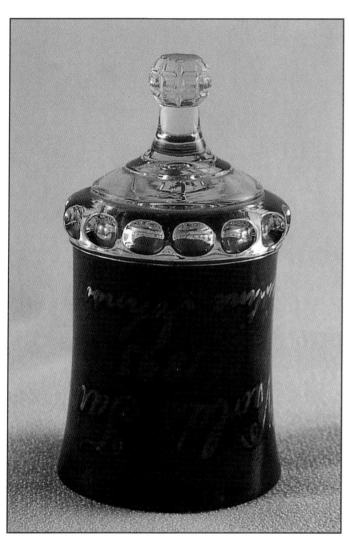

A clear bell shaped glass with ruby flashing, engraved with "Worlds Fair 1893" and "Christina Johnson." 1-3/4"d. x 3-1/4"h. $25-30.

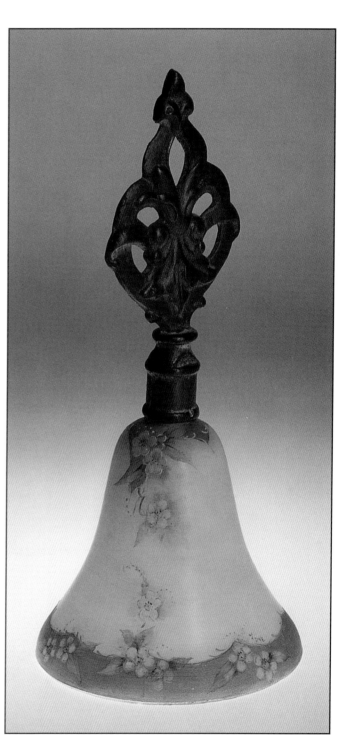

A milk glass bell with a painted floral decoration and gold painted metal handle. No clapper. Signed T. Dye. 3-1/2"d. x 7-1/2"h. $30-40.

Who Really Made These Glass Bells?

Glass Liberty Bells

For over forty years, glass Liberty bells with molded three link chain shaped handles, and generally made of opal glass, have been attributed by glass bell collectors as having been made by the Mount Washington Glass Company of New Bedford, Massachusetts, in the late nineteenth century or early twentieth century.

The United States Glass Company, a merger of eighteen glass companies from Pennsylvania, West Virginia, and Ohio formed in 1891, produced a similar bell for the 1893 Columbian Exposition in Chicago. The September 27, 1893 issue of the publication called *China, Glass, and Lamps* illustrated the bell as a souvenir of the year. A note in "The Glass Trade" section of that issue states, "The company illustrates elsewhere in this issue a handsome souvenir of the year in the shape of the Liberty Bell, reproduced in glass and an exact representation of the original at Philadelphia, inscriptions and all." It has a molded three-link chain handle and a simulated crack.

Similar bells, previously attributed to Mount Washington, do not have the inscriptions and simulated crack, but are decorated with flowers or gold paint.

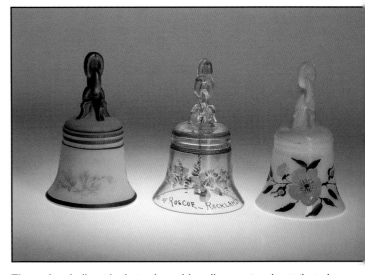

Three glass bells with chain shaped handles previously attributed to the Mount Washington Glass Company, but now established as having been made by the United States Glass Company. 3-1/4"d. x 5-1/4"h. $200-300 each.

A sketch of the souvenir exposition bell appears in the 1893 United States Glass Company records at the Rakow Library of the Corning Museum of Glass, along with a note on the sketch stating that a specimen in opaque white is located in the Kingman Museum. The location of that museum is unknown at this time.

Close examination of a sample of the 1893 bell, shown in the author's book *Glass Bells* under United States Glass Company, reveals a molded "1776" on the edge of the shoulder. This matches the molded "1776" found on all the Liberty glass bells seen by the author and previously attributed to Mount Washington.

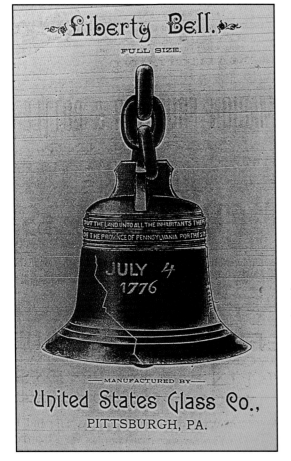

A print of an advertisement from the September 27, October 4, October 11, and October 18, 1893 issues of *China, Glass and Lamps*, showing the lead glass Liberty Bell made by the United States Glass Company as souvenir of the year for the 1893 Columbian Exposition, Chicago, Illinois. It shows a simulated crack, July 4, 1776, and molded inscriptions below the shoulder.

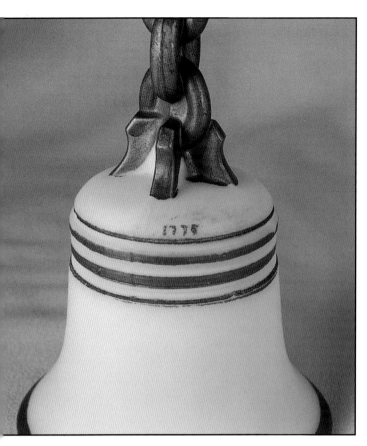

The shoulder edge of a U.S.G.C. Liberty bell (formerly attributed to Mount Washington) showing a molded "1776" common to all these bells. The date has been enhanced by a pencil rubbing on the satin finished glass.

Albert Christian Revi, in his book, *American Pressed Glass & Figure Bottles*, states that the United States Glass Company advertised "Liberty Bells" for sale in 1903. The author has been unable to verify a publication illustrating these bells.

An examination of United States Glass Company catalogs at the Carnegie Museum of Art Library and the Historical Society of Western Pennsylvania Library in Pittsburgh, Pennsylvania sheds no light on the attribution. However, the Center for Archival Collections at Bowling Green State University, Bowling Green, Ohio, has some inventories of glass produced by the United States Glass Company and its affiliated companies that show where the mold for a bell was located.

Around 1922, the Manufacturers' Appraisal Company, with home office in Cleveland, Ohio, made a typed detailed inventory and appraisal of the molds in all the United States Glass Company affiliated companies existing at that time. Included were molds from Bryce Brothers, Factory B; Richards & Hartley, Factory E; Ripley & Company, Factory F; Gillinder & Sons, Factory G; King Glass Company, Factory K; Central Glass Company, Factory O; A. J. Beatty & Sons, Factory R; and the plant in Gas City, Ohio, Factory U. The *only* company that listed a bell mold was the King Glass Company, Factory K. The bell was listed as mold 30048 with a description of "mould ring plunger valve shell" and having a reproduction cost of $120 with present value of $24. This appears to show that it was an old, well-used mold.

A typed Factory K inventory of October 10, 1930 lists "one press mould 30048 bell." In addition, an October 11, 1930 handwritten U.S.G.C. inventory of all molds in Factory K lists the 30048 bell. However, the left margin of the inventory listing shows a letter in brackets next to each mold. The letters shown are obviously the letters designated for each of the United States Glass Company factories. It is where the molds probably originated and lists the 30048 mold as having been made for Factory B, Bryce Brothers.

Although the U.S.G.C. merger of companies in 1891 included the Bryce Brothers company as Factory B (and it continued as Factory B), in 1892, two brothers, Andrew H. and James McDonald Bryce, left Factory B to found a new Bryce Brothers company independent of the United States Glass Company.

So who made these bells that have been attributed to Mount Washington? Based on the molded "1776" on all these bells and the above noted inventories, the author concludes that the bell made for the 1893 Columbian Exposition was made by Bryce Brothers, Factory B, in Pittsburgh, Pennsylvania, and subsequent similar bells were most likely made by the King Glass Company, Factory K, Pittsburgh, Pennsylvania where the bell mold resided for many years. It is therefore apparent that all the glass Liberty Bells with chain-molded handle were made by the United States Glass Company.

Kewpie Doll Glass Bells

There are four different glass bells with molded Kewpie doll handles known at this time. Three of them are of similar size. Bells made by R. Wetzel of Zanesville, Ohio, are easily identified by his name molded on the inside of the bell near the clapper attachment. A distinctive feature of these bells is the outstretched hands on the doll.

Two typical Wetzel Kewpie doll bells with outstretched hands. 2-1/4"d. x 5"h. $30-40 each.

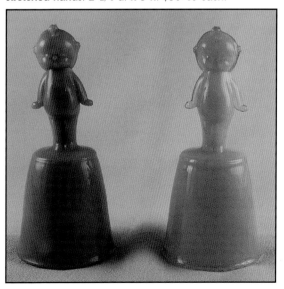

Two other companies made bells similar to the Wetzel bells. The earlier bells were made in clear colorless and clear pink glass. They have sharply defined fingers. Chains holding the bead clappers are held between two molded glass prongs. These once were believed to have been made by the Westmoreland Glass Co. of Grapeville, Pennsylvania, as the Kewpie doll handle is very similar to the Kewpie doll part of a match holder made by Westmoreland. However, some of these bells have been seen with a "Made in Taiwan" label. Similar but later bells have Kewpie doll fingers that are not so well defined, and the chain holding a clear glass clapper is attached to the glass by a plastic disk. These can be found in pink, red, and blue glass. The author believes they also were made in Asia.

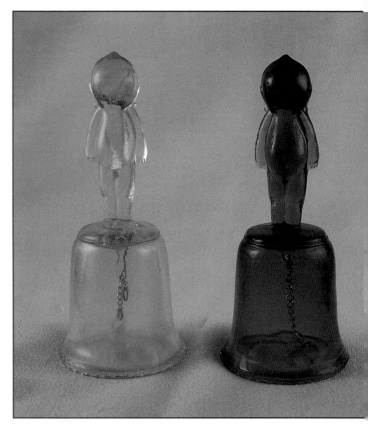

Two Kewpie doll glass bells. The pink bell has very distinct fingers and is believed to be an earlier version of the blue bell on the right, which has indistinct fingers. The earlier version has been found with a "Made in Taiwan" label. 2-1/4"d. x 5-1/2"h. $15-25 each.

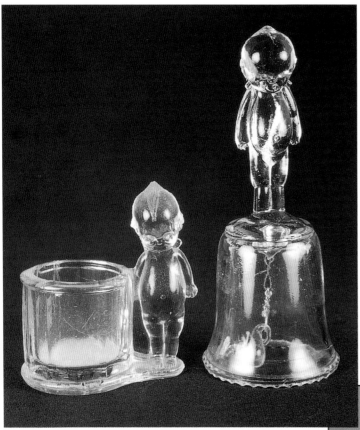

A Kewpie doll match holder made by Westmoreland on the left with a Kewpie doll bell made in Taiwan on the right, showing the similarities of the doll.

A larger variation of the Kewpie doll bell is of more recent origin and believed to also have been made in Asia. It is available in blue, green, gold, and amethyst.

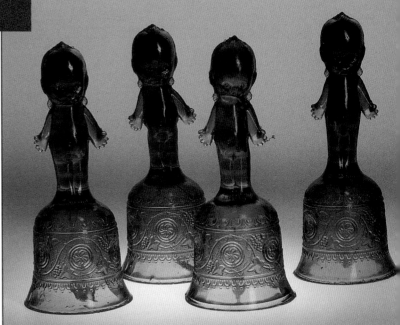

Four large Kewpie doll bells with outstretched hands in four glass colors. 2-3/4"d. x 6-1/2"h. $15-25 each.

Frosted Handle Art Glass Bells

Around 1980, the author purchased in California a 5" high, frosted ruby glass bell with white swirls and clear handle. At that time, the author believed that a local American art glass artisan had made this bell.

In recent years, similar bells have been seen on eBay auctions. Some show an etched signature near the inside rim of Loetz, Austria. Loetz was a very well known glass factory in Bohemia from 1836-1947. Other similar bells are without the signature, as is the one from California. The author looked at the signed bells with suspicion as the chain holding the clapper is attached to the glass by a glued disk, a sign of more recent manufacture.

Recently, a similar bell with a West Germany paper label was found on eBay, but with no signature. It is now clear where these bells were made. However, the author still does not know the name of the German factory that made them.

Central Glass Works or Bryce Brothers?

For many years, some older bells were produced in thin glass with a molded twisted round handle that has a hexagonal base. They have been attributed to having been made in Murano, Ireland, and elsewhere. The bell is known in clear colorless and colored glass. Some have engraved designs, others have etched or engraved inscriptions, and still others have a silver overlay.

In the book on *Wheeling Glass, 1829-1939*, which shows glass from the collection of the Oglebay Institute Glass Museum, there is a clear colorless molded glass bell, similar to the above noted bells. This bell is illustrated as having been made by the Central Glass Works of Wheeling, West Virginia, in a needle etched trefoil and lacy band pattern. Based on this, for many years similar bells have been attributed to the Central Glass Works. Some bells are dated to commemorate events in 1915.

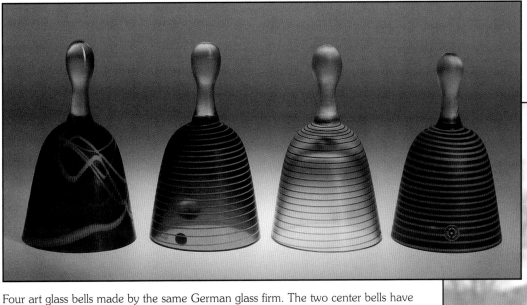

Four art glass bells made by the same German glass firm. The two center bells have been stamped with "Loetz Austria" on the inside rim. The bell on the right has a "Made West Germany" label. 3"d. x 5"h. $30-40 each.

The bell decorated with looped engraving, attributed to the Central Glass Works, on exhibit in the Oglebay Institute Glass Museum. *Courtesy of the Collection of the Museums of Oglebay Institute, Wheeling, West Virginia.*

A *China, Glass and Lamps* issue of December 20, 1900, shows a Central Glass Works small wine glass with a needle etched design no. 700 similar to that on the museum bell.

Part of an advertisement from the December 20, 1900 issue of *China, Glass and Lamps* showing a Central Glass Works No.700 2-1/2 oz. wine goblet with an engraved pattern similar to that on the bell in the Oglebay Institute Glass Museum, Wheeling, West Virginia.

However, a 1916 catalog of lead blown glassware by Bryce Brothers Company, Mount Pleasant, Pennsylvania, includes a line drawing of a similarly shaped bell. Another page of the catalog shows a line of needle etchings on glasses and stemware, several etchings of which are similar to those on the Central Glass Works bell at the Oglebay Museum.

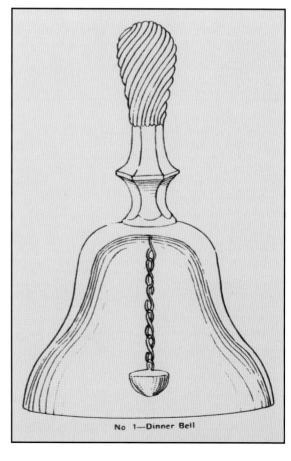

Part of a 1916 Bryce Brothers catalog showing a glass dinner bell similar in shape to the bells attributed to Central Glass Works.

In the 1920s, Bryce Brothers is known to have used the following colors in glass: amber, amethyst, dark and light blue, canary, green, pink, ruby, and black. During the same period, Central Glass Works produced glass in amber, amethyst, blue, canary, green, pink, red, and black. Many of the bells have been found with some of these colors.

Needle etched trefoil and lacy band patterns are not unique to the two companies. The pattern was very common and can be found in glassware produced by the following companies, among others, between 1900 and the 1920s:

Company	Pattern
Bryce Brothers Co., Mt. Pleasant, PA	#327 & #60
Cambridge Glass Works, Cambridge, OH	#272
Central Glass Works, Wheeling, WV	#700
Federal Glass Co., Columbia, OH	#1
Fostoria Glass Co., Moundsville, WV	#47
A. H. Heisey, Newark, OH	Tatting
Monongah Glass Co., Fairmont, WV	#272
New Martinsville Glass Co., WV	#2306
Seneca Glass Co., Morgantown, WV	#8 & #23
Tiffin Glass Works, Tiffin, OH	#259

The Central Glass Company plant, owned by the United States Glass Company, was closed in October 1893 and many of its molds were sold. A new company, Central Glass Works, was formed with a plant at the same site in Wheeling, West Virginia, on January 4, 1896. At that time, Central Glass Works did not have many molds and likely acquired molds initially from other companies to make their pressed glass and blown glass products.

So who made these bells currently attributed to Central Glass Works? It appears that the Bryce Brothers Company made the blank for the bell, but the needle etched design on the bell could have been made by any of the companies listed above, including the Central Glass Works. The colors found on some of these bells match many of the colors made by Bryce Brothers as well as Central Glass Works. While it appears that Bryce Brothers made the blank for the decorated bells, a more definitive attribution for the decorated bells awaits more research.

Hourglass Handle Bells

Several bells with very distinctive hourglass shaped handles occur in at least two different shapes. Over the years these bells have been attributed to various companies.

A 1942-1950 catalog from the Bryce Brothers Company of Mount Pleasant, Pennsylvania, shows various size goblets with a stem pattern no. 894 that exactly matches the handles of these bells. Pattern 894 was given a design patent 120136 on April 23, 1940. The author believes Bryce Brothers produced some of the bells that have been found with this handle.

In the 1930s and 1940s, Bryce Brothers sold blanks of stemware for decoration to the Cataract-Sharpe Manufacturing Company and the Lotus Glass Company. Lotus produced no glassware itself but applied decorated designs to undecorated stemware obtained from other glass companies, including Bryce Brothers. Examples, using the Bryce pattern 894 blank, are the etched "Bridal Bouquet" pattern and "Sovereign" pattern, patterns that can be found on other Lotus glass bells as well.

The Lenox Company acquired the Bryce Brothers Company in 1965, but the bell mold was not included.

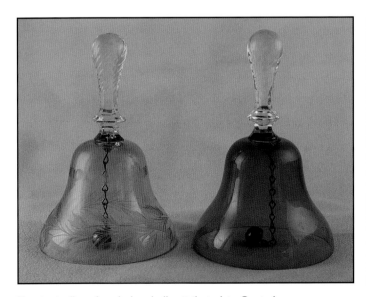

Two typically colored glass bells attributed to Central Glass Works. 3-1/4"d. x 4-3/4"h. $50-70 each.

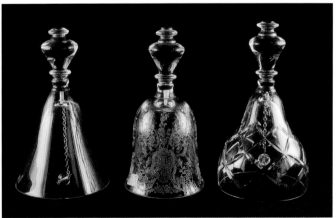

Three clear glass bells with hourglass shaped handles. The bell on the left has no decoration and the author believes it to be a Bryce Brothers blank. 3-1/8"d. x 5-1/4"h. $20-30. The other two bells have been decorated by the Lotus Glass Company in a "Bridal Bouquet" pattern for the center bell, 2-5/8"d. x 4-5/8"h., and in a "Sovereign" pattern for the bell on the right, 3"d. x 5-3/8"h. $30-40 each.

What Happened to that Glass Bell Mold?

Tracing the path of bell molds from company to company provides interesting background on the bells and helps to establish relationships among the companies. Here are a some examples of molds that were owned by more than one company.

Akro Agate Glass Bells

The Akro Agate Company of Clarksburg, West Virginia began operations in 1911 producing marbles. In the early 1930s, they started to produce colorless, colored clear, and colored opaque glass bells in a smocking pattern as well as clear glass bells in a ribbed pattern, both with a six-sided handle. The six sides carry down onto the shoulder at the base of the handle. The company closed in 1951. The bells were identified by the symbol of a crow holding two agates and "Made in USA" molded at the inside top of the bell where the clapper was attached.

The molds for these bells were sold to the Guernsey Glass Company of Cambridge, Ohio. Guernsey Glass produced bells in the 1970s in clear and opaque glass. A "B" for Harold Bennett, the owner of Guernsey Glass, was substituted for the crow in the mold. The bells can be distinguished from the Akro bells also by the rounded shoulder at the base of the six-sided handle.

Jefferson Glass Company Raised Rim Bells

In 1907, the Jefferson Glass Company of Follansbee, West Virginia acquired a bell mold from the Ohio Flint Glass Company as part of their Chippendale pattern glassware. It is not known if the Ohio Flint Glass Company produced any bells. Bells were produced as souvenirs by Jefferson Glass in a red flashed glass, amber carnival glass, and custard glass between 1909 and 1915. The bells have a raised rib just above the rim, and many were made with a gold band along the rim. Many of the custard glass bells had a rose decoration typical of many other Jefferson Glass items.

The mold was sold to the Central Glass Company in 1919. They used the mold to produce clear colorless bells, sometimes engraved with decoration, through at least 1929.

The Chippendale molds were sold to George Davidson & Co. Ltd., England, in 1933, but it is not known if the bell molds were included.

Upon the closing of Central Glass Co. in 1939, the company molds were acquired by the Imperial Glass Co. It is not known if the bell molds were included or ever used by Imperial.

See the Jefferson Glass Company and Central Glass Company sections of Chapter Five for examples of these bells.

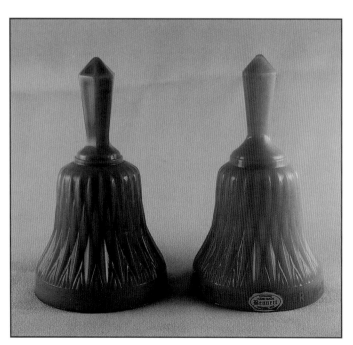

Two molded glass bells in a "Smocking" pattern, 3-1/4"d. x 5-1/2"h. The blue bell on the left is an Akro Agate bell with the sides of the handle carried down onto the shoulder. $70-80. The Crown Tuscan colored bell on the right was made by the Guernsey Glass Company from Akro Agate molds. The shoulder at the base of the handle is rounded. The "Bennett" label is for the name of the owner of the Guernsey Glass Company, Harold Bennett. The bell was made for the Bicentennial. $40-50.

Small Currier & Ives Pattern Bells

There are at least two differently colored 5" high glass bells in a pattern known as Currier & Ives that have been attributed to the L. G. Wright Glass Company, of New Martinsville, West Virginia, which started in 1930. However, the author has become aware of an advertisement in the Butler Brothers catalog of Christmas 1889 showing a bell in the identical pattern with a metal clapper that appears to match the flat clapper known in the bells attributed to Wright. Are they the same bell? The L. G. Wright Glass Company is known to have acquired old molds for some of its glassware.

Further research is necessary to determine the name of the company that made the 1889 bells. A possibility is the Co-operative Flint Glass Company of Beaver Falls, Pennsylvania, which was in business from 1879 to 1937 and made articles in a Currier & Ives pattern known as "Eulalia."

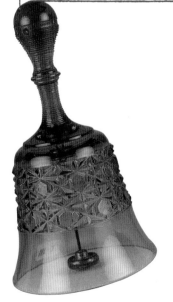

OUR "DIME" COLORED GLASS BELL.

For Dining Table Call Bell or Mantel Ornament.

A beautiful colored glass bell with metal "striker." A sure and rapid 10 cent seller.

..... Order here. Price, 80c. Doz.

An amber glass bell in a pressed "Currier & Ives" pattern previously attributed to L. G. Wright. The flat metal clapper on a stiff wire is held by a cork imbedded in the glass. Note the similarity to the bell in the 1889 Butler Brothers catalog.

A. H. Heisey & Company Bells

The A. H. Heisey Company of Newark, Ohio produced a pressed molded pattern bell in the 1940s known as "Victorian Belle." It was made in colorless clear glass and frosted glass. Some of the bells have the Heisey "H" in a diamond trademark molded on the back.

When Heisey went out of business in 1957, the mold for these bells was sold to the Imperial Glass Co. Imperial used the molds to produce similar bells in clear and frosted colors. These later bells usually have the Imperial Glass Company logo of superimposed "IG," "LIG," or "ALIG" (depending on when they were made) molded on the back of the bell.

When the Imperial Glass Company declared bankruptcy in 1982, the molds for the Victorian Belle were sold to the Heisey Collectors of America, Inc. This group has a museum in Newark, Ohio that lends the mold periodically to various glass manufacturers to produce the bells. They are usually marked with "HCA" and a date indicating when they were made. Sometimes the mark includes an identification of the company, such as "D" for Dalzell-Viking.

Part of an 1889 Butler Brothers catalog showing a colored pressed glass bell for sale at 80 cents a dozen. The metal striker and molded glass design are similar to bells with a Currier & Ives pattern and clapper previously attributed to the L. G. Wright Glass Company.

Three "Victorian Belle" glass bells. 2-3/4"d. x 4-1/4"h. The left bell is a Heisey Glass Company bell in frosted glass. $75-100. The center and right bells are made from Heisey molds acquired by the Imperial Glass Company. The center milk glass bell is marked "IG" and the frosted red bell is marked "ALIG." $30-40 each.

Appendix I
The American Bell Association

The American Bell Association (ABA) is an international association of bell collectors. It was formed originally in 1940 as the National Bell Collectors Club. The name was changed in 1948 to the American Bell Association; the word International was added in 1984 to reflect a growing international membership. In 1984, the association was also incorporated as a non-profit organization.

The American Bell Association has forty-five regional, state, Canadian, and overseas chapters that meet on a regular basis. It holds an annual convention during June/July and publishes a bimonthly magazine, *The Bell Tower*, featuring articles by members on all kinds of bells, bell news from around the world, chapter news, and details of important future bell meetings.

Conventions are held in a different location each year and afford members the opportunity to become acquainted with other members and their collections, as well as to forge lasting friendships. Highlights of each convention are a sales room and a bell auction with many opportunities to find bells to add to members' collections.

For further information, write to:

ABA
P. O. Box 19443
Indianapolis, IN 46219

Appendix II
American Cut Glass Bell Patterns

Pattern	Company	Page	Pattern	Company	Page
Jewel	T. B. Clark	13	No.3	Higgins & Seiter	18
Harvard		14	Monarch	J. Hoare & Sons	18
Winola		14	Wreath	Krantz & Sell	18
No. 40	C. Dorflinger & Sons	15	Belmont	Krantz, Smith & Co.	18
Parisian		15	Harvard	Libbey Glass Co.	19
Royal		15	Verona	Maple City Glass Co.	19
Strawberry Diamond & Fan		15	Allita	C. F. Monroe Co.	20
Acquila	T. G. Hawkes	17	Odolet		20
Coronet		17	Chelsea	Pairpoint Corporation	21
Pearl Border		17	Crabapple		21
Russian		16	No.41		21
Strawberry Diamond & Fan		16	Cathedral	Pepi Herrmann Crystal	23
Wexford Waterford		17	Millennium		23
			American Beauty	L. Straus & Sons	25
			Corinthian		25

General Bibliography

Anthony, Dorothy Malone. *The World of Bells*. Des Moines, Iowa: Wallace-Homestead Book Co., 1971.

———. *World of Bells No. 2*. Des Moines, Iowa: Wallace-Homestead Book Co., 1974.

———. *World of Bells No. 5*. No date.

———. *Bell Tidings*. No date.

———. *The Lure of Bells*. 1989.

———. *World of Collectible Bells*. No date.

———. *More Bell Lore*. 1993.

———. *Bells Now and Long Ago*. 1995.

———. *Legendary Bells*. 1997.

———. *Bell Treasures*. 1999.

Baker, Donna S. *Collectible Bells: Treasures of Sight and Sound*. Atglen, Pennsylvania: Schiffer Publishing Ltd., 1998.

———. *More Collectible Bells: Classic to Contemporary*. Atglen, Pennsylvania: Schiffer Publishing Ltd., 1999.

Eige, G. Eason. "East Wheeling Glass Works (Central Glass Company)." In *Wheeling Glass, 1829-1939, Collection of the Oglebay Institute Glass Museum*. Oglebay Institute, 1994.

Revi, Albert Christian. *American Pressed Glass and Figure Bottles*. New York: Thomas Nelson & Sons, 1964.

Index